Career
Photography

Career Photography

How to Be a Success as a Professional Photographer

Lida Moser

A SPECTRUM BOOK

Prentice-Hall, Inc., Englewood Cliffs, New Jersey 07632

Library of Congress Cataloging in Publication Data

Moser, Lida.
 Career photography.

 Includes index.
1. Photography—Vocational guidance. 2. Photography,
Commercial. I. Title.
TR154.M67 1983 770'.23'2 83-11178
ISBN 9-13-115113-4
ISBN 0-13-115105-4 (pbk.)

This book is available at a special discount when ordered in
bulk quantities. Contact Prentice-Hall, Inc., General
Publishing Division, Special Sales, Englewood Cliffs, N.J. 07632.

1 2 3 4 5 6 7 8 9 10

ISBN 0-13-115105-3 {PBK.}

ISBN 0-13-115113-4

Editorial/production supervision by Cyndy Lyle Rymer
Interior and insert design by Alice Mauro
Manufacturing buyer: Pat Mahoney
Cover/jacket design by Hal Siegel
Cover photo of Stephanie Cohen by Lida Moser

Prentice-Hall International, Inc., London
Prentice-Hall of Australia Pty. Limited, Sydney
Prentice-Hall Canada Inc., Toronto
Prentice-Hall of India Private Limited, New Delhi
Prentice-Hall of Japan, Inc., Tokyo
Prentice-Hall of Southeast Asia Pte. Ltd., Singapore
Whitehall Books Limited, Wellington, New Zealand
Editora Prentice-Hall do Brasil Ltda., Rio de Janeiro

To all the photographers
who helped make this book possible

Contents

Press Photography *57*

Advertising Photography *101*

Medical and Scientific Photography *133*

6

Staff Photography *161*

7

Performing Arts Photography *181*

8

Stock Photographs *215*

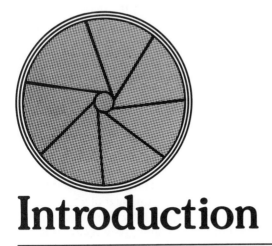

Introduction

○ You have a camera; you know how to use it. In fact, you're very good at it. You love photography; you love taking pictures. You love the excitement and joy you feel when your photographs are good. You've made up your mind that you want to make photography your career, but what do you do? Where do you start?

Well, you'll get your answers in this book. You will hear directly from photographers working in every kind of specialty. They'll tell you how they began and how things went along. You see, you're not the first one who has felt this way. Every photographer who is working at it once felt the way you do, and they managed to develop careers in all the different fields of professional photography.

In the course of explaining their work, the photographers discuss many technical points. But this book is not a technical manual. What this book does give you is much harder to find out about than technical information. You will learn about the attitudes that the professional photographers bring to their work: their approach, how they think through their photographic problems, how they act toward their clients, how they take care of the umpteen details a professional photographer must be concerned with in order to create a salable photograph. This precious information, which is priceless for the aspiring professional photographer, is given to you generously by the wonderful photographers who contributed to the chapters of this book.

The photographers you will meet in this book are all very different from one another. Some are men, some are women; some are talkative, some are taciturn; some swear by one camera, some by another; some have had all kinds of schooling, others are self-taught; some work with a large staff,

others are loners; some travel a lot, others stay put; some came to a specialty early in their careers and stayed with it, others have worked in many different specialties.

Despite these differences, what these photographers—in fact, what all good professional photographers—have in common is technical expertise, intelligence, dedication, great ability, a capacity for hard work, good organization, a lot of energy, a love of the medium, and a genuine desire to satisfy their clients. This is the groundwork for success. A lot of false glamor has been attached to photography. It is not easy work. Professional photography is a tough field, and the competition is keen.

Yes, all the photographers you will meet in this book first and foremost have mastered the basics, the techniques of using the camera, the understanding of lighting, of films, and of darkroom work, in order to produce beautiful and functional photographs. These are the basics, the heartbeat, and the lifeblood of the medium.

A book cannot put this knowledge into you. This knowledge and ability you can acquire and master only by doing, by practice, by trial and error, by repetition, by asking questions, by seeking answers, by being self-critical. Technical manuals abound; they are not hard to find. Every piece of equipment in the field of photography, every film, all the chemicals come with technical manuals and you need only to study them.

But the knowledge of the craft has to sink into your muscles, your fingers, your eyes, your mind so that it becomes an intrinsic part of you, like breathing. All these things you must do yourself—no book, no manual, no other person can give it to you. This book, however, can make you aware of the importance of these basics.

But technical expertise is not enough. The crux of the matter that you really must master is not only how to make a good photograph that pleases you—you'd be surprised at how many people who use cameras can do that —but what you must learn, and what you will learn from this book, is how to make a photograph that works and does a job for the person who is paying for it, how to make a photograph that satisfies a client so that he or she keeps coming back to you again and again.

All the photographers in this book have a thorough understanding of the needs of the people who are giving them jobs, giving them the assignments, who are buying the photographs; and the photographers bend all their talents, abilities, and imagination to produce photographs that work for their clients.

And who are the people who will buy your work? Who are the people who will be your clients? They are: corporations; advertising agencies; celebrities; performing artists—dancers, actors, singers, opera companies; newspapers; magazines; book publishers; hospitals; doctors; theater producers; film companies; people getting married; the parents of children; governments; officials; politicians; scientists; research laboratories;

graphic designers; art directors; editors; artists; small businesses; fashion designers; social service agencies; schools; universities; archives. The list is endless. You may even uncover some clients that no one else has thought of.

So you see, there are a great number of people out there who need your work, and the next thing you must decide is what you most want to do photographically. Then find out who your potential clients are, get to them, convince them that you are the one they need, and then finally prove yourself to them by giving them the photographs they want.

As you go through this book, even if a chapter deals with a specialty in photography that you don't think you're interested in, read it anyway. You may be surprised and discover that it's something you didn't properly understand or know about. It may be an area of photography that you excel in. The photographers have many interesting things to say about their specialties that can be applied to other fields of photography. Also, some of the photographers worked in other specialties before they started in their major specialty, and they talk about all the work they've done. This book is full of gems, priceless information, and unexpected insights.

So think of this book as an exciting trip into the working world of photography. The photographers you are about to meet will tell you things they know, things that one can only acquire through work, time, and experience. They are talented and they are generous—they share their precious knowledge and experience with you.

This book is the nearest approximation to working side by side with these successful photographers you wish to emulate, these photographers who have found their way in the kind of work you have chosen for yourself.

Free-Lance Photojournalists

○ The free-lance photojournalists are those who are unaffiliated, who earn their incomes from a variety of sources, who take their cameras and go anywhere and do anything for anybody. That may not be exactly the way they function, but quite close to it. Even free-lancers tend to specialize. Although they may not know where their next assignment is coming from, the successful ones have established a reputation, and their clients have come to depend on them. In this chapter you'll discover the many different ways that free-lance photographers work.

To set the scene of the free-lance photojournalist, we start off with Howard Chapnick, president of the picture agency Black Star, which represents the work of photojournalists. Black Star was established early in the 1930s by people involved in the beginnings of photojournalism and the picture-story idea when it first had an impact as a force in still photography.

Then you'll meet Martha Cooper. She started out as a press photographer, became a free-lancer because she wanted the option of photographing what most interested her, and then discovered the challenge of finding clients who were interested in the kind of work she does. In fact, she has introduced a new term for her work: She calls it "investigative photography."

Next we meet Jeff Blackman, sports photographer, who is moving into more general assignments. He is in sports photography because there he finds those elements of freedom, of the unexpected, that attracted him to photography originally.

Ida Wyman, who currently works as a specialist in photomicrography (see Medical and Scientific Photography, Chapter 6) did photo reportage during the heyday of the picture-magazine era, and the story of her early career has a historical dimension in photojournalism that is important to know about.

Bernard Wolf's career has taken him all over the world on travel assignments, then deep into people's lives for a series of books, and also into the corporate world, doing annual reports for big companies.

The group of photographers in Chapter 2 are all interesting free-lancers involved in many different areas: the culture of peoples, sociological conditions, children, nature, and art.

You'll find that the motivation for most free-lancers is an impulse to pursue those things in life that are of great interest to them.

Howard Chapnick:
Black Star—A Picture Agency

○ Black Star was established in 1936 as a picture agency dedicated to photojournalism. The president of Black Star, Howard Chapnick, defines photojournalism as "photographs concerned with capturing the decisive moment; photographs that are believable and realistic, as opposed to the stylized, illustrative approach of photography."

Black Star represents seventeen staff photographers and many more free-lance photographers. They also sell stock from their picture library of three million photographs, built from the assignments of their staff photographers, as well as submissions from free-lancers throughout the world.

Black Star was established by three refugees from Germany—Ernest Mayer, Kurt Kornfeld, and Kurt Safranski. Kurt Safranski was considered one of the leading aestheticians of photography; he was involved with the beginnings of the picture-story concept. He had been invited to the United States to work on the first dummy of a picture-magazine project, which eventually became Life magazine.

Chapnick first came to work at Black Star as an assistant messenger in 1940, during a college summer vacation, and continued for two afternoons a week during the school term, doing research and writing for general assignments. After three and a half years in the U.S. Army during World War II, he returned to Black Star, continuing with research and writing; then he began to make client contacts, and to sell; eventually he became president of the company.

Chapnick worked day in and day out for close to two decades with hundreds of photographers, and also with the people who buy photography. With this unusual and unique background, his advice to you about what it

takes to be a successful and well-functioning photojournalist has great validity.

LM: *What do you think are the most important attributes of a top-notch photojournalist?*
HC: 1. Intellect and the brain are a very important part of being a photographer. One must be well informed about world happenings; about the arts, the sciences, the humanities. You must use all available means of keeping informed through every possible source: newspapers, publications, radio, TV, films. You're a journalist, and you must be an acute observer and interpreter.

2. Technique must be second nature, like driving a car. You must be the master of the craft, of cameras. You must know what films can do—must be able to cope with any lighting situation, be it strobe, tungsten, or natural light, and use them all well.

3. You must get along with people, and inspire confidence as a responsible, thoughtful individual who is concerned about telling a story in an articulate, honest way, one who will not exploit or distort a story. You have to be at home with garbage men and kings, with scientists, politicians, and artists, and talk their language. You must be prepared to cope with the variety of situations that photojournalism may demand.

4. You must have a visual sense, a design sense, a sense of composition. You must be able to see and think in a well-ordered way, so that your photographs are made simply and directly, and are not confusing.

Chapnick urges photographers to strive for the highest possible standards, and although the field has become highly competitive, he says that the cream will rise to the top, as always.

Martha Cooper: Investigative Photography

○ Before becoming a free-lance photojournalist, Martha Cooper worked as a press photographer. Free-lancing suits her perfectly, since she is full of ideas and completely self-motivated. She can work day in and day out on her own, with energy and enthusiasm. She has a little car, she dashes around New York City from assignment to client, to photo-finishing labs, to the camera store, to her office—and always in a forthright, positive way.

MC: I like the concept of this book, and I'm very anxious to share my experiences. It's good that this book includes photographers who aren't famous, who aren't "names," who are just working hard and making a living.

What aspiring photographers want to know is, "Is there a place for me in this world?" When they keep reading one success story after another, it tends to give the impression that you're either a success or a failure, no in-betweens.

However, in fact, there's a tremendous area in photography for lots of people in between, who are making very good money and doing lots of interesting things. You seldom hear about them, and they're good. Often you see their work, and you say, "Isn't that nice," and you've never heard of that person, although their work is so good.

My theory is if you pursue a personal project with vigor and determination, you draw work to yourself, work that you never even would have thought of. For the most part, I don't think it's always necessary to be trained specifically in photography. I think a wider background is better to draw from.

In my particular case, my father was in the camera business, and I had a camera when I was two years old. So I grew up with photography, always taking pictures. But I didn't particularly think of making a living at it, and started out in a different career, anthropology, which turned out to be a firm base for photography. I had no idea how to make photography into a career.

[That's why this book has been written—to give insight into all the different ways that careers in photography develop, and all the different types of careers.]

I majored in art in college, taught English in Thailand for the Peace Corps for two years, did a year of graduate work in anthropology at Oxford in England, returned to the States. Then I got a job working at the Smithsonian in Washington, D.C., for a year. After that, I moved to a job at Yale as curatorial assistant in anthropology at the Peabody Museum, designing exhibits and overseeing students cataloging artifacts. I was constantly taking photographs during that time, as an adjunct to my work.

One day, while working at Yale, a curator from the National Geographic Society came to borrow a trepanned skull from Yale's Machu Picchu collection. (A trepanned skull is a partially healed skull showing evidence of a successful primitive brain operation.)

I asked him about the *National Geographic* summer photography

intern program, which I had just read about in a newspaper. He didn't know much about it, but he offered to take my portfolio to Washington. You couldn't really call it a portfolio. It was a looseleaf notebook with a collection of three-by-five-inch Kodak color prints from slides I had taken when I was in the Peace Corps in Thailand. I received a letter right back from Bob Gilka, the photo editor, saying that I had been accepted for a summer internship. I immediately quit my job at the museum. That notebook-*cum*-portfolio must have had something going for it.

It turned out that hundreds apply *every* summer, and that only three get the internship. It was the most prestigious intern program for photographers, but I didn't know that then. They usually take people in journalism schools, and I was twenty-six years old already. I had a wonderful time; in fact, that was a high point in my career.

I thought, "Well, this is easy, it's *easy* to be a professional photographer, and I'll be a *National Geographic* photographer!" Bob Gilka, the photo editor, said, "Give me some ideas." One of my ideas was to photograph a certain tribe I knew of in the Philippines, the Ifugao tribe, who farm extensive mountain rice terraces.

They gave me a five-hundred-dollar minimum guarantee, and all the film, and whatever equipment I needed. I spent fifteen hundred dollars, flew out to the Philippines, marched up into the mountains, and shot 120 rolls of color film. It never crossed my mind that they wouldn't use those pictures. I didn't know then that they don't use all the stories that are shot for them. Well, that was a blow. It took a long time for *Geographic* to decide not to use them, and when they sent them back, it wrecked my morale.

Later, I made a filmstrip from those slides. They are in my files, and over the years I have sold a few for stock. It was quite a while before I could get interested in taking pictures professionally again. I tried to free-lance a little bit, but I was really devastated by this rejection.

I got married and went off to Japan with my husband, who is an anthropologist. In Japan I began doing educational filmstrips. I researched the audiovisual companies in the U.S. through a book called *Audio-Visual Marketplace*.

I wrote letters, made suggestions, and got some jobs. It was the heyday of filmstrips, which are usually a series of 35mm slides, printed onto one piece of film, and marketed with cassette tapes and teacher's guides.

We stayed two and a half years, returned to the U.S., and four

months later returned to Japan with new commissions to make another six filmstrips: *Nagasaki, Life from the Sea, Silk Farming,* etcetera. Filmstrips were a big market then for photography.

After returning to the U.S. and finishing up the filmstrips, we went to live in Rhode Island, and I got interested in newspaper work, number one, because that was the only kind of work around, and number two, because I wanted to do journalism. I'm sort of a voyeur (aren't all photographers?). I am as interested in what's going on as I am in taking pictures. Using a camera for me is a way of participating in an event that isn't directly a part of one's life. I like the idea of never knowing where you're going to go, and just getting sent to these odd places, and into situations.

I worked on two weekly newspapers with large picture sections— the *Narragansett Times*, and the *Standard Times*. There was one editor, two reporters, and I was the only photographer for both newspapers. I worked my ass off. They were fifteen miles apart and I was always driving back and forth. There were maybe ten assignments some days. I worked harder—much harder, I later found out—than what you do for a daily. On top of that, I had to do all the developing of the negatives and the printing of the photographs.

LM: *How did you manage to do all that?*

MC: You just worked, you worked very hard, and late at night you did the printing. On Saturdays and Sundays you covered things like Little League baseball. I covered the tricentennial celebration of North Kingstown, Rhode Island. The salary was terrible, but it was very good training. They used an offset press, and the quality of the reproduction was wonderful; it was an amazing showcase for my work. They liked the pictures, and they used them well, they used them big.

It was exciting and I learned a lot. I thought of it as a stepping-stone to a big newspaper, and I came to New York, commuting to Rhode Island on weekends, where my husband was still teaching, with the idea of working for *The New York Times*. Of course, that didn't happen right away, or ever, but I began shooting filmstrips again, which was a very lucrative market.

I did them for a variety of clients; several for the Encyclopaedia Brittanica on "The Family in a Changing Society," a series for Butterick on sewing techniques, and a couple for Banker's Trust on "Saving, Spending, and Lending," to be shown in schools. This work taught me how to use big strobes and work with models.

I was making as much then as I'm making now, and with inflation, it was worth lots more. Then, still pursuing a career in journalism,

I heard of a job in Maryland at a TV station, and impulsively took it. I was the staff photographer at the Maryland Center for Public Broadcasting, but it turned out to be a public relations job, not like working for a newspaper, and I stayed only six months.

I came back to New York, and was lucky. I got a job at the New York *Post* as a staff photographer. They had a new photo editor who was exciting to work for. I realize that what it takes in New York, and I guess in any large city, is hanging in there. It's true what they say, that you have to know somebody, but the way you get to know somebody is to keep showing your work to art directors and editors, and letting them know that you're around, ready and able to accept and carry out assignments. It's a cumulative thing.

I kept going to the magazines and the wire services, A.P. and U.P.I. [Associated Press and United Press International] My portfolio from Rhode Island was a great plus. You just have to keep seeing people and keep going around. If you're not around for a month, they don't know who you are. There are millions of photographers. They don't call you. You have to keep calling them. So, I got this job on the *Post*, and for three years I worked on the *Post*.

The job was a lot of fun at first, but the *Post* was not a photo-oriented paper, and after a while the jobs got repetitious. They liked a certain kind of coy setup, and I got to be very good at doing that kind of posed picture. A lot of the crime stuff and the news stuff often were "aftermath action situations." Although we used radios, the cops and ambulances always beat us to the scene. There were a few interesting jobs. I got to cover Three-Mile Island. I went to San Francisco when all the people were murdered in Guyana, to interview survivors, relatives, and attorneys.

After three years on the *Post*, although the pay was good, I was ready to move on, and always in the back of my mind was *National Geographic*. I had the feeling that it was unfinished business, that I had had this wonderful summer internship, and why couldn't I parlay it into a career. To this day, I still have that feeling, and in a way, that probably is what keeps me going, because I have the definite feeling that I never achieved my goal, but I'm still working.

I do some work now for the *National Geographic*. I have had pictures published in it, and in *World* magazine, which is their children's magazine. I've done photographs for their books. I've been a still photographer on their film crews. You have to remember that *National Geographic* has a million assignments. It's not just a magazine, it's big business.

I have now been free-lancing for nearly two years, and I can't say that it has become much easier than when I first came to New York. After I left the *Post*, it was like starting all over again. However, during these two years, I have established a network of contacts which has stood me in very good stead, and which I didn't even realize I had until, for example, somebody would say, "You know that editor on the *Post*, well he's now an editor on a woman's magazine in New Jersey." This recently happened, and I went to see him and got work. It's surprising how many people I have gotten to know. It builds; it really does build. I haven't had to show my portfolio now for months.

What generally happens is that I get a call, someone has recommended me, and I go and do the job. If they like it, and if they have more work, then they hire me again. That's how I get clients. Some photographers have a few big clients, and they do all their work for them. I have numerous small clients, and I'm working away at this job here and that job there, but the jobs just seem to come in, and I go and do them, and it's working out very well.

LM: *You work very hard?*

MC: Yes, I do. I do work very hard, because I work for smaller jobs, and I'm probably the bargain of the New York City scene. I'm trying to work up a number of clients who have the kind of work that I want to do.

I do my best work when I'm interested in the subject. A good professional photographer should be able to take any assignment and do his best work. However, the truth of the matter for me is that I can do better work when I'm sincerely and honestly interested in the subject matter. Therefore, it's important for me to get jobs that intrigue me, and these kinds of jobs are usually low pay, low budget.

LM: *What kind of jobs do you do?*

MC: For instance, I work for a woman called Karin Bacon, who has a company that stages events, such as New Year's Eve at Studio 54 and festivals at the Bronx Zoo such as Easter-egg rolling and the elephant's birthday party. She goes around checking out various folklore events, because she incorporates folklore talent in her events. I met her at a Bronx folklore conference, where I was making a slide presentation on a certain kind of street dancing called "breaking," which I was investigating. She was interested in breaking, as she was thinking about using the dancers—b-boys, as they are called—in some of her festivals. As a result of that meeting, I now photograph for her. I document her festivals.

I photograph concerts and lectures at the Metropolitan Museum

of Art. I shoot publicity stills for television shows. I work for a magazine called *Woman's World*, which uses *Post*-type pictures: a woman who writes love letters for others; three sisters who had babies on the same day. These fall under the category of making a living. I go and do it, and I try to do a good job.

In 1981–82, I worked on a big project, Brooklyn Rediscovery, funded by the National Endowment for the Humanities (the NEH). The grant was obtained by the Brooklyn Educational and Cultural Foundation, a group of urban anthropologists and folklorists. Their concerns are urban folklore, which in Brooklyn includes such things as Hasidic weddings, Caribbean carnivals, Italian-American festivals, and a variety of street games, foods, etc. They are interested in how people alter the space, the neighborhood they live in, to suit their needs and customs. From this project I've gotten some assignments, such as a story on life-size Sicilian marionettes from *Smithsonian* magazine. I have continued to be interested in anthropology.

While I was working on the *Post*, I did a self-assigned project, over a period of a year, on unsupervised children's play in NYC. I collected the toys and artifacts that the children made themselves to accompany their games. In 1980 the Museum of the City of New York exhibited these photographs and also the artifacts and toys I had collected.

When I was photographing this unsupervised play project, a boy showed me his little book of designs for painting on subway trains. I had never really paid much attention to graffiti. I bought his design book for five dollars, and he introduced me to a graffiti "king," and several of the artists, or "writers," as they call themselves. That led me to a study of New York subway graffiti, and it's fascinating. I have been investigating and photographing it intensely since January of 1980, and will probably continue for years.

The graffiti project contains all that I'm interested in: art, urban anthropology, and journalism, and I just took off. I got completely, totally wound up in graffiti, train graffiti, and graffiti writers. I am compiling an intense documentation.

I have a picture of everything that's related to graffiti, both in and out of the train yards. I go with writers where they keep their paints, have their meetings, and compare designs. They often work alone when they paint, but they have groups and clubs, and their primary intent is to display their work for each other. They are very involved about it all, about all the minutiae—knowing every shade of color of all the different manufacturers, for example.

I'm just trying to document it. I couldn't sell a graffiti story anywhere

in the United States. No one wants to publish it here, except a few of the photographs are being used in Craig Castleman's graduate thesis, being published by the Massachusetts Institute of Technology Press. Maybe someday I'll publish a book on graffiti.

I showed the story to *Geo* magazine, and they didn't want it, but sent me to a German art magazine, and they used it. As a result, I have had a lot of work from that magazine in Germany. I was assigned to do a story for them on Fashion Moda, a storefront art gallery in the South Bronx. I also did a story for them on the new Rockefeller wing of primitive art at the Metropolitan Museum of Art. Another interesting story I did for them was about a Harlem artist who paints the iron gates of the storefronts. On Sundays and at night when the gates are pulled across the storefronts, his gate paintings go almost the whole length of 125th Street, and have become a tourist attraction.

I finance my personal projects by the jobs I do, but I'm trying to get out of little jobs into better-paying ones. I now see that if you just keep working at what you like, sooner or later you'll be known for it, so it's important that you get yourself into the kinds of assignments you like best.

The kind of work I've done and I'm doing, such as the children's play project, the b-boys, and the graffiti project, is generally called documentary photography, or reportage. But those terms do not really describe what I'm doing. I like to think of my work as investigative photography, because I like to photograph every aspect of an activity. It is specific visual reporting in depth. I keep chipping away, I take a picture of every detail. I want to make a thorough record. You need it all, not just the so-called "interesting, exciting, dramatic" photographs. Often I take pictures the way a reporter takes notes.

My income is derived from a combination of things: magazines, the Brooklyn Rediscovery project, public relations work, documentation of events, and the sale of stock photographs, which keeps mounting as time goes on.

I don't go in for a lot of equipment. That is my specialty—doing as much as I can with the least amount of equipment. I don't yearn for every new gadget. If I can't do a shot because I'm missing a piece of equipment, then I go out and get it. But I don't go out on a job with twenty times more equipment that I need. I usually take one strobe, with a hand-held umbrella, two 35mm camera bodies, five lenses from 20mm to 200mm. I do have a set of 800 watt-second Dynalite strobes, which I use on location when necessary, such as photographing an artist in a large studio.

When I shot the New Year's Eve celebration, I didn't look for celebrities, I concentrated on the event. Studio 54 has an all-white ceiling and walls, and you'd be amazed at how much can be done with bounce light from one little 285 Vivitar strobe, and a wide angle lens. If you wait for the flashing red or yellow lights, which are on a computer, and you pop in a little strobe during a long exposure, you can get the whole floor, and get a photograph of all those milling people jammed together in all their fantastic outfits.

LM: *Do you use assistants?*

MC: No. I do not like assistants. I do not work well with assistants. I don't like to have someone hanging around. I don't even like to have to think about telling them what to do.

LM: *How many hours a day do you work?*

MC: Ha, usually from about eight-thirty in the morning until about ten at night.

LM: *Do you do your own processing?*

MC: I do not do my own processing, either black and white or color. There's no point; you're out buying film, getting your cameras fixed, writing the captions, putting carousels together to show editors, and shooting, shooting, shooting. There are so many different things to do. There's no point in doing your own processing, because any client will pay for the processing, so why do it yourself?

There is no doubt that Martha Cooper, especially in her self-assigned projects, is creating historical documents, important records of our time.

MC: These investigative projects I'm working on, will be more important in ten, twenty, and more years from now. This is my rationale. Besides all the other reasons previously described, I also do this work, because I have this idea that instead of money in the bank, I prefer to put my money into my photographs, and I know that the time will come when they will draw interest. I believe the in-depth work that I am doing is very valuable. It's my own IRA.

As a postscript, as this book was going to press, Martha Cooper succeeded in two of her goals.

MC: When we couldn't find a publisher here for the graffiti book, we took a collaborative effort, a mock-up, with Henry Chalfant, who has

also been photographing trains, to the Frankfurt Book Fair (1983) in Germany. A number of European publishers showed serious interest, and we decided to let Thames and Hudson (of England) originate the book. Other publishers will put out editions in their languages. I went to England in March of 1983 to assist the designer with the layout of the book.

My other big news is that I finally got a real assignment from *National Geographic;* a story on "pollen." It's much more interesting than the subject might initially suggest. It includes pollen allergies; pollination by various means for agricultural purposes; pollen as a health food; natural history with bees and other pollinators; pollen used in archeology dating, and oil exploration; pollen in ceremonies, such as those of the Navaho Indians. It's a perfect topic for me. Each photo is in a different location. I'm in my element.

Jeffrey E. Blackman: **Sports**

○ Photographers involved in sports photography function in several different ways. Some work exclusively under contract for a magazine, some are attached to sports organizations and sports arenas. Others are completely free-lance, and develop careers that go in many different directions. Some photograph all kinds of sports and athletic events; others specialize in certain ones. There are some photographers who only photograph yachting and sailing, and some who specialize in the many aspects of horse racing.

Jeffrey E. Blackman is a free-lance sports photographer whose work appears in all kinds of publications worldwide. Advertising agencies also buy his photography.

JB: I photograph many different sports activities: horse racing, rodeo, polo, golf, tennis, football, soccer, and all kinds of auto racing. However, I also specialize in unusual sports events. For instance, I photographed motorcycle racing on ice in upper New York State, and sold those photographs to magazines all over the world.

Another unusual event I photographed was an automobile and motorcycle race up a mountain. This event, the Pike's Peak Hill Climb, takes place every July fourth in Colorado Springs. Two days before the event, I started photographing all the preparations: fixing the bikes, the contestants arriving, and the general building up of the excitement. I always try to include this pre-event activity in any event I'm photographing, if I have the time.

On the day of the Pike's Peak Hill Climb, I took a position three

quarters of the way up the mountain, where even in July, the temperature was below freezing, seventeen degrees Fahrenheit.

[That's another particularly important concern of sports photographers—they must constantly be aware of and anticipate weather conditions, since so much of their shooting is done out-of-doors. More on this later.]

Rodeo is a sport that is a world unto itself, and I have covered it comprehensively. It is possibly the most detailed documentation of rodeo that exists. I have photographed all the riding events that take place in the arena: bull riding, saddle and bareback riding, team roping, calf roping, steer wrestling, and girls' barrel racing.

There are many stories within the overall story of rodeo. For instance, I've done a detailed series of photographs just on the clowns, who are a major part of bull riding. After the cowboy has jumped off the bull at the end of his ride, or is thrown off the bull, the clowns come in on foot to protect the cowboy by distracting the bull to keep him from turning and attacking the cowboy.

I have also photographed all the befores and afters of the arena events: the cowboys eating, sleeping, and traveling from rodeo to rodeo. The successful ones have their own planes, others have cars and trucks, and some even have to hitchhike.

I worked at this detailed coverage of rodeo in between other assignments over a three-year period. Then I took three months off from all other work, and concentrated on rodeo exclusively in order to fill in and extend what I had already done. I photographed road signs, the spectators, the picnicking, details of the clothing both of the participants and the spectators, I took pictures of the vendors that come to these events, and all kinds of people who work around the rodeos. Although a lot of the photographing was done for assignments, and a lot of them are sold for stock, my ultimate aim is to have a definitive book on rodeo published.

For two weeks in the month of March, a dog-sled race takes place in Alaska, which I photograph. It's one person to a sled, and about forty-five sleds enter this race. Temperatures generally range from ten to fifty-five degrees below zero, every single day, and if you're going to be out shooting for a two-week period in this extreme cold, you must take precautions with your equipment. When not shooting, the camera should be kept in a well-insulated container. And also, it is advisable to go to a reputable camera technician beforehand, and have your equipment winterized, which is a process where special lubricants are put inside the camera body.

Fifty percent of my income is derived from sales to publications abroad. Japanese publications like these unusual types of sporting events. When I come across one, I will phone my contact there, and often I get a go-ahead. Or, if I have already shot it, they frequently will buy it. The Japanese love football and golf, and I photograph a lot of that for them. Every year I photograph all the big golf tournaments for them—the Masters, the U.S. Open, and the P.G.A.

Since outdoor shooting is the main part of my shooting, there is the constant problem of weather, the quality of the light, and the position of the sun. If it is raining, and the event is running, I am photographing, rain notwithstanding. With any sporting event, it helps to know your location. It saves a lot of time. With experience, you will know where is the best position to shoot from, how the light will fall, and the direction of the sun all day.

For instance, with horse racing at Aqueduct [the race track in Long Island, N.Y.] the major stakes races start about four-thirty in the afternoon, at which time the sun is situated behind the track. Even though it is still daylight, there is no light at the finish line. Knowing this, I use 400 ASA color film, and usually rate it at 800 ASA, so that I can shoot at 1/500 of a second. Of course, I instruct the lab to process the film accordingly.

At the U.S. Open tennis matches, a specific area is set aside for photographers, and there can be as many as sixty. Once you get a spot you can't move much. With the men's finals at four-thirty, I get there at nine A.M. in order to pick a good spot.

[Believe it or not, two other photographers got there before him.]

Now, how do I pick my spot? Number one, I like to be close to the net, yet be sure that the TV cameras—which are right at the net line—don't get in the way of my camera angle; number two, I pick the side where the sun will not hit into the lens; number three, for one particular match, I felt a certain player would be the winner, and with my first and second considerations satisfied, I was lucky, in that the wife of that player was sitting right behind me, which gave me a direct shot at him as he made his triumphant gesture toward his wife, when in fact he did win.

I only shoot color. If black and white is needed, conversions can be made from the color.

Another important consideration is that most magazines work three months ahead. So, if an event is coming up that I covered the year before, I will contact publications to find out if they want me to cover

it for them. If not, I tell them that I shot the event the previous year, and offer them material on the event. If they buy it, they will run some pictures on a general story of the event, and omit the winners.

For example, one year Blackman had an assignment to photograph the Monaco Grand Prix in Monte Carlo. This is a race where the automobiles drive through the streets, rather than on a track. In his file, he has photographs of the drivers, the cars, the street scenes, and the general area. These are the kinds of pictures that aren't dated, and they sell well in following years.

Equipment

○ A serious sports photographer has everything necessary to get the best possible coverage of an event. Yet he must carefully organize his equipment, since he must carry it on him while shooting, and not be impeded, so that he is able to move quickly.

JB: Through experience, I can anticipate what I will carry on me without being overloaded. Generally, I carry two bodies and at least six lenses: a 24mm, 35mm, 85mm, 105mm, 200mm, and a 400mm, which I can convert to a 600mm. I never use a zoom lens.

One of the characteristics of a top-notch sports photographer—or a top-notch photographer in any field—is that no matter what the cost, if a lens or a special piece of new equipment comes out that will enhance his work, he or she will get it. When a lens that cost close to four thousand dollars was introduced, the manufacturer lent it to Blackman to try out for a few weeks. When he determined that it had qualities that would contribute to the effectiveness of his work, there was no hesitation: He bought it.

Travel Planning

○ Travel planning to get to sports events is very important. Sometimes it must be done three to four months in advance, especially for the major popular events, such as the Masters Golf Tournament, or the Indianapolis 500 auto race. Flights have to be booked at least three months in advance. When Blackman first started photographing the Indianapolis 500, he phoned a motel situated right on the track four months ahead of time. He wanted to stay there, no matter what the cost. They told him that they had a seven-year waiting list, so he stayed somewhere else. (Obviously, that's an extreme example, but it does happen.)

Research

○ Another interesting aspect of Blackman's work is the research he does, especially since he pursues little-known and unusual events.

JB: I read every magazine in the world, and I comb the sports pages of *The New York Times* every day. If an item appears about an event that I'm interested in, and if it has already occurred—or if it's imminent, and because of prior commitments I cannot make it—I have a chronological file system, and I make a note of it for the following year, or for a future time when it will occur again, so that I can make plans to cover it.

Marketing

○ A free-lance photographer must always be searching out new clients as well as keeping in touch with everyone he has already done work for. This requires common sense and imagination, and is time-consuming, but necessary.

Blackman phones editors to show his portfolio and his published work. And he has developed a network of people who rely on him. Besides the sports magazines, he also does work for general-interest magazines, trade publications, and advertising agencies. Airlines call him for their publications. When his rodeo pictures appeared in several U.S. publications, an Italian magazine phoned him, bought some rodeo pictures, and now Blackman works for them fairly regularly.

Another way work is generated is by the credit line under his pictures in magazines, and he has received phone calls from many sources other than sports periodicals in search of photographs they believe he has or can get. These sources have included book publishers and major corporations.

JB: A number of corporations sponsor sporting events, and no matter how little or how heavily they're into a particular sport, they often want photographs for press kits, in-house publications, picture libraries, and advertising.

However, most of his assignments are attained by going after them. About four times a year, Blackman sends out a newsletter listing material he has recently shot, a list of his stock, and suggestions for covering upcoming events. His file system on future events, mentioned earlier, is very useful for this newsletter, which has been instrumental in getting new clients.

Most of the events Blackman photographs take place during four days— Thursday, Friday, Saturday, and Sunday. In the time when he is not photo-

graphing, he is doing all this other work—contacting clients, preparing for his trips, editing and filing his work, and preparing his newsletter.

About Processing

JB: I always divide my film into two groups and give the work to two different color labs. Or I will give one half of the take to a lab and the second half to the same lab later, to make sure that it is processed at a different time. I came to this precaution as a result of having had one unfortunate experience when the machinery in a lab went haywire, and a job that was priceless was destroyed.

History

○ It is always interesting to find out how someone became a professional photographer, and what attracts them to a specific area of photography. In some cases it's a deliberate choice; in others, it's a chance happening. In Blackman's case, it was a chance happening.

Jeff Blackman had been an artist and a successful illustrator for several years. He was commissioned to illustrate a series of children's books about athletes, and shortly after he started working on this project, the publishers decided to switch from illustration to photography. They asked him if he could do it. He said yes.

He had hardly done any photography at all before this, but he got hold of a camera and practiced intensely for a week. The sports he had to photograph were tennis, golf, auto racing, and baseball. He had to do portraits, action shots, and behind-the-scenes photographs. It all turned out quite well.

From then on he began to concentrate on photography, giving himself projects to practice on until he became quite proficient at it. He switched to photography because the money was better and the results were faster than illustration. Another thing that pleased him about photography was that most photographs were sold for a one-time use, and the photographer got the pictures back. He also had all the other pictures taken at the same time for his stock file, which he could sell. In illustration, one does not have this option, because there is only one drawing or painting.

Blackman had also reached a point in illustration where he was tired of all the changes the clients would request. If he used certain colors, they'd want others; if he put a figure in the left foreground, they might say, "How about moving it to the right side?" and so on. In photography, once you took the picture, if it was good, that was it. What was on the film was what they had to take. Another point Blackman made when explaining his strong attraction to photography was the sense of freedom he got from using the camera.

Although Blackman had no particular prior interest in sports, from that first photography job he got to love being with the players, having the best

seat, and the excitement of the unexpected, the action, and the speed. He enjoyed the challenge of anticipating and being ready to capture situations and outcomes that can happen and can change from moment to moment.

Having been an illustrator, Blackman had a thorough grounding in composition and design, always important in photography. (See the sections on Bernard Wolf, in this chapter, and Harold Krieger, Chapter 5, two other photographers who were artists first and who believe that art and design are of utmost importance to being a good photographer.) He had plenty of experience in dealing with art directors and publishers, and had an understanding of their problems. As an illustrator, Blackman had done the same thing that free-lance photographers have to do—search out new clients, and new assignments—and this experience stood him in good stead when he switched to photography.

Jeff Blackman's first three years in photography were spent working very hard at perfecting his photographic technique. He did this all on his own, just by doing—no classes; no being an assistant to another photographer. During this preliminary period, his earnings as a photographer were minimal, but he learned a lot and he built an effective portfolio. The first series of books he did photographically provided him with status in the field, proving that he could turn out a job.

An interesting development in Jeff Blackman's career is that he is now getting general-interest assignments, not only sports assignments. While he was in Tokyo, he was invited by the Japanese government to photograph a leading Kabuki performer applying his makeup. Another time, while driving through the countryside in France on his way to the auto race in Le Mans, he noticed the many different kinds of wooden shutters on the houses, and photographed them. He sold these pictures to a magazine as a general-feature story.

Then there is the tremendous stock file that he has built up. Since he doesn't just photograph the actual sporting event, but all the peripheral activity as well—the people attending the event, and many other things—he is acquiring a reputation with picture researchers for advertising agencies, and all kinds of publications, as a tremendous source for many varied kinds of photographs.

Ida Wyman: Early Photojournalism

○ Ida Wyman was one of those much-envied photographers whose work appeared in *Life* and other outstanding magazines from 1946 to 1951, the peak period of photojournalism.

Although she presently works as a scientific photographer (see Chapter 6), her early career is of great interest and much that she says is still per-

tinent. Her attitude about photography, her approach and her dedication to her work sets an excellent example for aspiring photographers. There is already a historical element in her story about that era in photography.

LM: *When did you first become interested in photography?*
IW: When I was fourteen years old. I convinced my parents that it was okay for me to spend $3.95 to buy an Agfa Pioneer, a box camera. Money was short in those days, so $3.95 was no small matter. This was the beginning of a very serious interest, and what turned out to be a lifelong involvement in photography.

I began taking pictures around my neighborhood [New York City]. I still have a picture that was printed through the local drugstore, which has not faded, and still has good black-and-white tones.

In high school I joined the camera club, and there I learned to work a Zeiss Ikon, a four-by-six-inch camera. I learned about lens openings and exposures. I did a lot of reading about the mechanics of photography, and about the chemistry. It seemed I was forever reading, even though I may not have understood everything.

I bought my first photography book, *How to Take Good Pictures*, by Kodak, which cost one dollar. I was shooting everything in sight. Later I began taking photographs for my high school newspaper.

A high school teacher, Stanley Weinberg, who headed the camera club, invited his friend Bernie Hoffman, one of the six original *Life* photographers, to come and talk to us. He continued to visit our club from time to time to review our work. Both were very giving people, and always seemed to enjoy the club, they enjoyed looking at our work, and took it very seriously. Bernie encouraged me to keep taking pictures.

I graduated from high school before I was seventeen, and had planned to attend nurses' training school, but decided to wait a year before enrolling.

With my great interest in photography, I was confident that I could get a job as a photographer, based on my experience in the camera club. I called up all the New York City newspapers of that time—there were about eight or nine. I had so little idea about how one went about getting a job. I then called the news services—the A.P., the U.P., Acme News Pictures, and Wide World Photos. The managing editor of Acme, Harold Blumenfeld, said, "Well, why don't you come down, and we'll talk about it."

It was my first time in a city room, and it was very exciting. Harold

convinced me that every photographer started in the mail room, which was the bottom. I felt that was okay, and I was the first female employee in the mail room, a fact frequently pointed out to me. The work consisted of going into the darkroom, taking out all the prints from the wash water, squeegeeing them and drying them on the large gas-drum dryers. We than pasted captions, a brief explanation of the event, on the reverse side of each print. Then we put the prints into the boxes that lined an entire wall for Acme's clients. Some clients wanted the entire output of the bureau, from cheesecake, to sports, to ship arrivals, to politicians, to news events. Other clients were only interested in one or two categories, perhaps entertainment and personalities. It fascinated me.

After a few months of that, I considered myself an expert, and I was chomping at the bit to become a photographer. Once again, I spoke to Harold. He said that there was no opening yet on the photo staff, but he thought working in the darkroom would be good training for me. I thought that I knew how to print from my high school camera club, but when they transferred me to the darkroom I soon realized that I knew little about production printing.

Again, I was the first female printer in the darkroom, and there was resentment from the male printers. They made the situation painful for me. But I persevered, because my determination to become a photographer was so strong. They didn't give me much help. But one of the printers, Irving Berman, was very protective, and showed me how to make really good prints. He was wonderful, full of jokes; whenever you left the darkroom, he would say, "Give my regards to Broadway."

The darkroom was different from any I have ever seen, before or since. The enlarger was a horizontal one. Brass tracks held an easel at right angles, on which there was a device for holding up to one hundred sheets at a time. You would print fifty or sixty, or whatever number was requested. You would develop all the prints while shuffling them like a deck of cards in a very large tray of developer. It was an unusual but effective way of agitating them. When the development time was up, the prints were washed; then I put them into the hypo. You would use a big wooden paddle to agitate them in the hypo. Then they were transferred into the wash tank. When that was done, someone from the mail room would come and get them.

We also made prints from glass negatives of old historic photographs, which I loved. I always read the captions. I also remember that I used to soak my feet in the hypo, because it was a printer's myth that

hypo cured athlete's foot. Anyway, it was very refreshing. I would climb up and sit on the edge of the hypo sink, dangling my feet in the cool hypo solution.

It was a wonderful learning experience. I had been saving money, and I bought myself a 3¼-by-4¼ Speed Graphic, because in that era that was the camera of the news photographers. Then I spent lunch hours going out looking for things to happen, news-type things. Since Acme bought pictures from free-lancers, I hoped that some news event would happen in front of me. I soon realized that the likelihood of seeing a newsworthy happening was rare, and it was a natural evolution that I began to think in terms of human-interest stories and features. I also realized that I wasn't interested in strict news, and began to think up little stories. I began to show my photographs to editors and art directors of magazines. I wanted to be taken seriously and accepted as a photographer.

[Although all this is going on in the mid-1940s the concept is the same today.]

By this time, I had scrapped all ideas of becoming a nurse, and I was determined that I was going to be a documentary magazine photographer. I was especially interested in getting into *Life* magazine. I didn't realize that *every* photographer was keen on getting into *Life* magazine. I had faith in myself, but I didn't know anything about the mechanism of how to get work accepted and published. Later I understood that if you want a job, you don't call up people and tell them you want a job.

LM: *But you got a job that way?*

IW: Yes, I did get the job at Acme that way, but I was lucky. I did learn how magazines functioned and what they were looking for simply by going around to them. That is actually how I got started. Acme never bought anything from me. They were constantly receiving photographs from press agents who were touting their clients, or their products, so they had a tremendous pick of photographs.

I was photographing things that interested me. On my days off, I began going around to all the magazines of the day—*This Week, Look, Life,* and many others. I showed those editors my work, and they were very nice to me. *"Portfolio"* is a later-day term; we just called it "your work."

While I was still at Acme, I sold a story to *Look* magazine, and they ran it—six pictures on one page. It was a story about a trained bear cub being given a bath by his trainer. I was absolutely ecstatic. I have no memory of how much I was paid. For some strange reason,

I thought that since I was still employed at Acme, I shouldn't use my own name, and for the first and last time, I used a pseudonym, Dorothy Hillis—I don't know where I got that name.

I left Acme after two and a half years and began getting assignments from *This Week* magazine, a Sunday supplement magazine. I also sold pictures to other magazines, and I began to get assignments from *Business Week*; later, I got five or six assignments from *Life*. But there were big gaps between the *Life* assignments. The picture editor I was seeing kept urging me to go out of town. She pointed out that it was relatively easier for newcomers to get assignments outside of New York. In 1948, after free-lancing in New York for three years, I went to Los Angeles, and sure enough, I began working for *Life* amost immediately.

I was never a *Life* contract photographer, and I was also doing work for *Business Week, Fortune,* and other magazines. But *Life* was the mainstay. It was wonderful working for *Life;* I loved it. I got a variety of stories to do, all kinds: political campaigns; sappy stories, such as real legs displaying stockings in a department store window, and the reactions of the crowds that the display drew; and a high school rummage sale. I never knew what I would be assigned to, and I could shoot as much as I wanted.

The cameras I used were, primarily, a Rolleiflex, and also a Contax with a normal and a wide-angle lens. Depending on the assignment, I would carry a box or two of flashbulbs for indoor situations. I used natural light whenever possible.

My photographs appeared on the covers of many magazines. The competition to make the cover was keen, especially for a holiday issue. One of my *Life* stories, "A Day at the Beach With a Lifeguard," ran for several pages as well as getting on the cover. Several of my *Business Week* assignments also made the cover, as well as running inside the magazine.

Sometimes when I went out to shoot an assignment story, another story would emerge, a kind of off-shoot of the first story. I would shoot the original assignment, and also do the new story that unfolded.

I did stories on the making of about twenty films. I would have to cover a scene or two in production. It was great fun to see how movies were made, but acting seemed like very hard, even dull, work. The actors and actresses had to repeat the same lines and action over and over again for numerous takes. A few of the movies I covered were: *Harvey* with Jimmy Stewart; *A Place in the Sun* with Montgomery Clift, Elizabeth Taylor, and Shelley Winters; *White Heat* with Jimmy

Stewart; *M* with David Wayne; and *Bedtime for Bonzo* with Diana Lynn and Ronald Reagan.

In March 1982, *Life* magazine sent me a box of the negatives of eighty-five stories I had shot for them (not all of them ran). Had I been a contract photographer, the negatives would have belonged to *Life*. I reviewed the material, and soon discovered that some of it is of interest to museums, especially the coverages on filmmaking. Much of it has already acquired a historical importance similar to the photographs from the glass-plate negatives I enjoyed looking at so much when I first worked for Acme.

LM: *Do you think young people will get inspiration and guidance from this book?*

IW: I think that young people get their inspiration in many ways, and it's not predictable. It could be a book, it could be an event, it could be just knowing someone. For me there were the magazines, which I looked at avidly, and the wonderful people I met through the high school camera club. Also, there were nine newspapers then (pre-TV) with great photogravure sections and a lavish use of photographs on a daily basis. All those things inspired me.

There were also my own curiosity about the world around me, and the urge I had to get closer to things that were happening. The camera was and still is my medium of expression.

Bernard Wolf:
Travel, Annual Reports, Books

○ The story of Bernard Wolf's career in photography unfolds like a great adventure. His work has taken him to many parts of the world, photographing for magazines, government tourist offices, major airlines, corporate annual reports, and many other assignments. Besides this work, which is very demanding and requires great skills, he has a unique talent for a very different aspect of photography: He originates the concepts and does the photography and writing for children's books based on serious themes. These books have garnered many honors and awards.

As he tells us about his career and how it evolved from a circuitous beginning, we see that he followed no set pattern, that he built his career in his own way, with a buoyant spirit, great energy, intelligence, hard work, and a nice dash of humor. What also come through are his enthusiasm for photography, his prolific ideas, and his constant and close attention to the techniques and the tools of the medium.

BW: You'd have to begin with the extraordinary high school I attended, the High School of Music and Art in New York City. It was the most meaningful turning point in my life. I studied fine art and design, and frankly, that's what has enabled me to do the photography I do. That school had some great teachers.

They did not teach photography there. I never studied photography in my life, never went to school for it, never took a lesson. I became involved in photography, while in high school, through my sister, who studied photography at another school. I saved my pennies for two years until I could buy a Rolleicord, which I took with me every day on the long subway ride to and from school. I took pictures on the subway and in school. The subway pictures were taken between one-half and one second hand-held. Even today, by my own standards, some of those pictures are pretty remarkable.

I did my own developing, which I learned on my own. If you can read and understand and follow instructions, you can operate a camera. It's a tool. After all, you can take the finest piece of equipment in the world and do nothing with it, or the most mediocre camera and produce masterpieces. It's all in the way you see, and think, and feel, and design. And this I owe to my training at the High School of Music and Art, for which I am forever grateful.

Another thing—I had no interest in foreign languages then, but as it was required, I took Spanish. The foreign-language teacher was incredible. She really inspired me, and I went on to study French for two years. Thanks to her training, I learned both languages well. That has been one of the biggest gifts ever given to me, since I do a lot of traveling around the world. I can't tell you how invaluable this has been for me, and how I bless that woman.

LM: *Were you encouraged in photography at that school?*

BW: They gave me my first exhibition, because my art teachers were amazed at what I was doing. My feeling was, "If they think it's good enough to be exhibited, maybe it's not so bad."

After I finished school, I became intrigued by the dance, and met professional dancers and choreographers. I photographed them and did theater photography—all with available light. But I was a lousy businessman, and we all know that dancers are among the brokest people in the world, so I couldn't make much of a living at it, although they were very exciting experiences. But I became discouraged.

[See Chapter 8 for experiences of performing arts photographers.]

I feel, though, that all I have done and experienced has contributed to the photography I'm doing now, and there isn't anything else I'd really want to be doing.

I finally decided that I had to make a modest but steady income. I was tired of running around in ragged clothes and scrimping on food. Since I'd had the training at school, I became a furniture designer and an interior designer. I got a free-lance commission to design an apartment for a young woman who told me what she wanted. She then had to go away and left me on my own. As it turned out, she was extremely pleased, and so was I.

I wanted to have pictures of that apartment, but I was no longer in photography; I had sold all my equipment. I did know someone then who was fooling around with photography, and he offered to photograph the apartment for me, so it turned out fine. After making inquiries, I realized that if I had had to hire a professional photographer, it would have cost a lot. I went out and bought a 35mm camera, a Topcon, and began to photograph the interiors and furniture I was designing.

At this point I had to go to a manufacturer's showroom for a customer, and I showed him the photographs I had been taking. He said, "They're good; can you take some pictures for us?" They did big installations for decorators all over. "Why not?" I replied, and that is what brought me to being a full-time professional photographer.

I bought more equipment, a wide-angle Rolleiflex camera, a tripod, photoflood reflectors, and light stands. I shot both Kodacolor (color negative film) and black and white; my work was good, and it appeared in prestigious magazines—*House Beautiful, Town & Country,* and so on. I shot an entire floor in Bloomingdale's for a designer. I continued that work for a few years, but I was not always entranced by the taste of the designers whose work I was photographing.

Travel Photography

○ I thought to myself, there must be more to photography than just shooting interiors. So I went to Mexico and I did a lot of shooting there, for myself. I used Kodacolor, and had eleven-by-fourteen color prints made. I took my portfolio around to magazines and tourist organizations.

My first official job as a professional travel photographer was done for the French Tourist Organization, which sent me to the Caribbean

island of Guadeloupe to make photographs for a travel folder. That's the hard part for a photographer starting out—having something to show.

Armed with this folder and my color prints, I went to see an interesting man, the New York representative of Piccadilly Press, a large Argentinian publishing corporation. He gave me an assignment to report happenings, people, and places in England, Paris, Holland, Spain, and Portugal. It was my first trip to Europe. For instance, I did the opera at Glyndebourne; the Shakespeare Festival at Stratford-on-Avon; I did a coverage on Ian Richardson, a leading actor, in costume, and at home with his family. I covered bull festivals in Portugal, which led to jobs with the Portuguese Tourist Organization.

Piccadilly then assigned me to do a coverage of the National Art Gallery in Washington, D.C., for one of a series of books they were publishing, called *The Museums of the World*. The first half of the book consisted of my black-and-white photographs of the galleries of the museum, candids of people looking at the paintings, their reactions, and overall exteriors. The rest of the book had color reproductions of the paintings, which they got from the museum. That book served as a fine showpiece for my work.

Then the man at Piccadilly was recalled home, and that source dried up. Since I loved to travel, I decided to try to go after that kind of assignment. The French Tourist Organization official for whom I had done the job in Guadeloupe was very encouraging, which is important when you are starting out. He referred me to an account executive at the big advertising agency that handled the advertising campaign for the French government.

This turned out to be a terrible experience. I walked into his office trembling because I had never been inside an advertising agency before. I was very nervous, very unsure of myself, except that I knew the pictures I brought to show him were good.

Here was this portly gentlement, with a twelve-inch cigar in his mouth, his feet up on the desk, and he curtly said, "What do you have to show me?" He looked at my work with an air of complete disinterest, puffing away on his cigar.

Then, in a very condescending way, he turned around to me and said, "You really don't know where it's at." At that point, I was ready to crawl under the rug. I replied, "I don't understand."
He: "You don't come to an ad agency with C prints. We look at chromes (transparencies); we want to see the originals. You got to learn, kid."

Me: "I can shoot Kodachrome too."

He: "Well, do it, and then come back when you learn what the right way is."

He was so rude, and it was so unnecessary. I never forgot that. Such gratuitous rudeness was unforgivable.

LM: *But it didn't destroy you?*

BW: No. What it did was make me immediately start shooting Kodachrome, which I discovered is one of the greatest films in the world.

I then got an assignment for the Portuguese Tourist Organization. While I was shooting a festival, I met another photographer from New York, and we became friendly. I asked him if he did travel photography, to which he replied, "I'm doing this for fun on my vacation."

"Well, what do you do?" I asked him. "I do industrial photography." "What's that?" I said. "Do you mean you shoot machines?" "No, I do corporate annual reports." "What's that?" I didn't know from beans.

He explained, "Every corporation has to publish an annual report, and you photograph everything from the inside of a plant to workers on an assembly line, to equipment, executives, construction, trucks, whatever—and I get paid very well for it."

So, when I got back, I decided maybe I should look into this. By then, I had also learned that one of the most difficult things for a photographer to do is edit his work. I think editing is one of the most essential things a photographer must learn, and the most difficult because it is so personal. My wife, who is an artist, was very instrumental in helping me in this.

She's the best picture editor in the world. She can go through two hundred slides, and end up with three shots. It makes your head spin, and you're on your knees, and she doesn't give you an answer. The next time you look at it, you realize that she's absolutely right. She's picked the best ones.

Annual Reports

○ I went around with two carousels of my best Kodachrome slides. I went to see graphic design companies, and one of them introduced me to a very talented young designer starting out, who now has his own firm. I was wise enough to know that you just talk straight. I said, "Look, I've never done this work, but I'd like to try it. I think I can do it." He looked at my work, and he liked it, even though it had

nothing whatsoever to do with industrial or corporate photography. He said, "Let's give it a whack."

So he sent me around to several plants. The work was coordinated through his office. They gave me a schedule and enumerated what they wanted me to shoot: overall shots of a plant, portraits of the executives, scientists in a research laboratory, close-ups of products, and so on. I used two 35mm cameras, several lenses, and photofloods on stands. I got some great shots. He was pleased. So much so that he said, "How would you like to go to South America?" "Yes, where?" "Ecuador," he said.

Books

○ It is at this point that Bernard Wolf started working on what has turned out to be an unusual series of books, superb not only in their themes, but also in the quality of his photographs and his writing.

BW: After having done research, it seemed to me that most children's books were too rosy-posy, and had nothing to do with the real world. I had had this idea for a while of doing photojournalistic books about children living in cultures other than our own, books that were serious and respectful of children's intelligence. I was sure that there had to be a market for these books.

I define photojournalism as a medium through which as much truth as possible is incorporated in a photograph. This means there has to be an intimate connection between the photographer and the subjects. To have another person, a writer, along in the kind of situations I would be photographing would have been too distracting. So, if the books were to be as I conceived them, I would also have to do the writing. As it turned out, the photography has been difficult and demanding for all my books, but I have found the writing ten times harder.

So when I got the commission to go to Ecuador to do a corporate annual report, I thought, "While I am down there, I'm going to do more than shoot for this corporation."

I went to a publishing company—walked in cold. I told them that I was going down to Ecuador to do a corporate annual report, and that I wanted to do a book about a young Indian boy living in the Andes Mountains. They liked the idea, looked at my portfolio and liked it. The editor-in-chief said, "Great, let's draw up a contract. On second thought, on your way back, how would you like to do a book about a young boy living in Jamaica?"

The advance was ridiculous, but I really wanted to do this work. In addition, on this same trip I got an assignment from Time-Life books to go to Columbia, and do a shoot on Latin American cooking for their series, *Foods of the World.* At the same time, I did a color take for myself of scenics and people in Ecuador. I spent a total of six months on all this work.

When I did *The Little Weaver of Agato* (Cowles Book Co. Inc., 1969), I didn't know what I was going to do, or how I was going to do it, or how I should do it. I just sort of did what I felt, and I came out with photographs that to this day I prize very highly, and I shot it all on seventeen rolls of black-and-white film. Today I would shoot sixty to one hundred rolls of film.

LM: *How did you locate the family?*

BW: I looked around; I scoured. I hired cars and drivers in various parts of the country; I talked to people.

[Here's where Wolf's knowledge of Spanish was so valuable. See also Chris Johns and Frank C. Dougherty, Chapter 3.]

I kept looking for the right locale, until I finally came across a tiny village in the Otavalo Valley, inhabited by Otavalo Indians. They survived by adaptation, and learned to use the loom that was introduced by the Spaniards. They made *chalinas*, beautiful woolen shawls, using the wool of llamas and alpacas, coloring them with their own dyes.

The story is about one week in the life of the family, especially the role of the twelve-year-old boy—how he takes part in their farming, the weaving of the *chalina*, the Saturday market, and also their fun.

On the way back home, I did the shooting for the second book, *Jamaica Boy* (Cowles Book Co., Inc., 1971), which was also about a week in the life of a twelve-year-old boy living in Port Royal, a fishing community near the capital city of Kingston on the Caribbean island of Jamaica.

LM: *Haven't you found that a great part of the challenge to a photographer, especially when working abroad, is pinpointing and seeking out the right subject matter?*

BW: It's strange that as a photographer, when I'm away, especially in a foreign country, I seem to live at a heightened level, at five times the speed that I do when I am home. I see everything with such magnified intensity, the pictures practically take themselves. That sounds corny, but it's true.

When I got back from South America, I was very, very tired because I had been working nonstop. I had also contracted dysentery

halfway through the trip. It didn't stop me from working, but it was
very uncomfortable. But it was very exciting to see all the work I had
produced under very difficult circumstances. My wife helped me with
the editing of this mountain of material. She has a passion for art,
as I do—really good art and design. She has an eye for the non-
essential that very few people I have ever known can equal, and she's
ruthless.

[This is exactly what it takes to edit well.]

We looked at zillions of pictures, and eventually the editing was
accomplished. My perception of my own work has improved
to a point where today, maybe I'm as good an editor as she is, but it's
tough to be objective about your own work on any level.

The annual report for the Ecuadorian company won an award, and
one photograph I took for it is in the Life Library of Photography;
it is still a very special picture.

Having made all that money, it was a thrill to be able to spend
it on all kinds of things. I spent it on new equipment, and I indulged
myself here and there, and I wound up broke. I decided I had better
go back and start seeing studios again, and I got several more annual
reports to do.

Two of the people in a design company I contacted were gracious
enough to come to my apartment and look at umpteen carousels
of slides. I shudder to think of it today. When I was finished showing
them my work, they asked, "When can you start working for us?
We have all kinds of stuff pending."

"Anytime," I replied. And for the next six months, I worked for
that outfit all over the country. I didn't stop. Their studio manager set
up the schedules, and I was in constant touch with her by phone.
I would no sooner finish a take in one place than she would say, "You
have to shoot this scientist in Chicago. Be there by . . ." I was flying
and hiring cars, and I went to the West Coast for them. I kept shipping
the film back by air express, since they were up against tight deadlines,
and they were very pleased. I did seven annual reports. It was an
incredible year. But in the end I was ready for either the loonybin
or a rest cure.

The Essentials of Corporate Annual Reports
and Graphic Design Studios

○ Graphic design studios design and produce corporate annual
reports and many other types of printed matter. In working on an

annual report, there are many variables. A corporation will hire a specific design firm based on their prior work, their reputation, and their dependability. A really competent designer has a strong idea of the kind of photographs he wants and how his design will go, and he seeks a photographer whom he judges will do the work most effectively.

There is almost always a meeting between the photographer, the designer, and the client to discuss beforehand the kind of pictures they want. It can happen that the designer and the corporation people don't know exactly what they want photographically. This makes it tough for the photographer. Sometimes, when the photographer appears on the actual shoot, what they've told you doesn't tally with reality.

I have learned that the earlier you get to a location, the better, and that can be six or seven A.M. The first thing I do is get a guided tour to determine what's photographable, which doesn't always agree with what the company people think. I try as tactfully as possible to convince them what will and what won't work. As I go through a plant or a large office building, I make notes. "This is good; forget about that—hopeless, will take all day."

Then I go back and start shooting. There are always problems. Lighting is crucial. You must know lighting, how to balance existing lighting—which can be daylight, tungsten, or fluorescent—with the lighting you bring in. You try to keep the company people off your back. You must also find out what the work schedule is, when shifts go off, because after doing a complicated lighting setup, you can find that people you wanted to have in your photograph have disappeared, and you still have shots to do. This can also happen during an outdoor shooting of construction, and suddenly all the workers have gone home.

Most shots are done under impossible situations. You have to move. You can't take too long on each picture, and the pictures have to be top-notch. There are also cases where a plan has been determined beforehand between the designer and the corporation, and a few predesigned picture concepts are required. Then you can really take your time and do a superb job.

Things to Avoid

○ Sometimes a public relations person or an executive wants to give you a lengthy and time-consuming lunch. While I love good food, it's very difficult to work again after those meals. So I usually say

"A sandwich and a cup of coffee would be fine." If you have to be there more than one day, they may want to give you huge dinners. Don't do it—you're going to have to be up again, probably at 6 A.M. And you're under enormous pressure. You're making a lot of money, but you really must produce and produce well.

As far as I'm concerned, corporate photography is without question the most demanding, most difficult photography in the entire field. To begin with, you must have a rapport with the designer who chose you for the job, and keep in mind what he wants for the final product. But, then, its rewards lie not only in the money, which is quite good, but also in the constant new challenges that face you in every new situation. You can't take anything for granted. You've always got to be on your toes and think creatively.

LM: *Would you please describe your equipment?*

BW: By this time I had made a major step-up in equipment. I had always wanted to work with Leitz equipment, but I find it difficult to work with range finders. I have to see what the lens sees. Around this time, Leitz came out with the single-lens Leicaflex (SL), which I grabbed. The results were like night and day. I had been using a Topcon 35mm camera—not bad, but certainly not like anything in the class of Leitz optics.

It was a superb instrument. The metering system was dead accurate; the lenses were unbelievable. My color took a leap forward. I wound up getting five bodies, and I don't know how many lenses. My lighting was the same floods, and I was still using Kodachrome. Besides using a tripod, I also shot hand-held (and still do) down to one fifteenth of a second, wide open. I have a very steady hand, which is just lucky.

I now work with strobe wherever I can't work with available light. Now I go with an assistant. I used to drag all the stuff myself.

LM: *What do you look for in assistants?*

BW: These are the qualities I look for in an assistant:

Must be compatible
Must be good with people
Must be able to follow instructions
Must be dependable
Must not get flustered
Must be alert, but remain relaxed, no matter what pressures
 come up
Must have a decent sense of humor

Must be an expert technician, especially with lighting equipment
Should not be afraid of hard work and long hours
Has to be an expert driver
Must have lots of muscles
Must be very intelligent—I will tell an assistant, "If while I'm
 shooting you see something worthwhile, point it out—I
 appreciate that."
Never talk to a client—that's my job
Must like what I like—good food
Must not mind my smoking, my one vice

I had a bad experience with one assistant. He made my life
a misery. He was uptight, and bad with people. He had been very
highly recommended. He seemed to know his stuff, and I felt that he
should be no problem. But he brought his own camera, and commenced
to take the same photographs I was taking, to a point where I said
to him, "Leave your cameras in the hotel or go home." He was more
interested in his own pictures than in helping me. Now I tell all
assistants, "Leave your cameras home; your job is to help me."

Magazines

○ The next thing that happened was that someone said, "You've
done quite a bit of traveling and unusual photography, why don't you
go see some of the photo magazines," which I hadn't bothered to look
into. I was too busy working. So I called an editor at a magazine. He
said, "Where have you been all these years?" I hadn't recognized the
name, but it was the fellow who had helped me when I first started
doing interior photography. Well, that worked out, and a color photo
essay on Portugal was published in *Camera 35* magazine.

Subsequently, the editor moved to *Travel & Camera* magazine
and gave me an assignment to do two special issues devoted to the
Orient. I had six and a half months to shoot. I started off in Madeira
(near Portugal), spending three weeks there. Then I went on to
Athens, where I shot the Acropolis. That was a thrill, because all my
life I had wanted to see the Acropolis, and it was every bit as thrilling
and more than I anticipated.

Then the long haul from Athens to Columbo, Ceylon, for a month.
My contact there, the director of tourism for the government, was
very cooperative. They gave me a car and driver, and the shooting
schedule was all set up before I got there. Then I moved on to one

month in Thailand, then to Singapore, from Singapore to Macao, and from Macao to Hong Kong.

From Hong Kong I went to Japan, which turned out to be a real nightmare. They didn't understand the significance of the magazine wanting to devote a complete issue just to Japan. The tourist people in Tokyo shuttled me from one hotel to another. When I got to Kyoto, where they had a large tourist office, they again started thwarting me. I called my editor, and he told me to photograph the construction of Osaka's World Fair, the Tokaido bullet train, and Tokyo's largest department store. He said to forget the rest and come home if I wasn't getting any cooperation. This lack of understanding can happen, and sometimes you just have to give up.

I took over fifteen thousand pictures on this trip, and only worked for the magazine. I kept sending the film back to my wife. She saw to the processing, stamped my name on the slides, and loaded them into carousels.

[This is a very tedious, but necessary, task in photography.]

And so I kept getting feedback on how I was doing. She did me a service that nobody else could have done, and she kept me from cracking up. After that trip, I vowed never to go on that long an assignment again, because by the time I got through, I was really a basket case.

I have continued doing annual reports and magazine assignments, and have become more and more involved in the photojournalistic books for children. The publisher for whom I did *The Little Weaver of Agato* and *Jamaica Boy* was sold to a company who couldn't care less about the books.

I began to look around for a new publisher, found one, and did *Daniel and the Whale Hunters* (Random House, 1972). The book is about Daniel, fifteen years old, whose father is a whale hunter. They live on the island of Pico, in the Azores, and the book describes how they live, and Daniel's first trip on a whale hunt. Then I did a book entitled *Tinker and the Medicine Men* (Random House, 1973). It is about a six-year-old Navajo boy, in Arizona, whose father and grandfather are medicine men, and how he is getting ready to become a medicine man too.

The books were extremely well received. The Ecuador book, *The Little Weaver of Agato*, got an award at the International Book Festival at Bologna, Italy.

Then I started thinking along new lines. I felt there were subjects

never dealt with before for young readers, subjects that badly needed to be done. For instance, I had the idea that it would be interesting to do a book about a child who is an amputee. I presented this idea to Random House, and their immediate reaction was "Yuk." I went around to see other publishers, and I met an extraordinary editor. Her reaction to my idea was, "Fantastic." I worked with that editor for something like eight years, and produced five very unusual books, all of which won awards and honors.

My first book of this series, *Don't Feel Sorry for Paul* (J.B. Lippincott Co., 1974) was about a child born with three incompletely formed limbs. He worked with three prostheses. He was one of the most beautiful boys I have ever known, from a wonderful family. I'm still in touch with him. The reviews were great; everybody felt that it was different from anything that had ever been done before. That book was selected by the National Book Council as one of the outstanding books of the year, and by the President's Council for the Handicapped. Recently it was selected as one of the outstanding books for the International Year of the Handicapped. The sales on that book were extraordinary. It is in its eighth printing, and I made money on that.

LM: *How long did you work on this book?*
BW: The photography took a total of two and a half months. The writing took much longer, and I was doing other jobs during that period.

Then I did *Connie's New Eyes* (J. B. Lippincott Co., 1976) about the training of a blind girl to use a seeing-eye dog. It also describes the training of the dog as a puppy, before a blind person gets it, by teenage volunteers, under the supervision of the Seeing Eye Center.

To give you an idea of some of the problems in getting one of these books underway, here is a description of the preliminary work on *Connie's New Eyes.*

BW: Three years before the photography on this book got underway, I approached the public relations person who handles the Seeing Eye Center in New Jersey. Her response was, "Can't be done; you'd be disturbing a relationship." I spoke to my editor, who said, "I'll get somebody to help you."

She knew an author who was very friendly with Morris Frank, a blind man who introduced the use of guide dogs to this country.

He was a remarkable man, very intelligent, with a great sense of humor, and a former director of the Seeing Eye Center. I spent a whole afternoon with him and taped him. He was very cautious and felt me out to determine how serious I was.

I described my previous books to him, and explained what I hoped to accomplish. He picked up the phone and called the director of the Seeing Eye, who reacted negatively to my proposal. So Morris Frank responded, "Well, that's all right, I'll just send him over to—", mentioning another center, "and they'll welcome him with open arms." The next thing I knew, he had it going for me.

I went to see the director, I showed him my previous books, and said, "Look, I'm a responsible person, I'm not going to do anything dumb, but I need your help. I can't do a book like this without your help." Finally, I convinced him of the worth of my project, and got to do the book.

The editor got letters from librarians all over the country saying "Why doesn't Mr. Wolf do more of this kind of thing." I then did a book about a deaf child called *Anna's Silent World*, (J.B. Lippincott Co., 1977), which also was immediately successful, and has been translated into German and Spanish editions. During the International Year of the Child, ten books were selected as the finest books produced in the U.S. over a ten-year period, and that's millions of books, and *Anna's Silent World* was one of them. It was also featured at the Moscow Book Festival.

After that, people wanted more of the same, but these books are very painful for me, because I get very involved. I don't like getting pegged, doing the same thing over and over again. So the editor and I decided to do something different, something very simple for very young readers. I did a book about a boy's first week in first grade, *Adam Smith Goes to School* (J.B. Lippincott Co., 1978).

Then I did a book about a Mexican-American family, *In This Proud Land* (J.B. Lippincott, 1979). It was an extremely difficult project, as it was written for all ages. I am very proud of that book, and it subsequently was chosen by the U.S. Library of Congress as one of the outstanding books of the year in 1979.

The next book was entitled *Michael and the Dentist* (Four Winds Press—Scholastic, 1980). It is about a young child's visit to a dentist; of course, it's a very special and delightful dentist.

In the works is a book about juvenile diabetes. The problem this book presents is, how do you photograph something that is invisible,

and make the impact about what is in fact one of the most serious diseases in the world today.

Then there is a book about a firehouse and the firemen. The firehouse itself is an old historic building with real character, and the firemen are fantastic. I photographed it almost entirely on Kodak recording film, black and white, rated at ASA 3200. It is all shot with available light, and mostly in the street, at night. The average exposure ran anywhere from one-half second to a full second wide open, hand-held.

I'm also doing a book, ostensibly on cowboys, but when I got to Montana I realized that it will go much further than that, because the open spaces are disappearing due to strip coal mining and the monstrous power plants that are being built for the benefit of places like Reno, Las Vegas, and Los Angeles.

At this point it must be stated that all the Bernard Wolf books are superb on many levels. The subject matter has turned them into classics, and they sell year in and year out. This is due to the fact that they treat the subjects seriously and in depth, but without being ponderous or heavy. The quality of the photographs never deviates from the very highest level. The combination of all these elements makes the books powerful and takes the readers right into the experiences.

Processing and Printing

○ Bernard Wolf does not do his own black and white processing or printing.

BW: I give it all to a master printer, Mike Levins, who is also a superb photographer. I have been working with him for years. He is an extraordinary craftsman, and also makes all my exhibition prints. For me to try to duplicate that quality of work would be stupid. I'd be spending all my time in the darkroom when I can be far more productive shooting.

Advertising Work

○ An advertising agency that handles the account for Air Canada commissioned Wolf to photograph western Canada, the Rockies, the plains, the west coast, and Vancouver. He had to cover scenics, hotels, dining rooms, city scenes, theaters, and stores.

For this assignment, and for many of the corporate reports, Wolf has done aerial photography.

BW: To get these jobs, you have to have the right calibre of work to show them. You have to present ideas of your own that are suitable. You have to be able to follow through, and then you get the jobs.

Equipment

○ For black and white, I always used Nikons, mainly because the lenses are faster than Leitz optics. But for color, I always use Leica-flexes—the optics are just in a class of their own. They cost a lot more, but their superiority was proven when I was on vacation in Morocco several years ago, and I was shooting side by side with a very competent photographer. We were doing it for fun. When we compared the results, the difference was so startling that he immediately went out and bought Leicaflexes.

In recent years, Nikon has done the most extraordinarily innovative things with optics. I am now shooting and trying out all the many Nikon lenses with color and getting the most astonishing results. From the time they started multicoating their lenses, something different has happened to the results you get with color film.

In black and white they have always been great. Now they've gone even further. They introduced extra-low dispersion glass, which means that the haziness and fussiness is eliminated, especially with long telephoto lenses, and the image sharpness is retained. That's a major achievement. I just bought my third F3 body. The camera is a dream; it's a joy to work with compared to their former cameras, and certainly one of the best they've ever made. The versatility they offer is practically unlimited, and they give you so many options: You can shoot fully automatic, or you can shoot fully manual. It has a double-exposure system. If you want to make multiple images, it's foolproof. If you want to put it on a tripod and take long exposures, it has a shutter curtain that closes out the viewfinder window to prevent stray light from entering and affecting the reading. There are so many features, it's an incredibly flexible tool. It feels great in my hand. They have also come out with something that is a boon for me, a viewfinder that's called a high-eye point finder, made for people with glasses. That's the kind of thing this company does, and the color I'm shooting with it is unbelievable.

LM: *Have you ever done any studio work?*

BW: Some, but it's not my primary thing; my best ability lies in the area of the unexpected. In on-location photography you're never certain what problems you'll be facing, and that's good, because I feel that I'm always learning something new. Every time I do a shoot, even in my personal photography, I learn something new. If I don't learn something new, I feel I've wasted my time. The greatest thing about photography is that there are always new ways to explore things. It's just like art—there's no end to that either.

For that reason, to me, photography is an ideal avenue of self-expression. There is no other work I'd rather be doing.

With all my years of experience as a photographer—after all, I started when I was sixteen—although I've had no formal training of any kind, I have many, many experiences under all kinds of conditions. In spite of that, each time I pick up a camera, it's as though I'm doing it for the very first time. Literally, I get very uptight, my stomach gets knotted, and I break out into a sweat. I'm an absolute nervous wreck until I actually start shooting, and then I'm fine.

LM: *What advice do you have for young photographers?*

BW: I tell young people that at best, a photographic school will teach you technicalities. But they cannot teach you how to see. So my advice for anybody who wants to become a serious and creative photographer is to go to the best art and design school you can get into. Study art. Study the history of art. Go to museums. That's what I did when I was a kid. I used to live at the Metropolitan Museum of Art; I loved it.

To me, learning what makes a great work of art tick will teach a potential photographer how to see, how to compose, and how to think visually. I feel that anyone can learn how to operate a camera, but it takes much more than that to have the insight to produce an image that is going to be unique and meaningful, and that's what you should strive for.

Bernard Wolf is a phenomenal photographer on many levels. The first consideration is the consistent high quality of his work. He has an incredible ability to follow through on each and every project he undertakes, and they are different kinds of projects, no easy matter: the corporate work, the travel assignments, and the books.

A tremendous amount of work goes into just one project—organizing,

making sure the equipment is in top-notch condition, getting the supplies, seeing to the processing and printing. Wolf has to make umpteen phone calls: to get the jobs, to get them underway, to contact the people you're going to be involved with when photographing. When a project nears completion, he has to watch a hundred and one details to make sure the finalization is absolutely correct. The books in themselves require untold hours of work, and Wolf always has two or three projects going at a time.

If you are able to do just one third of what Bernard Wolf is doing, and if you do it well, you may consider yourself a successful photographer.

Photography
Books

○ The photographers in this chapter are all free-lancers who have pursued their interests and have had books of their photographs published. Many of them have also done the writing to accompany the photographs.

Besides explaining how photography books get to be published, and all the different reasons and outcomes, this section also shows you the various interests and areas that free-lance photographers can be involved in. That in itself makes this section on books a valuable lesson.

Almost every photographer yearns to have a book of his or her work published. There is something strong and powerful about a book. It is like a monument. A thorough look at the photography section of a well-stocked bookstore will show you that there are a tremendous number of different kinds of books of photographs.

There are books showing the beauty of places, of cities, objects, buildings, flowers, nature, landscapes, animals, people, and children. There are books presenting a body of work of one photographer, or of a photographer's unique point of view, or special techniques. There are books on events and conditions, or on a particular group of people. There are erotic books; there are books that tell stories. There are books of photographs of famous personalities in the arts, in world affairs, in sports. There are anthologies showing the work of several photographers, and many, many others.

How do photography books get to be published? There are several ways.

1. A photographer gets an idea, takes the photographs, presents them to a publisher, and if the publisher likes them, the book gets published.

2. A photographer gets a concept, goes to a publisher, the publisher thinks it's a great idea and says, "Fine, here's an advance. Go ahead and shoot the pictures, and we'll publish a book."

3. The reverse of 2. A publisher gets an idea, finds a photographer, and assigns her/him to take the photographs.

4. A photographer has been working on various magazine assignments, personal projects, or is involved in a particular specialty, such as dance or theater or special effects. After a while—it could be several years—there is an accumulation of work, and the photographer realizes there is enough material for a book. He/she presents it to a publisher, who says, "Yes, there's material for a book here; let's do it."

5. A photographer is awarded a grant, completes a project, and a book is published.

The foregoing is basically what happens, but it doesn't often go that simply or smoothly. In fact, it seldom goes that way. It is more usual that you have to go to several publishers, or that a publisher is half interested and doesn't agree with you totally and wants you to make some changes. Or you can't interest anyone, and you have to reorganize the presentation before something happens. Or you publish it yourself.

Financial arrangements with publishing companies vary. Sometimes the photographers get a flat fee, just like getting an assignment for a magazine. But more frequently, with book publishers, the photographer gets an advance and royalties. Contracts vary and should be carefully gone over. It's advisable to get an agent or an attorney who specializes in publishing contracts.

Don't expect to make a lot of money on books. Sometimes, not often, a book hits and earns a good income. Further along in this chapter, photographers will explain their publishing contracts. For more legal, contractual, and tax information—not only about book publishing, but about business arrangements in photography—see *The Business of Photography* (Crown, 1981), by Robert M. Cavallo and Stuart Kahan, both attorneys with many years of experience advising photographers.

However, a little-known fact is that the royalties you get from books do not count as income when the time comes for you to collect social security. However, this is a government regulation that may change, so be sure to check it when the time comes for you to apply for social security.

Many of the photographers in this book have had books published, and you can learn about their experiences with books in the following chapters: Bernard Wolf, Chapter 2; Jack Manning, Chapter 4; Dianora Niccolini, Chapter 6; Kenn Duncan, Jack Mitchell, Chapter 6 and Martha Swope, Chapter 8.

Dianora Niccolini originated a concept for a photographic anthology to

illustrate the theme, ''the fullness of life,'' and she also wanted the book, entitled *Women of Vision* (Unicorn Press, 1982), to bring attention to the work of women photographers. She found the publisher and she chose the photographers—twenty of them; each is represented in the book with five photographs illustrating the theme, and a written statement. Each photographer was paid a flat fee. The author of this book is very pleased to have been chosen as one of the photographers in *Women of Vision.*

Several of the photographers in the anthology *Women of Vision* have had books published, many different kinds of books. Following are explanations of their experiences with getting books published, and the kinds of books they have produced.

The variety of books these photographers have done is very broad—you will find a tremendous scope of subject matter. The ways in which they got their books published are very diverse, and there is great variety in their arrangements with their publishers. The end results, once the books were done and out in the world, vary from tremendous success, to satisfactory, to disappointing.

Marcia Keegan

○ Marcia Keegan has had eight books of her photographs published, and they've come about in several different ways. The subject matter for five of her books is the American Indian of the Southwest. She considers this subject her life's work, and says many more books will come out of the photographic documentation that she works on continually.

The publication of her books on the American Indian came about in the following ways. The publisher commissioned her to illustrate *Only the Moon and Me* (Lippincott, 1969), a book of poetry for children, gave her an advance and royalties, and then she did the photography.

The Taos Indians and Their Sacred Blue Lake (Julian Messner, 1972) was also a children's book. It was her idea; she discussed it with a publisher, who liked it and gave her a contract and an advance; then she proceeded with the photography.

She had already done the photography for her next three books. She got the ideas; put together complete presentations, which she showed to publishers; got approvals; and they were published with a contract that provided an advance and royalties. Their titles are *Mother Earth, Father Sky* (Grossman, 1974), *Moon Song Lullaby* (1981), and *Pueblo and Navajo Cookery* (Morgan & Morgan, 1977).

Oklahoma, 1979, (Abbeville, 11½ x 15 size) a book on the people and the landscape of the state, was her idea. After she got the contract and an advance from the publisher, she then proceeded with the photography.

We Can Still Hear Them Clapping (Avon, 1975) was a large-format paper-

back. This book was about ex-vaudevillians living in the Times Square area of New York City. Marcia had received a grant to carry out this photographic project. When it was completed, a major exhibition of the photographs was mounted in Lincoln Center. Then *The New York Times* did a big feature article on the exhibition, which the publisher saw. He contacted Marcia and gave her the standard contract, an advance, and royalties. This book was a disappointment, because paperback book companies withdraw books from distribution after a certain amount of time and shred them without informing the authors. This happened to *We Can Still Hear Them Clapping*, and Marcia was distressed, because she only found out about it when she tried to order some of the books.

Marcia Keegan formed her own publishing company in order to publish her most recent book, *The Dalai Lama's Historical Visit to North America* (Clear Light Publishing Co., Inc., 1981) because she could not interest a publisher in the book.

She had traveled with the Dalai Lama of Tibet during his visit, photographing the tour and making tapes. She edited the tapes for the text and designed the book of sixty-nine color photographs herself.

Keegan's company is the Clear Light Publishing Co., Inc., 1023 Boulevard East, Weehawken, New Jersey, 07087. She distributes the book as well as having distributors sell it mail order ($17). She is a really enterprising woman, one who shows conviction and belief in her work. She is deserving of all the support we can give her.

Jill Freedman

○ Jill Freedman studied sociology and anthropology; as a photographer, she is primarily interested in how people live and express themselves in various societal conditions. For her first book, *Old News, Resurrection City,* (Grossman Publishers, 1971) she joined the poor people's campaign and lived for six weeks in Resurrection City in Washington, D.C., documenting the life there. She sold pictures from this take to magazines and newspapers, and they were shown in several exhibitions. She then approached a publisher with the photographs, and the book was published in 1971.

The procedure was similar for her second book, *Circus Days* (Harmony, 1975). She traveled with a circus for seven weeks of one-night stands, photographing all the time. These photographs were used in several magazine stories and exhibits.

Since she already had credibility, she initiated the ideas for her next two books. She got substantial advances and then carried out the in-depth photographic reportage. The first one, *Firehouse* (Doubleday, 1977), was about firemen at work. The second book, *Street Cops* (Harper & Row, 1982), was

about the daily life of policemen working out of a midtown Manhattan precinct.

The photography for *Street Cops* took two years. She obtained permission from the police department to ride around in police radio cars. The book got great reviews. It is both a poignant and a brutally honest reportage on the underbelly of the criminal world and the everyday life that policemen and city dwellers face. The photography is superb, and is totally in harmony with the subject matter. Freedman did the writing for this book, and it is terse and pungent.

At the time of the publication of *Street Cops*, Jill Freedman had a major retrospective exhibition of her work.

Tana Hoban

○ Tana Hoban made her reputation in photography for her work with children. She did the photography for national advertisements for such accounts as Eastman Kodak, Campbell's Soup, Bell Telephone, and many others. She also did many, many magazine assignments.

She originated a unique idea for a series of books for children that deal with concepts such as counting, spatial relationships, and size. She has had seventeen books published, and you can get an idea of what her books are about from their titles: *Look Again* (Macmillan, 1971); *Count and See* (Macmillan, 1972); *Over, Under, and Through* (Macmillan, 1973); *A, B, See!* (Greenwillow, 1982); *Shapes and Things* (Macmillan, 1970); *Take Another Look* (Greenwillow, 1981); *Big Ones, Little Ones* (Greenwillow, 1976).

Hoban comes up with the ideas, and although most of the books have no words, she still receives credit as the author. She does the photography and makes a rough layout, which is finalized by the art director. When she gets an idea, she discusses it with her editor. Even if the editor does not think it is feasible, Tana Hoban goes ahead and works on it, then shows the dummy to the editor. Often, the editor then realizes that it works.

Tana Hoban has the good fortune of having worked with the same editor for all her books. Macmillan published the first few, and when the editor moved to William Morrow & Co., Hoban went along with her.

Tana Hoban has received many citations and awards for her books. Three of her books have been named American Library Association Notables—a very high honor. Several books have been printed in foreign editions. Her arrangement with the publisher consists of the standard contract, an advance, and royalties. More than 500,000 copies of her books have been sold, which amounts to a lot of royalties.

Although she did not conceive of her books as textbooks, she has discovered that teachers and librarians use them for teaching children.

The Floating Foundation of Photography

○ Photographer Maggie Sherwood converted a barge into a photo gallery and a school, calling it The Floating Foundation of Photography. Its affectionate nickname is The Purple Boat. Maggie and the staff—Steven Schoen, Chuck DeLaney, and Sardi Klein—launched a program of teaching photography in prisons. After the program had been operative for a while and enough interesting work was being produced by the students, Steven Schoen got the idea of putting together a collection of the photographs. Published in 1977, it was called *Photography From Within.* The Floating Foundation of Photography was the publisher. They had obtained funding to produce the book from grants from the National Endowment for the Arts, the New York State Council on the Arts, the New Jersey State Council on the Arts, and contributions from the general public.

A second anthology of prisoners' photographs, *Sing-Sing, a View From Within* was produced in 1981 by the Floating Foundation, but this book was published by a commercial publisher, Winterhouse Publishers.

Sonja Bullaty and Angelo Lomeo

○ Sonja Bullaty and Angelo Lomeo, wife and husband photographers, work together. They are essentially photojournalists who also do lots of nature and landscape photography. Their first book, *Vermont in All Weathers,* (Viking, 1973) was a collection of existing color photographs they had taken over the years. They edited their work themselves and presented a collection to the publisher, who accepted them practically as a complete package, except for one or two details, and gave them an advance and royalties. However, they were disappointed in the lax way the publisher distributed the book, for they could never find a copy of the book in any bookstore in Vermont, which seemed a logical market.

Early in their careers, Sonja and Angelo photographed artworks. They were experts at it, and did this work for museums and great collections. In describing this work, they say it was the ultimate challenge in maximum control of the technical aspects of photography. The work demands complete attention to the minutest details of film, exposure, developing, and careful printing. According to Bullaty and Lomeo, elements of this refinement and control have seeped into all their other work. Photographing great works of art served as their art education.

Because of their expertise in this area of photography, they were commissioned to photograph, for a book, the collection of the 700 Renaissance medals in the National Gallery of Art in Washington, D.C.—1,400 photographs, because both sides of the medals had to be shot. Remember, metal is one of the hardest things to photograph; the medals are comparatively

small; and the details in the designs of the medals are minute, and must be brought out because each is a distinct work of art. They designed a special camera for this work, which was "excruciating." For this book they were paid a very nice fee, treated as a straight commission.

Another similar book they did consisted of 1,600 color photographs, for the *Audubon Eastern Tree Guide* (Knopf, 1982). For each species of tree, they had to photograph the bark, the foliage, a leaf, a flower, and, if it existed, the fruit. Again, the arrangement with the publisher consisted of a fee. The problem in this task, besides precision, was to develop a system to keep the identities correct. They used this opportunity to get very good photographs for other purposes.

They did an inexpensive book for children, a story about baby bears in the wilderness, entitled *The Baby Bears* (Western Publishing, 1980). The photographs for this book were the overflow from an original assignment for one of the Time-Life Wilderness book series.

Bullaty did a book on the work of Joseph Sudek, the great Czechoslovak photographer. She edited the photographs and wrote the text, a labor of love, for she got no money for it. She considered it a present, a memorial to a great photographer whose work she felt should be better known in the world. The explanation she gave for doing this book, entitled *Sudek* (Clarkson N. Potter, 1978), was, "One does things like that in one's life."

Suzanne Szasz

○ Suzanne Szasz has had ten books published. She is an outstanding photographer of children, doing not just pretty pictures, but photographs depicting family relationships, how children express their emotions, and how they confront problems and puzzling situations.

"One of the things I like about doing books," she says, "is that after doing an in-depth coverage, most of the material really gets used. A magazine usually publishes a small percentage of the pictures."

Szasz doesn't wait for someone to call her with an assignment; when she finds something she would like to photograph, she goes ahead and does it. She also keeps her photographs in meticulous order, and most of her books are put together from these files. Her coverage in the area of children and family relationships is so comprehensive that many picture researchers, magazine and book editors know about her work, and call on her frequently not only for assignments, but also for stock photographs. She is a one-woman stock house.

She keeps getting ideas, which accounts for her numerous books. Her first book, *Helping Your Child's Emotional Growth* (Doubleday, 1954), was based on twenty-one picture stories originally done for magazines. The sales were disappointing.

SS: But don't get discouraged if the first incarnation of a book doesn't work out. It is possible that a later use can make up for it.

[In this case, the whole book became a part of a fourteen-volume child-care encyclopedia.]

This is just one example of why it is so important to retain secondary rights to your books.

How you present your book is also important. Once all or most of the photography is done, I submit the material with a short text, an outline, and a sample chapter. I also make a proposed layout for the book, and insist on working with the designer on the final layouts.

It helps if a well-known person is willing to write an introduction to your book. I was delighted that Dr. Benjamin Spock wrote the introduction to one of my last books, *The Body Language of Children* (Norton, 1980). I did a lot of research in child psychology books, then combed my files of twenty-five years to illustrate the expression of every emotion. Sometimes there would be a new photo alongside one I had taken fifteen or more years ago.

This is also true of my most recent book, *Sisters, Brothers, and Others* (Norton, 1983), showing sibling relationships. I keep in touch with as many of my subjects as I can, which is not only a fascinating way of seeing all the children grow up, but also enables me to get releases when I need them. I also pay my subjects for all commercial use.

Although her books are *about* children, not *for* children, Suzanne has discovered that children love them too. They like to look at the photographs of the children in the books.

Only two of her books are not about children. One of them, *Modern Wedding Photography* (Amphoto, 1978), came about because so many of the children she had photographed over the years had grown up and asked Suzanne to photograph their weddings.

The other book, *The Silent Miaow* (Crown, 1964), is the life story of her cat. It was done twenty years ago, but keeps selling at the same yearly rate. It has never made less than $200–$300 a month in royalties in all these years, with sales now close to 500,000.

SS: The financial success of this book is nice, of course, but the book was done for love. I had never had a cat, and when an adorable kitten appeared at our door in Westhampton one day, my husband and

I were hooked. To me, it was only natural to photograph one animal's life as if she were a person: to show her growing up, having kittens, and bringing them up. There are many books about cats, but this seems to be the only one to date about *one* cat.

During this year-long project, I kept loaded cameras and photofloods around all the time. When the kittens were small I even had a camera under my pillow. It was lots of fun.

After some unhappy experiences, Suzanne now uses help to get good contracts. She retains all secondary rights, which means that she can sell single pictures from the books, groups of pictures for magazine articles, permissions for translations, and so on.

SS: I love to work on my own, with a purpose and an aim. I also find that whenever I am doing a book, I get involved with lots of new people and often my work branches out into unexpected areas— exhibitions, for instance.

Erika Stone

○ Erika Stone presented an idea for a book on family situations to Walker Publishers. At first they were enthusiastic, but then decided that it was too similar to a book they had already published.

However, soon afterward they needed a photographer for three books they were planning to publish for their Open Family Book Series, and they contacted Stone and commissioned her to do the photography for these three books, entitled: *On Divorce* (1979), *The Adopted One* (1979), and *About Phobias* (1979). Erika Stone was called in for a meeting with the editor and the author, and together they planned the shooting. A lot of preliminary work, research, and planning was required; locations had to be found, props and the right people were needed. These books are aimed at both parents and children, and Stone had to keep that in mind during the shooting. Her arrangement with the publisher was a flat fee, which was satisfactory, and she has found that the books are an excellent showcase for her work.

For her fourth book, she came up with the concept, presented it to the publisher, who approved of it, and then she proceeded with the photography. The book is about the experiences of a city child's visit to a farm family, sponsored by the Fresh Air Fund, and it is entitled *Nicole Visits an Amish Farm* (Walker, 1982). Stone's contract for this book provided for an advance and royalties.

Kathryn Abbe and Frances McLaughlin-Gill

○ Kathryn Abbe and Frances McLaughlin-Gill are photographers. Although they are twins, they had never worked together; they pursued parallel careers doing features, magazine reportage, and advertising assignments. They always worked for different publications, different agencies, different clients.

In 1980, Frances got the idea of doing a book with Kathryn about twins; the next day, Kathryn thought of the title—*Twins on Twins* (Clarkson N. Potter, Inc., 1981). It was their first joint effort, and it worked out wonderfully.

The theme was thoroughly developed ahead of time. It was meaningful to them, and they had a definite viewpoint. They decided to make it a happy, positive approach. First they did a little shooting, and did sittings with two other pairs of twins. They did research on twins in art and history. Then they made a presentation dummy of about twenty pages. The second publisher they approached accepted their proposal.

They were given an adequate advance, and the sales have been good. Within a year, the book went into a second printing. Abbe and McLaughlin-Gill were lucky with their publisher, and the quality of the photographic reproductions was extremely good.

But what was so wonderful was the way the public responded to and welcomed the book. It was a first—this upbeat happy approach to the subject of twins. It was the right idea at the right time. Abbe and McLaughlin-Gill didn't have to knock themselves out getting publicity; it just rolled in. At a publication party at the Dalton book shop on Fifth Avenue, people came in waves. The photographers were invited to appear on twenty TV shows and thirty-five radio talk shows. Also, two sets of twins in their book, the Ellises, who were in the catering business in Washington, D.C., and the Keiths (Dr. Louis Keith and Donald Keith), directors of The Center for the Study of Multiple Birth, arranged a big party for Abbe and McLaughlin-Gill in Rayburn Hall, in the House of Representatives, which drew a lot of media attention.

Their book came out at an opportune time, and the kind of response it received is something that you can't make happen.

Lida Moser

○ The author of this book has had four books published. Three were how-to's, and one—*Amphoto Guide to Special Effects*, published in 1974—is still in print and continues to sell satisfactorily. The fourth book consists of a large body of photographs I took in 1950. It came out in 1982, and is a source of great joy to me. Its title is *Québec, à l'été, 1950* (Quebec in the

Summer of 1950). It was published in Montreal by Editions Libre Expression, with a text in French by Roch Carrier, a leading Quebec writer, that is a poetic and literary interpretation of the photographs.

The photographs were taken in 1950 when I was assigned to go to Canada for *Vogue* magazine. The editor wanted a six-page feature and enough stock to dip into for the next five or six years. Her instructions were that I should just go up there and photograph anything I wanted—no research, nothing.

I arrived in Montreal and, after a few days of scouting around, decided to concentrate my reportage on the French-based culture. The atmosphere there was different from anything I knew on the North American continent. Quite by accident, or perhaps because of my powerful desire, I met the cultural minister of Quebec, who invited me to join a tour of the province that he and two other colleagues were soon to undertake.

This was a photographer's dream. My companions on the tour were deeply attached to the region. Besides knowledge, they had a profound love and understanding of their world. They pointed out significant elements to me. Also, they were well-known and very much liked wherever we went, so I with my camera was not an intruder. In fact, I was hardly noticed. Realizing that this was an incredibly rare opportunity, I went far beyond the demands of the assignment and ended up with a broad coverage of the people, the architecture, the arts, the cities, and the towns of the province of Quebec.

While working on my reportage in the darkroom, I realized that the many old ecclesiastical wood carvings I had photographed resembled the people and the children of the region. I convinced *Look* magazine that it would be a good idea for an article; they agreed, and I returned to Quebec for these specific photographs.

Besides the *Vogue* and *Look* articles, I sold photographs from these takes to many other periodicals and newspapers for the next six years.

In 1975, twenty-five years later, I took a portfolio of the photographs back to Montreal, and fourteen pages of them were published in the 1975 Christmas issue of *Perspectives*, a weekly Sunday supplement for French-language newspapers throughout the province. This 1975 article led to a gallery show, then a major exhibition at the McCord Museum in Montreal, which was later toured. Reviews of the exhibition contained statements such as "The photographs are uncluttered and direct . . . taken in a spirit of innocence and with a great deal of love and mute respect." (Montreal *Gazette*, November 19, 1979, Review by Anne Tremblay.)

Following this, a museum, a university, and two important archives purchased large numbers of the photographs, declaring them important national documents. Finally the book, *Québec, à l'été, 1950* was published. The book reviews were laudatory, and a letter from Réné Lévesque, the provincial prime minister, was particularly gratifying. He wrote, "You have conceived and realized a remarkable work. . . . The images of ourselves which

you have returned to us, constitute a document of *grande valeur* [great worth]."

You can imagine how gratifying that kind of acknowledgment of one's work can be. It has given me great satisfaction to know that plunging in and following my instinct early in my career eventually proved to be so worthwhile.

This experience should be an example to you: If you feel strongly and passionately about something, go ahead and do it. In my case, I did not foresee the eventual outcome of this 1950 body of work. However, at the time, I was determined to take full advantage of all that was being revealed to me by my guides. In 1975, it was instinct again that impelled me to go back up to Montreal with the photographs. Even then, I had no conception of what would ensue—it just felt right to me to do it. And it all led to the beautiful book, which still may not be the end. I envision still more: an opera based on my book, *Québec, à l'été, 1950.*

There you have it: many photographers doing many kinds of books. As far as the money returns on a book, it's a good idea not to peg your expectations too high. However, some books, as you've just read, do become highly successful. When that happens, a photographer should be considered lucky. It may be that a book just catches on, but an important element in its success is good advertising and publicity by the publisher.

However, there are other reasons for doing books besides money, which you may or may not make. It's a great feeling to see your work in a book of its own. It also is a good showcase for your work, and a well-designed and well-printed book can give you increased status in the eyes of the public, your clients, and your colleagues.

Press
Photography

○ There is no set formula for breaking into photography, be it press photography or any other field of photography. This becomes apparent as you read the accounts of all the photographers in this book. Each has created a career in his or her own special way. However, the qualities they all share are technical expertise, an enthusiasm about the medium, great energy, persistence, dedication to their work, organization, and a capacity for hard work.

How does one break into press photography? The press photographers you'll meet in this section got into the field in their own individual ways. Jack Manning of *The New York Times* suggests working for a small newspaper first, although he didn't do it that way. Chris Johns, while a graduate student, was chosen to be a summer intern at a newspaper and subsequently went on staff. Frank C. Dougherty? You'll find out when you read his story; it is unique.

Assignment editors on the wire services and the newspapers regularly look at free-lancers' portfolios. When queried about what they look for, they replied, almost unanimously: 1.) technical expertise, 2.) an instinct for news, and 3.) versatility. They also said that overshooting does not necessarily produce the best results; that a good photographer can think and edit in the camera. They all suggested that you shoot features, advising not to be discouraged if your work is not bought immediately. It's okay to keep coming

back. They all use free-lancers, often hiring staff photographers from the ranks of the free-lancers. However, some photographers prefer to remain free-lancers.

Wire services such as the Associated Press and United Press International, and picture agencies, such as Black Star and Magnum are good starting-off points. These agencies call on free-lance photographers all over the country and the world. Pay for free-lance photographs can range from $25. to as much as $10,000. The latter is a rare sum, but that's what is paid if it's a very special exclusive photograph, and if the wire service gets all the rights.

Some outstanding photographers work for the wire services. Eddie Adams, one of the most renowned photojournalists, works for the A.P. His annual income is in the high five figures ($50,000 plus). But he is an exception. Ron Edwards, who won the Pulitzer Prize for Spot News in 1982 for his photographs of the assassination attempt on President Reagan, is a staff photographer for the Associated Press, and so the photographs went into the A.P. like any others. However, the A.P. has a policy of matching any prize money their photographers win, which in this case amounted to $1,000.

Press photography is very challenging. You're shooting under constantly changing conditions; you have little control; you're confronting all kinds of people. The situations you shoot, for the most part, cannot be reshot or restaged. You have to get the action when it happens. You are constantly faced with split-second decisions. With experience, you learn to anticipate what will happen. You'll learn how these challenges are met by the wonderful photographers you'll soon be reading about.

Press photographers concentrate totally on what's happening in front of the camera and getting it down on film. Press photography gives you the opportunity to participate in events and to meet people you ordinarily wouldn't see.

Every year for the past forty-plus years, the National Press Photographers Association, in conjunction with the University of Missouri School of Journalism, holds the Pictures of the Year (P.O.Y.) Competition which is open only to working press photographers employed by newspapers, magazines, the wire services, picture agencies, and the Armed Services. It is considered the most prestigious photography competition in the U.S.

The winning photographs are published every year in a book, *The Best of Photojournalism*, which is very much worthwhile for you to study. It will make you aware of the high level press photography has achieved all over the United States. It not only contains the winning photographs, but it gives you 1.) a good breakdown of the many categories in the field, such as spot news, features, sports, human interest, pictorial, and so on; and 2.) a list of the newspapers, magazines, services, and agencies that the winning photographers work for.

Three outstanding photographers are going to tell you about their work. Reading what they have to say is the nearest thing to going out and working with them. All the things they have to tell you, each in his own way, are invaluable. They're all successful and highly respected in their field, although each photographer is quite different from the others. Here they are: Jack Manning of *The New York Times,* Chris Johns of *The Seattle Times,* and Frank C. Dougherty, free-lancer.

Jack Manning, New York Times

○ Jack Manning is an outstanding press photographer on the staff of the *New York Times*, which means being out there photographing five days a week. He was a recognized free-lance photojournalist when he joined the *Times* in 1964, and his level of enthusiasm for photography is as high today as it was when he first started photographing in high school many years ago. Everything a photographer does on a big metropolitan daily, he has done—politics, art, entertainment, crime, press conferences, heads of states, U.N. meetings, fashion, portraits of celebrities, sports, breakthroughs in science, and all kinds of human-interest features.

Besides his job, he does many other things in photography. He has had eight books of photographs published, writing the text for seven of them. He does assignments for magazines, including over fifty how-to articles for the *Camera* column of the Sunday *Times*. In addition, he has written and illustrated pieces for the Travel Section of the Sunday *Times*. He also pursues self-assigned creative photographic projects. He is very much interested in the technical aspects of photography, and has designed a camera and various accessories. His capacity for work is astounding, as is his work output. One wonders how he does it. It is very evident that his commitment to photography is absolute. He explains it thus: "When what you're doing is something that you care so much about, as I do for all aspects of photography, time has a way of expanding amazingly, and I guess that's how I manage to do all that I do."

First, Manning will explain his work as a press photographer, and then he'll explain all his other projects, which are as important for you to know about as his newspaper work.

Newspaper Photography

○ Jack Manning summed up the requirements of a good newspaper photographer with the following list:

1. To be able to take good pictures under any and all circumstances.
2. To be able to solve all sorts of photographic problems technically.
3. To deal diplomatically with all kinds of people.

4. To get pictures back to the paper on time, and be sure to meet the deadlines.

5. To make sure that you have adequate and correct caption material.

If you feel you have these qualities and want to become a newspaper photographer, Jack Manning has these suggestions.

JM: Start on a small newspaper, and do *every* conceivable type of picture. You must bring imagination, ingenuity, and a creative approach to this work. Remember that there are two kinds of pictures which are of no value in press photography, no matter how great they may be: those that are too late for the deadline and those that have no caption material.

You should know how to develop and print, even though you may not have to do darkroom work. This knowledge will give you an understanding of how to shoot in order to get good prints.

I love photography, especially newspaper photography, which is exciting because you don't know what you'll be doing next. If you draw an uninteresting assignment, the next one is only twenty-four hours away. A good newspaper photographer must be confident, has to be resourceful, and has to be able to control existing conditions in various ways by shifting position, by changing angles, high or low. For instance, if instructions for an assignment are "hostages in the bank, stakeout," I take a hard camera case, because I can stand on it and get a higher angle, which gives me an edge. If I have to move fast, as in riots and demonstrations, I take a small, soft case, for more mobility. You must use your ingenuity. When covering a political leader, with every photographer elbowing for the center, where you get the worst possible pictures, I will first do that and shoot maybe six frames, and then move fast and go on to shoot from a half dozen different angles.

A classic example of ingenuity is that of Dr. Erich Salomon, considered the father of modern photojournalism, who back in the 1930s used the 35mm camera for press photography (something almost unheard of until the middle 1960s). He was sent to photograph a "secret" meeting of important politicians in Paris. When he discovered that no photographers could get in, he acquired a waiter's uniform, put his camera on a tray, covered it with a napkin, and got his pictures. The photographs were published worldwide, and he became famous.

Before he actually joined the staff of the *New York Times*, Jack Manning had done many free-lance assignments for their Sunday Travel and Arts and Leisure sections, and their magazine section. He already had a solid reputa-

tion as a free-lance photographer, having done many features for magazines and newspapers, and had spent twelve years free-lancing in Europe. It was this kind of background that the *Times* was interested in. Newspapers were then beginning to change their attitude and broaden their use of photography from spot news and studio-type portraits to the kind of photography that was called "magazine photography." Currently, there is hardly any demarcation between newspaper photography and magazine photography.

Assignments

○ Jack Manning works Monday to Friday, from nine to five. The assignments come from the assignment editor, and Manning averages two assignments a day. To give you an idea of the types of things he covers, here is a short description of nine assignments he did in one week. We can't call it a typical week, as there is no such thing as a "typical" week for a press photographer.

1. A political candidate, Mario Cuomo, announces his intention to run for governor of New York. Cuomo was surrounded with microphones, and to make the picture more interesting, a telephoto lens was used to get a tight head shot, thus eliminating the microphones and the clutter.

2. U.N. debate about the situation in El Salvador. This was shot with a 600mm telephoto lens. Although only one picture was used in the paper, it took about five hours of waiting to get it.

3. A model junior high school in East Harlem. Spent about two hours on this, shooting three or four different classes.

4. Stuyvesant Square, an architectural landmark area. A perspective control (PC) lens was used; I took pictures of buildings, including people passing by to give scale and perspective to the structures.

5. Kodak introduces the new Disc camera. Since this was a small item, a macro lens was used to get close enough to show important details.

6. St. Patrick's Day parade. General human interest shots—a 35-80mm zoom lens was used, enabling me to move fast and shoot a great variety of situations in little time.

7. Mayor of Miami visits New York to promote his city. Photographed him standing in snow up to his ankles on the terrace of his New York hotel room.

8. Photographic essay on high technology at hospitals for better health care, and how it is driving up health-care costs. For this story, lots of impressive equipment had to be photographed, so I used accessories to attach my camera to hospital microscopes; macro lenses

for close-ups; wide-angle lenses; short telephoto lenses; high-speed film to enable picture taking without the use of flash.

9. Morosco Theater torn down to make way for the beginning of construction of the Portman Hotel. Many theater celebrities were demonstrating.

A photographer may also be called at home, after his normal working hours. This happened once, when I was called at midnight to shoot a raging fire at an oil refinery from a helicopter.

Although the assignments come from the picture assignment editor, there are occasions when a photographer will originate an idea. For instance, Jack Manning was at the beach on his day off, when he saw a boat with policemen on it. He phoned the police department and learned that it was the harbor police. They watch out for all sorts of things: tankers in trouble, pleasure craft speeding or getting too close to the beach and endangering swimmers. He shot some pictures of the boat and showed them to the picture editor, who decided it was a good idea and sent out a reporter along with Manning for a second shooting, to get more pictures. It ran as a three-picture feature.

When the NYC blackout occurred, Jack Manning was on his way back to the office from an assignment. He left the subway and got into a taxi. While in the cab, he received instructions via the two-way radio carried by all *New York Times* photographers to go back into the subway. He radioed the desk and told them that exciting things were happening in the streets, and they told him to stay in the cab. He kept shooting from the taxi, despite the fact that people desperate to get home were hammering on the taxi windows, asking to share the cab. In fact, some of his shots were of the people at the window. He stayed in the cab, worked until 7:30 P.M., and got excellent coverage.

When Manning is finished with a day's assignments, he hands his film into the lab. A lab assistant processes it all in five minutes on the Kodak Versamat film developing machine. Jack then edits the negatives and notches those he wants printed, generally four prints. In special cases he will ask for several more. However, in cases such as the blackout, with other photographers covering the same event, the picture editor and the picture assignment editor review all the negatives and choose what is to be printed.

Captioning

JM: I try to wait, to caption the prints when they are in my hands to see everything in each picture, and so include all the pertinent facts important to the picture and so to the story. When taking pictures,

I make short notes of the locations, the people, etcetera. I may even call people after I see the prints, to double-check on names and streets. If there is no time to wait for prints, I will caption everything I have taken, since I don't know what will be picked. I prefer the first way. Sometimes I will get a call at home at eleven o'clock at night, and they will say, "We've chosen another picture from your take," and I will give them a caption on the phone. But there are times when they will hold a story for three days or so, and then call me at night, and I will tell them as much as I remember. If I'm not home, they will have to take another picture or figure out the caption from other material.

After you've been in the newspaper business a while, you develop a network of contacts. Important people get to know and trust you. They like the way you work and what you produce. For instance, a president's wife sent a Secret Service man to fetch me when she saw me in a group of photographers, to accompany her and photograph her when she went backstage to visit an opera star.

Some photographers develop an excellent rapport with the police department, or the people in City Hall, or with various cultural or educational institutions. Some press photographers become very much liked by sports figures. All of this is very important and enhances the work.

Jack Manning drew many assignments to photograph in the music, theater, and art world, and was considered sort of a cultural specialist for *The New York Times*. Recently he was asked if he wanted to take on another specialty—covering science.

JM: I said yes and I photographed at the Rockefeller Institute, a world-leading research foundation; at the New York University Medical Center; and at Sloan-Kettering, a hospital and research center for cancer.

I did a fascinating story on the so-called bionic arm. It was really eerie. This is an artificial arm which, when attached to an amputee, makes movements governed by the thought processes of the amputee. With the arm attached, all the person has to do is think that he wants to pick up a glass of water, and the artificial hand closes around the glass, picks it up, and brings it to the mouth of the amputee. He just thinks that he wants to make a fist, and a fist is made. The thought process creates electrochemical nerve impulses, which are transmitted

to a set of buttons at the end of the artificial arm. This is just the beginning of some very important developments. I photographed an operation where a tiny TV camera was inserted into a joint that an operating surgeon was working on, and the inside of the joint and what the surgeon was doing was projected onto a nineteen-inch screen in front of him. This occurred at the New York University Medical Center.

I am not attached to the science section, I am still attached to the picture desk, and these stories may be run in the science section, or in the first or second news sections as a general-interest subject.

For this science work, I use and design a lot of my own gadgets, such as table clamps and mini-tripods, to make it easier to do this kind of thing.

Equipment

○ As far as equipment is concerned Manning points out that some photographers work simply, while others work complicated.

JM: I am technically inclined, and I like to know about and have every possible piece of equipment that will enhance my work. But I take along only what is needed for the specific job. Carrying too much equipment can hinder both thought processes and picture taking. However, I am gadget minded, and I have discovered that if I take along a special-purpose lens, such as a perspective control (PC) wide-angle, or a close-focusing macro lens, the chances of enhancing and improving difficult pictures are increased, or the equipment may engender a new kind of image. Or, if I have a piece of special equipment, the picture then presents itself.

The New York Times has a pool equipment locker for the use of all the photographers, with the following equipment: several Nikon bodies, two 500mm lenses and a 1,000mm mirror lens with a fixed aperture, a 640mm standard telephoto, a Brooks Veri-Wide camera with a 110-degree angle of view, a Hasselblad with several lenses, and an old Rollei.

My own personal equipment consists of 1) special-purpose lenses: 16mm full-frame fish eye, 35mm perspective control (PC), 50mm macro. 2) Regular lenses for the Canon: 17mm wide angle, 24mm wide angle, 50mm 1.4 standard, 100mm f/2, 200mm f/2.8, 300mm f/4.5 telephoto. (I have just switched back to Canon cameras and lenses.) A 4-by-5-inch Linhof camera for architectural jobs with a 47mm extreme wide-angle lens, 75mm wide angle, 150mm, 210 mm.

The Linhof also takes 120 roll film, and also 4-by-5-inch Polaroid, and it also will accommodate 3½-by-4-inch holders.

For assignments, I tailor my equipment to the job. Example: for the Republican convention in New York City, I took only telephoto lenses—180mm, 300mm, and 500mm—and a floor tripod, and only did close-up heads of the delegates, knowing that other staff photographers had been assigned to general views and other specific angles. However, if I don't know exactly what I will be encountering, I will carry 24mm, 50mm, 85mm, and a 200 f/2.8 telephoto lens with tele-extender, a tripod, and two thyrister strobe units.

Opportunity for Breaking into Press Photography

○ Newspapers rarely send photographers overseas. An exception for the *Times* was sending a photographer to Europe for the return of the hostages from Iran.

Enterprising free-lancers, realizing this, go overseas, photograph, and then sell to newspapers, wire services, and magazines. It's a way of breaking into the field. You discover a need and fill it. (See Frank C. Dougherty, p. 85.)

His Own Photographic Projects

○ Besides his work as a newspaper photographer, Jack Manning is very much involved in other aspects of photography. He writes and photographs for books and magazine articles. He has written over fifty how-to articles for the "Camera" column of the Sunday *Times*. He experiments with negative development, and has designed a camera, and accessory equipment. He carries out self-assigned creative photographic projects. His work outside the newspaper, and the whole scope of his total involvement with the medium of photography, is as important to know about as his newspaper work.

JM: For several years now, I have been photographically exploring light—how light transforms different subjects. Beyond transformation, it almost becomes a creative medium in itself, which you happen to chance on and record. But light, it's amazing. I'm interested in photographing the white egg against a black background, which represents to me either an absence of white or a presence of white. While Steichen photographed the egg hundreds of times, he was interested in getting one egg against a white background to look like an egg. In my own experimentation, in certain configurations the black that sur-

rounds the egg is more important than the white of the egg. In others, the white of the egg is more important. The change of perspective and the size of the black or the white governs this. I always have a black background, and usually I use several eggs that can be manipulated to form a variety of different shapes and end up not necessarily looking like eggs.

I notice that various parts of the house at different times of the day look different. A very interesting thing I did with Polaroid was to photograph a closed shade in my bedroom. However, creeping in through all four sides are radiations of light, and my photograph is extremely fascinating. Dark expanses with extreme light coming in through the sides. The light seems to have a life of its own. It becomes a force that sometimes transcends reality and transforms the world around us with moments of magic.

I've been doing this for several years. There's a lot of frustration and fascination, but I have answered a couple of questions. However, I've raised many more questions than I've gotten answers to. And so, I'm continuing to investigate the new questions in a very unscientific way. Somehow or other, I believe that the more technicalities you let creep into photography, the more you drive out the creativity; and the more creativity you bring into it, that drives out the technicalities.

I most enjoy working from pure instinct. I don't know what my ultimate goal is, but I'm continually seeking it. I can't articulate it because I don't know what it is. It's an anomaly.

I'll tell you something. I made a very interesting discovery. I used to collect coins when I lived in Spain. I became a numismatic expert on Spanish coinage, and I amassed a fascinating collection. The collection was very valuable, and when I returned here, I had to put it in a vault, and the collection ceased to have any interest for me. What could I do? Go to the vault and look at them? That's ridiculous. Bring them home? Then I'd live in fear that they'd be stolen. So I got rid of all of them, and I made a discovery. The excitement for me was not having the coins, but the act of acquiring them. Wherever I traveled in Spain, I looked and found the coins, and along the way met many fascinating people. Also, the coins were beautiful to look at, but the real fascination was the search. And so it is with my personal projects. It's the involvement and the doing that's exciting and important.

Another project I have assigned to myself and have been working on is this: I firmly believe that it's possible to duplicate 4-by-5-inch negative quality with 35mm film. I have succeeded in bringing the quality of 35mm negatives up to 2¼-inch film, and even bettering it.

Design of a New Camera

○ Manning has designed a camera and built a model of it: the Superwide I. It's called that because the implication is that there's going to be a Super- wide II, and a Superwide III, and so on. There are several wide-angle cameras on the market, but none of them quite do what this one does.

JM: It takes 120-roll film and Polaroid. It has interchangeable wide- angle lenses. At the moment, it's strictly for wide-angle use. It has a perspective control in the front and a revolving back. Unlike a view camera, it has no bellows. It can be handled like an oversized 35mm, without a tripod, and with all the quality of the larger-size negative. It has an optical finder on top, and next to it is a spirit level. It's especially suited to architecture, and street photography and gives tremendous quality. I'm still just running tests, and it hasn't been used on jobs yet. I've done architectural pictures, children playing, and landscapes. I sometimes use the camera almost at ground level, holding it at my side like a gorilla. I shoot without even aiming through a finder. There is so much depth of field that there's no problem of focusing. And the children don't even notice because the camera is not put up to the eye.

In any wide angle, if you hold your camera level, there is little or no distortion. If you tilt a wide angle, then the lines go off, and if you do a portrait with a wide-angle lens, close-up, then you're going to get exaggeration. One must learn to use wide-angle lenses properly.

I started building the camera with the front plate, which was built to my specifications by a camera store in Barcelona in the spring of 1982, when I was there on vacation. I took the plate with the two knobs that enables it to ride up and down in front. I bought a revolving back, which is positioned so that the lens on the front plate is at infinity with the rear. The revolving back takes roll film and also Polaroid. Then all I needed was the middle of the camera, which I had built at Marty Forscher's shop in New York City.

That's something I did for fun. Everything I do in photography is for fun. What I do in my work for the *Times* for fun is to make good pictures out of difficult assignments. I usually have the most fun doing pictures I'm mostly interested in doing.

Books and Other Publications

○ My first book was done in 1959 on Venezuela. That was for Doubleday. They called me, and I did the photographs for it.

In 1963 I wanted to do a book on Cuba. I showed photographs to

a number of publishers, and one publisher, Dodd Mead, said, "We like your work, but we're not interested in doing a book on Cuba, would you do a book for us on the children of Puerto Rico?" I said okay, but I nearly fainted when they said they expected me to write it too, because I had never done any writing. "I don't think I can write." They were very nice. They said, "But we think you can. Don't worry about it, you'll have the pictures and we can always assign a writer."

This was my first entire book of both pictures and text. I went to Puerto Rico, took the pictures, printed them up, sat down at the typewriter, and couldn't figure out what to say, how to start, and the time kept disappearing. Finally the book was due on a Monday. I called the publisher on a Friday, and my editor said, "How's it coming, Jack?" I said, "Fine, I'll have the text on Monday." I had nothing. I sat down and I did the text somehow. I don't know how, but I did it.

Monday morning, I got up at five-thirty, reread it, ripped it up, and threw it away. I went to the publisher and confessed. I said, "I'm having an awful time with it, and I'm sorry I didn't meet the deadline." She said, "Deadlines here don't mean anything. If you need an extra three or four months, that's okay." So I said "Well, all right."

Three weeks passed, and I was at a friend's house, when all of a sudden I thought of a first sentence. I left in a hurry. I said, "Bill, excuse me, but I thought of a first sentence." I went home and sat down at the typewriter.

The whole book came out. The first sentence unlocked the door. It was: "Sixteen hundred miles from New York as the jet flies, and one thousand miles southeast of Miami lies the beautiful tropical island of Puerto Rico." From there on, I did a series; besides *Young Puerto Rico*, there was *Young Spain, Young Ireland,* and *Young Brazil.*

I then did a travel book on Spain, with Tad Schulz, for the *Times.* For Amphoto publishers I did a book of fine 35mm portraits. *Newsweek* book publishers did a book I wrote for them on automatic cameras, and I did another one for Harper and Row on Polaroids. At present I am working on a children's fantasy book with a friend of mine, a fine artist, and I'm just doing the writing. It is nonphotographic.

Manning has also written and supplied the photographs for several photography-oriented articles for the Travel section of *The New York Sunday Times,* which covered Spain, France, and Germany, and dealt with the kind of equipment to take on a trip. He also did a piece for the Travel section on the camera store in Barcelona, as part of the series, "Shopping Around the

World." He knew the people of that camera store from when he lived in Spain, and they are the ones who built the front part of his Superwide I camera. They threw a farewell dinner for him when he was there on vacation in the spring of 1982, inviting Spanish photographers and artists.

He shared a byline in *Popular Photography* magazine with his eight-year-old daughter, Sara-Jean Manning. It was a two-page spread of pairs of color photographs taken with the new Kodak Disc camera. He had attended the press conference introducing the camera, and a Kodak V.I.P. said, "This camera is so simple that even an eight-year-old can operate it." That gave Manning the idea for the article. On their vacation in Spain, they both used the camera, and the pictures they took were used in the article.

JM: I'm also preparing work for exhibitions in museums and galleries. I traded in my Rollei for the latest model Leica enlarger, which is an autofocus with a wide-angle lens so that you don't have to rack it up too high in order to make sixteen-by-twenty-inch prints. I have to do an enormous amount of printing, which I do on weekends. I start in the morning and print for eight or nine hours. I may not get more than six really fine prints. I'm starting with old negatives that go back more than forty years—some have never been printed. This will be for a number of exhibitions and books, and I shall be doing only photographs that I like.

The difference between professional work and creative work is that professionally, you photograph everything that's asked for, and creatively, you do what you like.

An outstanding photographer who skillfully combined these two aspects of photography was the late Gene Smith, a friend of mine. Editors would want to print the photographs of his that he liked the least, and he stood up to them and didn't give them that option. He was one of the few photographers I know of in this business who was able to run a successful magazine career, and the photographs you saw printed in the magazines were the ones he wanted you to see. But, physically and mentally, he paid a terrible price for that, as it's not easy to always be fighting the people you are doing work for. But he also had a tremendous gain out of it too, and the satisfaction was extremely important. He quit *Life* many times, and they wanted him so badly that they kept asking him back.

You should all know about W. Eugene Smith's work. There have been many books published, and the Aperture publishers' cross-section of his work will give you the clearest view.

We must keep in mind that Jack Manning himself is quite remarkable in that he is doing all this personal work in photography while still working effectively as a press photographer at the *Times* five days a week.

One wonders how he finds the time for all that he does—his work at the *Times*, his creative work, his investigations into technical aspects. He explains it this way: "In essence, I'm doing things that I like, so you make the time. I have discovered that all good photographers do things in photography besides what they earn a living at, and very often this additional work eventually becomes income-producing."

In the course of his career, Jack Manning must have come in contact with everything: politics, sports, art, entertainment, education, science, spot news, and travel. He has met people in every imaginable field of endeavor, and his interest and enthusiasm for his work has never flagged or diminished. He is a prime example of the fact that photography is an ever-renewing medium, a work without end.

Chris Johns, *The Seattle Times*

○ Chris Johns had been a press photographer for only five years at the Topeka *Capital-Journal* when he competed in the P.O.Y. in 1979, and won Best Newspaper Photographer of the Year, one of the four top awards. His winning portfolio was a group of seventeen entries, including four picture stories. The entries included everything from a fatal house fire to fashion. We asked him about winning.

CJ: Of course I like winning. It's nice to win one thousand dollars and a camera, but I have mixed emotions about the whole thing. By no stretch of the imagination am I the best newspaper photographer in the country. One must keep it in perspective. Contests can do you a lot of good. They force you to take a good hard look at what you've done during the year.

An exhibition of the winning photographs tours the country. To accompany the exhibit, Chris Johns created a slide show that posed an important moral question, one that every aspiring press photographer should be aware of and think about.

Here is the text that accompanied the slides:

I love this profession, but sometimes I wonder—is everything I do in the best interest of my community? Is it right that I photograph a daughter as her father burns to death inside a house? Is it right that for several days, I am incredibly close to a person in a story, and then am gone, never to see him or her again?

Do I have the right to go anywhere, anytime, under the guise of the public's right to know? Is a picture worth exploiting someone?

There are no simple answers, but I feel one way to confront these questions is to spend a few minutes with some of the people directly affected by the news I reported. It gives me a chance to see some old friends and hopefully make some new ones.

His follow-up showed that most of the people had not been adversely affected by his original reportage. A seventeen-year-old unwed mother whom he did a story on told him that people were more sympathetic and understanding as a result of his newspaper story. An old man who went around to hospitals to sing for the sick people thoroughly enjoyed the attention and recognition he got from the newspaper story.

As mentioned earlier, Chris Johns came to the *Capital-Journal* in the early seventies as a summer intern, and stayed on. The Topeka *Capital-Journal* has a history of photographers who win in the P.O.Y. At the time of Chris's win, Richard Clarkson was the director of photography on that paper; he is now with the Denver *Post.*

CJ: Rich Clarkson is a genius with the ability to inspire photographers. He doesn't often tell you that you did a good job. What he does is force you to think; he wants you to become independent. He puts a heavy emphasis on being a complete journalist and getting involved in the community. He wants you to be looking for stories all the time, and not just visual things; he wants the photographers to write. He doesn't drool over contacts, but he does talk about how you act on assignments, in the office, and how you get along in the newsroom. He wants you to follow through, from taking pictures to processing, and even into the press room, to observe how things are coming along.

After winning, he said that he wasn't treated any differently at work than before, and here is one of his weekly schedules after returning to work from the P.O.Y. competition:

Day 1 Shot a color fashion layout.

Day 2 Went to a murder scene, sat around for hours, never got in, got zilch pix, shooting with a telephoto lens.

Day 3 Shot a housewife, who was chosen "home cook of the week." Processed the film, and made final arrangements for the fashion page. Did printing, captions, and layout, and set the headlines.

Day 4 Covered the Rock Island Railroad strike, was shooting for page one, and also for inside pictures, trying to show a portrait of the town, lots of friction building up, people carrying guns.

Day 5 Processed and printed the Rock Island pictures. In the afternoon, flew to Pittsburgh, Pa., to cover the Kansas football game.

This schedule should give you an idea of the variety of work a press photographer handles. Compare Chris Johns's schedule with Jack Manning's schedule for *The New York Times,* on page 61. They're not too different. For many photographers, the variety in press work is a big attraction. However, it isn't on every newspaper that photographers get to process their film, or to work on layouts, or to set headlines—only on the smaller papers is this so.

CJ: I wouldn't trade the years spent with Rich Clarkson working on the Topeka *Capital-Journal* for anything. The paper is just the right size: small enough so that a photographer can keep control over the product, big enough to pull away and take a leave of absence; close enough to Kansas City, a big city, and small enough to get close to the community.

Shortly after winning at the P.O.Y., Johns got an assignment from the *National Geographic* magazine, and was allowed to take a leave of absence from his paper to work on it. The reportage was about the forest fire fighter interagency, elite twenty-man crews who are flown all over the West, into the very roughest terrain, wherever they are needed, to bolster the local fire fighters.

For the first part of the story, Johns stayed with the fire fighters throughout their training.

CJ: It's one of the ultimate tests against which a man can pit himself; in a fire, they will work for forty-two-hour stretches.

For the second part of the story, he photographed them during the actual fire fighting. The story was published on four pages in the September 1982 issue of *National Geographic*.

Chris Johns said that everything he learned under Rich Clarkson on the *Capital-Journal* was of great value, and that he applied all of it to his work on this magazine assignment.

After working for five years on the Topeka *Capital-Journal*, Chris Johns went to work on *The Seattle Times*, a newspaper with a much larger circulation, a metropolitan newspaper. He functions both as a photographer and a picture editor on *The Seattle Times*.

Now that you have been introduced to Chris Johns, who has built a fine career in press photography in a relatively short time, let's backtrack to his beginnings and hear directly from him about how his career developed.

CJ: I went to Oregon State University in 1969, and was a preveterinarian major. I had had nothing to do with journalism or photography, and up to my junior year was still planning on being a veterinarian, but admissions to vet school were limited, and I realized that I wouldn't make it. My roommate, also my best friend, was an agriculture major, and he bought the Time-Life photography books. I had always been a lover of books, and started reading them. Then my friend bought a camera, and I got interested in his camera.

I then took my first journalism class from a very good professor, and enjoyed that. I finally saved up enough money to buy a camera, and in order to support my new habit, I started working for the school yearbook and the school newspaper. I then decided to switch my major to journalism. I was fortunate enough to receive a summer internship at the Corvallis [Oregon] *Gazette Times*, a daily paper of about fifteen thousand circulation.

I spent the summer there working as a reporter mostly, doing a little bit of photography. In my senior year in college, I worked about thirty-five to forty hours a week for the Albany *Democrat Herald*, twenty thousand circulation, about ten miles from where I lived in Corvallis, Oregon. I photographed all their sporting events, working weekends. It was an excellent paper, and a very good experience.

I felt due to my late arrival in photography and journalism (I don't want to just keep it to the photo angle) that I needed a little more background from a bigger university. When I graduated, Mr. Zwahlen, the head of the journalism department at Oregon State University, helped me get a teaching assistantship in photographic communication at the University of Minnesota. I did that for a year, taking classes and running the photo lab at the U. of Minn. One of my teachers there suggested that I apply for the internship at the Topeka, Kansas, *Capital-Journal*. The reputation of that newspaper was excellent.

I phoned Rich Clarkson, and he told me to send him an application and a portfolio. I sent him about twenty-five slide copies of my work in a carousel.

[Rich Clarkson was not only director of photography at the *Capital-Journal*, but also a contract photographer for *Sports Illustrated*.]

Rich Clarkson had an assignment for *Sports Illustrated* in Minneapolis. He interviewed me and gave me a summer internship at his paper. After interning at the *Capital-Journal* for three and a half

months, a staff photographer left, I applied for the opening, got the
job, and worked there just over five years.

LM: *How do aspiring photographers learn about summer internships?
Are notices sent to colleges and universities?*

CJ: As far as getting notices to schools and universities, I think that
it's more of a word-of-mouth thing. There are a lot of good summer
internships all over the country, for all different sizes of papers, from
the size of the Everett, Washington, *Herald*, to *The Seattle Times*, the
National Geographic, the Louisville *Courier Journal*, and the Los
Angeles *Times*. There are also some smaller papers, too, like the
Missoulian in Montana. The list goes on and on. The educational com-
mittee at the National Press Photographers Association can help place
some students with summer internships. (National Press Photographers
Association, P.O. Box 1146, Durham, NC 27702.)

I think summer internships are a superb way to get started in the
business and get a glimpse of what working on a newspaper is like,
be it a small newspaper or a large newspaper. Of course, it's not quite
the same as being on staff at a paper, but it's about the closest approx-
imation you can have.

When I came to Topeka as an intern, I was immediately thrust
right into the thick of it. The first day, I rode with a photographer, and
tried to find my way around town a bit, and from then on, I was com-
pletely on my own. I was given daily assignments just like any other
photographer, and I was treated like any other staff photographer.
I was given encouragement to come up with my own story ideas and
do my own things on company time. There was the usual direction
from the rest of the staff and from Rich Clarkson. He watched over
me a little, and helped out with things, but still I was basically on
my own, which I think is far and away the best way for an intern
to function. I know it's the same at the *National Geographic*. There've
been interns who've gone all over the world, photographing stories
for them. [See Martha Cooper, Chapter 2.]

I think one of the nicest things about being an intern at Topeka
is that I was given room to have a few minor successes, and also
to make a lot of mistakes. I think one of the most important things that
can happen to you as an intern is that you'll be cut loose and some-
one will have faith in you to go out and do the job.

After working five years at the Topeka *Capital-Journal*, Chris Johns left there
in 1980 and went to work at *The Seattle Times*. He describes his work there.

CJ: Before I explain just what I do at *The Seattle Times*, it might be best to describe what the paper is like. *The Seattle Times* has a joint operating agreement with the Seattle *Post Intelligencer*, which puts our Sunday circulation up to about half a million. Now this is substantially larger than the Topeka *Capital-Journal*, which was just over one hundred thousand circulation on Sunday. Working now for a real bona fide metropolitan newspaper gives me a lot more resources, but I also function differently at this paper than I did in Topeka. Space is a much more valuable commodity. I'm dealing with fourteen photographers and competing in a very healthy way for space. I'm also competing with some excellent writers, and a good strong newsroom, too—a newsroom that hopefully is getting stronger all the time. Gary Settle, a very fine photographer, is the assistant managing editor of graphics.

Since I have been at *The Seattle Times*, I have spent a little over half my time as a night picture editor. My responsibilities are the assigning of photographers to assignments, deciding what assignments will be covered, and deciding whether or not we will cover certain assignments. I dispatch photographers all over the state of Washington or the country. I'm also responsible for the A.M. editions, for writing cut lines [picture captions], and for coordinating words and pictures, reporters and photographers. I'm responsible for the placement of local pictures, and for the picture play on page one.

All in all, it's a pretty fascinating job. I would say one single thing that has probably helped my photography more than anything I've done as a news photographer is working on the picture desk as a picture editor. It's made me, I believe, a much better and more responsible journalist. It's made me more articulate in my dealing with newsroom personnel and word people. It's also made me a much more disciplined photographer, because I realize what a picture editor has to go through to get pictures in the paper, and how responsible those pictures have to be. It has also made me realize that a lot of the things Clarkson told me were even more true than I felt when I was working there. That is, that I have to have good, strong journalistic instincts.

This is even more true at *The Seattle Times* because, as I said before, we have a real space crunch. We only have so much space in the paper, and as a result of that, the pictures must have much more content than they do at a smaller newspaper. You really have to deliver the goods. My experience at *The Seattle Times* is, if and when I deliver the goods, I get some space and I can go with it. But it has to be good, meaty, strong, responsible journalism. Quite frankly, I find

that to be quite appealing, especially when I see some of the things that win in contests, which are rehashes of things that have been done for years and years and years, in the old tried-and-true formulas.

LM: *Could you articulate your concept of journalistic instincts?*

CJ: I, hopefully, am trying to expand my horizons and deal with technically difficult issues—issues that do not have hard black-and-white answers; complex issues—and to really offer something to the reader that goes beyond the superfluous nature of many photographs; to have photographs that really explain, really show things as they are, and do it in a responsible way. Sometimes those kinds of stories, ones that deal with the complex issues in our society, don't necessarily make award-winning photographs. But I think that the satisfaction I get from dealing with those subjects, and the challenges of those subjects, may hopefully have a positive impact on the world we live in, and that thought makes it worthwhile.

Now I'll get back to what I do when I'm not working the picture desk, when I work as a photographer on the street. More than most photographers on the staff, I would tend to be occupied more on projects of the kind I was just elaborating on. This is one reason I was probably selected to go down to Mexico. I tend to deal a little more with picture-story things. I work several months of the year for our Sunday magazine, which of course affords me a little better space. I don't always use that space as well as I should, but we're working on that.

Foreign Assignment

○ On May 18, 1982, Chris Johns was sent by *The Seattle Times* to cover the volcano erupting at El Chicon in Mexico. We asked him the following questions.

1. What equipment did you take?
2. What unforeseen problems arose?
3. How did you handle the language barrier?
4. What preparations did you make?
5. Were you given any instructions before you left?

We also asked him to give us a detailed account of that experience.

CJ: The next thing I'd like to talk to you about is when I was in Mexico, covering El Chicon, a volcano blowing up about one hundred miles from the Guatemalan border.

I was talking to our city editor, and as a result of working the

picture desk, I do have a lot of contact with city editors, with manag-
ing editors, and the upper echelon, so to speak—the power base of
a newsroom. I also work very, very closely with Gary Settle, who
obviously has much more clout in the newsroom than I do. But I had
been talking with one of our city editors about a swing of stories I'd
like to do in Central and South America. I gave him a pretty strong
case for some things I've felt we should do down there, some very
strong local angles on stories. Then we could even look at them with a
little more international scope, focusing around these local angles.
I articulated all this to him verbally, and then I wrote a detailed
account of what we should do down there and how we should do it.

He seemed quite receptive to the idea. *The Seattle Times* has not
really been a paper of national or international scope. We are slowly
trying to become the regional newspaper for the Pacific Northwest,
which is quite a challenge in itself. Because of its geographical isola-
tion, the paper has been pretty provincial in its dealing with news.

Anyway, the next day, I was scheduled to fly on a private charter
to Yakima, Washington, to photograph Phil Mayer, who had won the
World Cup in skiing, and his brother Steve, who had also competed.
Their home is near Yakima, and the local people were having a big
homecoming for the Mayer brothers. We had to use an airplane, to
make deadlines and to get film back, as it's a good distance away and
up over the Cascade Mountains. I left around noon, and came back
about seven-thirty P.M. to make the first edition.

One of the assistant city editors told me that Alex MacLeod, our
major city editor, had made a decision that Tomás Guillen, a bilingual
reporter in our newsroom, and I would go to Mexico the following
day, leaving Seattle at about seven in the morning. We would go to
El Chicón, a volcano blowing up in Mexico, the local angle being that
May 18 (1982, that day) was exactly two years after the eruption of
Mt. St. Helens, so we do have a good deal of readership interest in
the eruption of volcanos. And there are links between Mt. St. Helens
and El Chicón in the Pacific ring of fire. With that, he said, "Are you
ready to go?" Always, under all circumstances, I try to be ready to go.
Having done quite a bit of traveling, I've refined my equipment and
my clothes so that it's all very easy to put on an airplane. I have plenty
of luggage. I have a cart for hauling my equipment around airports.
I have a current passport which is always up to date. In just a matter
of a few minutes, I can pack and be ready to go anywhere in the
world, hopefully. I feel that's part of my responsibility as a photo-
journalist. I should always be ready to go, my equipment should

be in good shape, and I should be ready to hit the road at any time.

I got the Mayer brothers assignment out, and I tried to get a few hours of sleep that night. We jumped on the airplane with a two-thousand-dollar advance, American Express and all the rest of the credit cards I own, and headed for Mexico City. When we got into Mexico City we learned that all the airports near the volcano were closed. One thing, when you're traveling in foreign countries, is that you have to be ready for everything to go wrong. Because virtually everything will go wrong. So finally, after several hours, we were able to get a rental car.

We drove all night long, over five hundred miles, to a town called Villahermosa. We checked into a hotel, talked to some people, and a guy needed a ride to one of the villages, so we took him out there. By about one in the afternoon we were getting close to the volcano.

It's a much different volcano from Mt. St. Helens. It's a volcano coming out of the ground, instead of out of a mountain. When we first got there, it looked like we didn't have much of a story at all, but as we stayed there for three and a half days, we found that the story just kept getting more and more fascinating.

The volcano erupted on us. One time when we were in a small village, it started raining hot rocks on us. It was really kind of a frightening thing, as we'd just gotten down from the mountain, and if we would have been a half hour later, I don't know if we would have made it out. Quite a few people perished in that eruption and subsequent eruptions.

As far as the language problem goes, I don't speak very good Spanish. Believe me, I'm working on that—I would like to speak good conversational Spanish. But I have found with traveling that the best way to get along in a foreign country is to never get irritated, no matter how badly things are going. Everything is slow; the pace is different in Latin America. You have to roll with the punches, never get excited. When things go badly, you have to smile and shrug it off. You can't get irritated at the people. What you have to do is remember that you're in their country. You're their guest. You're there to be a gentleman. You are there to learn from them, and to ask questions. I continually find that people appreciate it, just your trying to speak their language. They enjoy the fact that you're making the effort, and that you're a pleasant person to be around.

I feel that with those kinds of attitudes, traveling internationally, you can get along most anywhere fine. If you start ordering people around and acting like an American big shot, you're going to have

nothing but trouble, and you probably deserve to have nothing but trouble. But fortunately, the reporter I was with is bilingual. Tomás was an invaluable aid. I can usually understand what people are saying in Spanish, and carry on an elementary conversation. But nonetheless, if you're writing a story, you have to really understand, to be a scholar of the language. As a photographer, I don't necessarily have to have that, although it would be nice.

Equipment on the Mexican Assignment

○ As far as equipment goes, I try to travel light, although I have to carry extra equipment, especially when covering a volcano. That's about the most destructive thing you can possibly deal with regarding equipment. I had three Nikon F3's with motor drives. I had six Nikkor lenses: a 300mm f/2.8, a 180mm f/2.8, an 85mm f/2, a 55mm, a 28mm, a 20mm; and a T.C. 1.4 tele-adaptor. I also carried three compact Vivitar strobes, extra power packs, and a tripod.

I have a paranoia about running out of film, therefore I took eighty rolls of Tri-X, thirty rolls of Kodachrome, and twenty rolls of high-speed Ektachrome. I didn't know how long I'd be in Mexico. Three and a half days really wasn't as long as I would have liked to have stayed, but such is the newspaper business. We were just glad to be there.

As I mentioned, a volcano is about the most destructive thing regarding equipment, and I would like to mention the cleaning bill on my equipment. The only lens that didn't need cleaning was the 300mm f/2.8 Nikkor, which is a very expensive lens. It was hardly used, because the ash was so thick that a telephoto really wouldn't cut through it very well. However, all the other equipment had to be thoroughly cleaned and rebuilt by an authorized Nikon service dealer. The bill to have all that equipment cleaned was $971. So you can see, that's a pretty expensive proposition. But if the equipment hadn't been cleaned, it wouldn't have lasted more than a few weeks out in the field again. It was hopelessly trashed out.

The Shooting

○ When I was out covering the volcano, I used a hip belt, in which I could store film, extra lenses, strobe lights. I carry three camera bodies on me, usually with a 28mm lens or a 20mm lens, an 85mm lens, and a 180mm lens. Two camera bodies have black-and-white

film in them, and one camera usually had Kodachrome in it.
My primary responsibility was to shoot black-and-white film for the
newspaper. Color film was shot to be sent to Black Star [photo
agency] for marketing. I usually shot the black-and-white, and if
I had time, I shot some color.

Dealing in a foreign country is different from dealing in America.
You have different power bases, you have a different bureaucracy.
In the case of this volcano, it was much different from Mt. St. Helens
because we had access to go right up to the volcano, which in retro-
spect was very dangerous. We didn't realize, until we got out of there,
what a dangerous situation we were in. We stayed nearly all night
in a village that later was virtually buried, and most of the people in that
village were killed. So, we were in a very precarious position. In a
foreign country you just have to be a little more aware of what's going
on around you, and it's a little harder to get information. The foreign
press isn't nearly as sophisticated, as a general rule. Now by that, I'm
not talking about West European press. I'm talking about third world
press, or Latin American press.

It was interesting, because the photographers from Mexico City
would just take pictures of the general strutting around. They didn't
really take many pictures of the volcano, or of the refugees who were
being affected by the volcano. Another thing, everything works slower,
everything takes more time. The phones don't work right. You can't
get mad about the phones not working right; it's an exercise in futility.
If the phones don't work, you keep trying; you try to courteously find
out a better way to use the phones.

As far as getting a helicopter and getting up in the air, you have
to bribe helicopter pilots. I know that sounds strange to Americans,
but the only way I could possibly get up in the air to shoot aerials
of the volcano was to bribe some helicopter pilots, and I mean a fairly
substantial bribe. But that's the way you do business in a foreign
country. When in Rome, do as the Romans do.

For the week I was in Mexico, I may have averaged two hours'
sleep a night. I only have so much energy, and on a story like that
you operate on a lot of nervous energy. You have to pick and choose
what things you want to photograph, how you're going to approach
them. You've got to edit even before you get there. I don't care how
old you are, or who you are, you're going to have to use that energy
constructively, and pick and choose how you're going to cover the
story. That's where being a good journalist is even more important
than any other aspect. You have to know what you need to tell the

story, and you have to know how to get those pictures to tell the story, and I think that just comes from journalistic experience, nothing more.

Topeka *Capital-Journal,* versus *The Seattle Times*

○ I think I might elaborate on the differences between the two newspapers. *The Seattle Times* is bigger. It has a bigger bureaucracy, but it's a bureaucracy with many more resources. The Topeka *Capital-Journal* would never have sent me to Mexico. It just wouldn't have been done. I will also, for about a month, be up in Alaska this year, doing a whole series of stories up there mostly for our Sunday magazine *Pacific. The Seattle Times* has more money, and fortunately is in a strong financial position right now. Our newspaper is becoming more and more aware that the quality of the product is what may determine the longevity of the newspaper.

But there are also some problems. As I said, the space problem at a metropolitan newspaper is a little more acute than it is at a place like Topeka. Also, because of unions, I can't really go and do some of the things I used to be able to do at Topeka. Although I have found that by treading softly, I can go to the back shop and supervise the paste-up of a page. With Gary Settle's help, I edit my own film. I also have an art director here to help me lay out photo pages. He can teach me some new things and be a further stimulus to my photography and to the final product that appears in the newspaper, just as Gary is a stimulus to my picture editing—and, since he is one of the finest photographers in the U.S., he can offer some insights into my shooting.

All in all, I find that a lot of photographers tend to bad-mouth metropolitan newspapers, but I think that's because they're not complete journalists. At metropolitan newspapers you're playing for higher stakes, you're playing with brighter, better-paid people—people who are a little harder to convince. You're competing with better writers for space, so you really have to deliver the product journalistically. And you have to be articulate in presenting what you want to do with photographs at the newspaper, and you just have to have a good strong argument.

Description of a Local Assignment

○ One thing I might talk about is an assignment I did on Western State Hospital, which for years and years and years has been in the

news. In fact, a very famous actress was gang-raped there. It's
a mental hospital, and an awful place. It's a place that has tried to
clean its act up. But the fact of the matter is, the state of Washington
doesn't want to spend the money to make the place better. Politicians
don't feel that making the place better will get them reelected, and of
course being reelected is what most politicians want more than any-
thing else. I hope that doesn't sound too cynical, but I guess that's the
way you get after you've been in the newspaper business for a while.

This hospital had been in the news again. They're suffering from
overcrowding, and a court order said that they had to take patients
whether they were overcrowded or not. We had not given our
readers, for quite some time, a good view of what that hospital looked
like inside. What that overcrowding meant; what it did to the patients
and to the people who work there. I read the story in the newspaper
—actually, in the competing newspaper, the Seattle *Post Intelligencer.*
It was quite a good story.

I went to Gary Settle, and said, "Gary, we have to do a story
on this thing." I articulated what I thought the story might be. I don't
want to preconceive too many things, but I expressed how I would
approach photographing the story, what I thought a reporter and
a photographer should deal with in covering the story, and I gave
this typewritten detailed proposal, about a page long, to Gary. He
siphoned it to the newsroom. The city editor said, "Great idea."
We got a reporter and the next day we were there.

Now once again, as in Mexico, I'm in the old time bind. I've got
deadlines, and I've only got about five and a half hours to do it,
and in that time I photographed the best I could. I almost always try
to photograph, on an assignment, like I'll never have the luxury of
being back there. I try to take it slow and easy with people. I don't
try to manipulate people or push them around. But by the same
token, I find that I do my best work when I'm under pressure; that's
when I'm looking my hardest.

The fact of the matter is, in the newspaper business we don't have
the luxury, most often, of spending gobs of time somewhere. And
I don't know of too many magazines that do photojournalism that allow
you to spend gobs of time somewhere. You have to get in quickly,
get the job done as best you can, do the story as honestly as you can,
and just do it.

That's what we ended up with, about five and a half hours in this
place, and our access was pretty good. The one problem was, we had
to be real careful that people weren't readily identifiable in the pictures.

And that doesn't mean that you can't take pictures of people's faces, but not too clearly. Actually, instead of getting all shook up about this, and thinking it's going to destroy my pictures, I find it an interesting challenge. And a couple of the pictures were actually better, graphically, because of the mystery of not being able to totally see the person's face.

Instead of complaining about your access when you know you can't get better access, you do the best you can. You say, "Well, I'm going to try to make this work in my favor, instead of against me." That's one of the old psychological things that Clarkson taught me.

Chris Johns's photographs—the mental hospital, the Mexican volcano, as well as many others—have the impact of pulling you right into the experiences and events he has recorded. Then, after this hits you—and it's a powerful thing—you realize you're looking at a terrific photograph, rather than the other way around: Your first impression being "Wow, what a terrific photograph," and then seeing what it's all about. This is a subtle shift of emphasis wherein lies a world of difference. There also exists in his work the rare combination of tenderness entwined with strength. All this comes not from whether you use this or that camera, or this or that lens, or even knowing when to press the button. It comes from a deep inner conviction and commitment.

CJ: I want my photographs to work on several levels: emotionally, visually, and intellectually. I want my photojournalism to deal with the universal experience of life, to provide insights into life. Actually, those are lofty goals I seldom, if ever, achieve.

I like the honesty and integrity of photojournalism, and I regard photojournalism with a certain amount of sanctity. I really don't want to dilute that. I've very seriously explored free-lancing, but I would probably have to do quite a bit of corporate work, and I really feel a bit of a problem with that, an ethical problem. If I'm going to be a journalist, I feel that I should probably remain devoid of a conflict of interests, and I'd be uncomfortable with doing corporate work.

I also can't help but bring up the point that when I left the Topeka *Capital-Journal* and came to *The Seattle Times*, I nearly doubled my salary. I have some real apprehensions about making a lot of money in the business. I feel money can do one of two things to you: It can set you free or it can trap you.

I have some projects back in my hip pocket that I slowly try to work away at. One of these projects is a documentary of the Pacific

Northwest loggers. I'm fascinated with them. Being a native of the Pacific Northwest, and because my grandpa was a logger, I feel a very strong affection and respect for these men. I don't necessarily condone their environmental activities, but nonetheless, I really like them as people. Along with that, I do a little teaching, some guest speaking at universities and professional organizations, and I work on a couple of projects, like the one on the loggers, all of which I find to be a nice outlet and a nice way of broadening my horizons some.

I also do free-lancing for magazines, and I'm hoping again to do some more work for the *National Geographic*. The story I did for them in 1980 on forest fire fighting was published in the September 1982 issue. That story was similar to the volcano story. You never knew what was going to happen next. You always had to be ready to go anywhere, anytime. It was quite an adventure that I really enjoyed. The longer I'm in photography, the more I come to appreciate adventures like that, chances to go places and do things, that very few people ever get to do. Photography is quite a passport for all kinds of very interesting experiences, hopefully all over the world.

The longer you're in the business, the more refined your skills become, so that you can always produce good pictures; and the more traveling you do, the more exotic stories you do, the more the pressure's on you to produce really fine, fine quality photographs. I hope I'm maturing in that way, so that I can do these things better and better all the time. The day I quit becoming better, the day I don't have the challenges I feel now, I'm afraid that I'm going to have to leave the business and go into some other aspect of journalism.

I have done some teaching. I have put on some seminars around the country at universities. I'm a member of the National Press Photographers Association. I'm not real active in the NPPA. I'm probably a little more active in Sigma Delta Chi, the professional journalism outfit. I tend to become more and more attached to the journalistic elements of things. Instead of leaning more toward art photography, I'm leaning more and more toward journalism.

I might say that I enjoy writing a lot. In fact, the longer I'm in the business, the more I enjoy writing, the more I feel the correlation between good solid photojournalism and good solid writing, good solid reporting. It's also been a real pleasure, at *The Seattle Times*, to work with higher-quality reporters. I find that we can really feed off one another and produce a better product.

I own a home in Seattle, do some gardening and woodworking. I'm also a bicycle enthusiast. I live with my wife and my Scottish

terrier. I hope that what I've said is of some benefit to you. I find what you're doing to be very interesting and, I think, a real service to photography.

Frank C. Dougherty:
Free-lance "Hot News" Photographer

○ Frank C. Dougherty is a free-lance photojournalist. Let him tell his own story.

FCD: I've done everything in press photography at one time or another: sports, personalities, real estate, spot news, politics. Locally, I've covered everything from fires to presidential elections. But I mostly enjoy politics and travel. When I go abroad, I have photographed human-interest stories, and also wars, "hot news" situations.

My work goes into *The New York Times,* the Philadelphia *Inquirer,* and *Newsweek* primarily. It also goes into local papers and other magazines, and I also sell to the wire services.

In 1982 I went to Beirut three times for *Newsweek*—twice in the spring, and I had just come back to the States from the second trip when I had to return a week later for the invasion.

Most newspapers and magazines rarely send staff photographers into a war situation, so it is the free-lancers who get these assignments. The pressure on the photographer in a "hot news" situation isn't just in the photography. You've got the pressure of working under life-threatening possibilities; you have great obstacles in getting to where the action is; you must protect yourself once you're there; and finally, you've got to see that the film gets out to the publications. These are all things that are relatively minor problems under normal situations.

FCD: Once you're in the war zone, you must be able to size up the situations, be involved and aware of what's happening, but not over-whelmed. You must be able to communicate with the people you're photographing, and not necessarily verbally, because often you don't speak the same language. You must find ways to convey that you are not unsympathetic. You must be able to get in there and get the shots without being obnoxious or too aggressive. You must protect yourself although you can't keep out of danger.

These photographers are paid well, and they get the assignments not only because they're good photographers, but also because they can handle all these other aspects.

FCD: Photographers must get involved, must have some feeling for the story beforehand, and yet maintain objectivity. For instance, it was a tricky situation in Nicaragua. There was no doubt that Samoza was so bad, but that did not make the Sandinistas angels. One must be careful not to go overboard.

You must know the depth of the situation rather than just the surface. There's a very fine line between understanding and being involved. When you're working for a news magazine or a paper, you can photograph something that is strong, that is proving a point, but you still have to say, "This is real; this is how it is," even if it is going to upset somebody in Washington or Tel Aviv, or anywhere.

One of my photographs, published by *Newsweek*, showed a large American-made canister with unexploded cluster bombs. Now this became a hot issue in the States because Begin had denied using them (he said, "We only use them on military targets"). And right after that Reagan said that he stopped sending them. It was near the airport, and I photographed it. It was a very boring shot. I had just been doing a story, and the cluster bombs were part of the story. It's just a documentation of a fact, which is what you have to do. It may not be as dramatic a photograph as a soldier throwing a grenade, but you're there to report facts, not just looking for interesting photographs. You photograph people carrying water because the water supply has been broken, and that is what people do in those situations. They are people just trying to stay alive.

During the invasion, getting film out became a big problem. After the second day of the invasion of Beirut, the airport was closed. We had to get the film to the office manager in the *Newsweek* Beirut office. We were worried about it, but it was his job then to get the film out. He got it to Syria by taxi, and then it was flown out of the Damascus airport. They were paying taxis five and six hundred dollars a day. It was really a rough time. They were also sending it to Cyprus by boat.

Getting film out was also a problem in Nicaragua in 1979, because the airport was closed there too. Once in a while a small plane would come in to take out a rich supporter of Samoza, and we'd get the film out that way. Once, five of us were sitting on a plane's wing, (some from *Time*, and some from *Newsweek*) and the

pilot was freaking out. But we communicated to him to take the film to the airport in Costa Rica, and that someone would be there to pick it up. He took it. That's part of the job, too, to see that the film gets back to New York. You must have good connections and use your ingenuity.

LM: *How do you caption your material?*

FCD: I try to caption it as best as possible. If it's black-and-white, and transmitted by wire, I write the captions underneath the photographs. In Beirut, I would process my own black-and-white film in U.P.I.'s darkroom. They were backed up with their own film, and I brought my own chemicals with me from New York because I don't like the chemicals they use. (I've also developed film in a hotel closet, for the king's [Jordan] wedding.) Usually, the U.P.I. photographer would make the prints, but sometimes I would print if he was too busy. In the case of color film, we attach the captions to the cassettes.

Time Changes

○ Now in Beirut, which is east of New York, you have really good time to play with. It's seven P.M. in Beirut, and it's only one in the afternoon in New York. In Nicaragua, it was just the opposite. A lot of things happened about four or five P.M., and it was five or six P.M. in New York, and so we were way behind.

This time in Beirut, the *Newsweek* and the U.P.I. offices were hit by an Israeli shell. After that I was no longer shooting black-and-white, as it couldn't be transmitted. Then I was just shooting color. I like Kodachrome. On Saturdays and Sundays I would try to use Kodachrome because it would still get to New York in time. After Monday, which is early in the week, I had to use Ektachrome, because by the time it left Beirut, it was three days later before it even got to New York. (Kodachrome takes one day to process, and Ektachrome takes only three hours.) They like to have all their stuff in by Thursday or Friday. You had to keep thinking of things like that.

I carried three camera bodies, two loaded with color and one with black-and-white. You can transmit color, but it's very expensive, and the magazines tend to shy away from it. But it was done recently in Beirut. They processed the color there, and it was transmitted, because it happened on a Saturday, and it hit the magazine, whose deadline is Saturday. It didn't make the whole run, but it got into a good part of the run. It was a photograph of the first Palestinians leaving Lebanon by boat.

So you see, there's a lot of different aspects to working abroad, depending on the country and the situation. Feature stories are a whole different matter; you don't have the problems of transmitting and shipping film for immediate publication. There is usually a good long time lapse between the time the photographing is finished and the story is published. It can be from several months to a couple of years.

[See Chris Johns, preceding section. He shot a forest fire fighting story in 1980, and it was published in the *National Geographic* September 1982 issue.]

However, when you work on a feature, you have to stay away from a hot-news situation, because so many changes can occur. This happened to a photographer-writer team who did a feature in Beirut in April 1982—the whole story got killed as a result of the invasion in June.

LM: *How do you function under that kind of pressure?*
FCD: I would get tired. This time, I really got tired. Sometimes the pressure is in spurts, but this time it was really consistent, and the weather was very hot, too. I was in Beirut for a period of ten weeks, from the second day of the invasion until the day after the last attack on Beirut.

Problems of Getting into Lebanon

○ On this trip, during the invasion, our plane was coming in on Monday to land at the Beirut airport. You could see smoke rising out of the southern part of the airport, and we could see the city, and all the tracer bullets. We circled around, and there were Israeli jets in the air; and our plane was the first plane that wasn't allowed to land. Just as we were descending, on June 7, 1982, the airport closed, and we went back to Cyprus. There they kept us in the plane from four-thirty in the afternoon until nine that night, waiting for a slowdown in fighting. From minute to minute, no one knew what was happening. By nine the next morning, the airport was still closed.

We were the first plane to be turned away from Beirut, and within two hours there were five more planes that had been unable to land in Beirut, and they came into Cyprus. There were photographers on the other planes, too. We all went to a hotel, and the next day, the airline officials said they would send us on a plane to Damascus, and then we could take a taxi from Damascus into Lebanon. Under normal circumstances this is a four-hour trip.

All the press people, the reporters and photographers, were ready to get on the plane. They were from Europe as well as the U.S. We got our passports stamped that we were leaving Cyprus, and went into the waiting room. Then a telex arrived from Damascus saying that they would only accept Syrian and Lebanese nationals. So that left all of us journalists out of it.

We had to go back to immigration to have the stamp removed that allowed us to leave the country, and be stamped back into Cyprus. Just as we were getting into a taxi to see if we could rent a ship, an airlines official came running out. He had this book, some kind of international regulations book, saying that journalists could be allowed out, and he said, "So, we're going to put you on the plane anyway, not guaranteeing what the Syrian officials will do."

We felt, what the heck, we would go anyway. Syria was closer to Beirut than Cyprus. So, we had to have our passports stamped again. While all this is going on, the Lebanese and Syrian nationals are in the plane waiting, and it was hot as anything. Finally we went on, and we reached Damascus at five P.M. that night.

About five of the journalists were based in Beirut, and they had residency cards for Lebanon, so the Syrians gave them automatic visas. The rest of us contacted our connections in Damascus, who in turn got in touch with the Syrian press-relations center, explaining our credentials to them, requesting them please to give us transit visas so we could get to Lebanon.

After five hours of sitting in the airport, a list came out of those getting transit visas, and I was on it. By this time it's ten P.M. We found a taxi driver who would take us only to the Bekaa Valley, where we found a hotel. When we awoke the next morning, we could hear the fighting up in the mountains. The BBC said that the Israelis had reached the Damascus-to-Beirut road, and it was closed. But we found a Lebanese cabdriver who said that he'd take us to Beirut. He had an old Mercedes, and six of us piled in with all our equipment and our luggage, and off we went.

As we climbed up the mountain and reached the ridge, there were shells breaking all over. We said, "*Woa*" (meaning stop). But the taxi-driver said, "I can make it, I can make it." "Are you crazy?" we asked. We took a vote, and said, "Okay, let's go."

For about a mile and a half, shells were firing, but we got by another ridge, where we were basically safe, and it was all right until we got to West Beirut.

At one of the entrances to Beirut, you go through the camps,

and that's when we realized that the jets were bombing the camps and that there was antiaircraft fire. You go from the Christian side of East Beirut, into the Moslem side, and we went up into the main center at eight in the morning.

It is in situations like this that you find out that a taxi driver, a good one, is as important as a good photographer or a good reporter. They risk their lives. One was killed seconds after a film crew got out of his cab. Several taxi drivers were wounded. A good taxi driver knows where to go. He also has to want to be with you, and has to speak English. Many of them would only want the money, and then would only cross the street. There were a lot of those. Near the end, the good ones were risking their lives every day.

You could cross East Beirut without too much trouble. Many times we would give the film to cabdrivers, and they would come back and say that all exits were closed, but that they would wait a couple of hours and try it later that night. There were basically three exits out of West Beirut, which would be closed down at night. The drivers would try one, and if it was closed, they'd try another. But they'd try to get through the Israeli lines with the film, and it was very dangerous. The photographers would not try to cross the lines.

Another problem in working in this kind of a situation is to create a rapport with the people you're going out on the front lines with, without losing your integrity, without being too partisan. If they think you're working for the Israelis or for the other side, it's bad. They might even think you're a spy. There was a foreign woman photographer who was accused of that, and she had a very bad time of it. She was asked to leave and had to get out of West Beirut. A photographer is not looked upon at all like the International Red Cross. A lot of times you had to establish a trust.

In Nicaragua you could work both sides. In this situation, the fellows who were photographing the Israelis worked out of their Tel Aviv bureaus, or were with the army. If they or we had guides, they were not necessarily army guides.

I worked out of the *Newsweek* Beirut office. I was listed with the Palestinian Press Information Center. I'm also listed with the Christian Lebanese. I'm okayed by all groups in Lebanon: the Palestinians, the Christians, and the Lebanese—all except the Israelis.

To a lesser degree, it also goes on in Latin America and in Belfast. I was in Belfast after Lord Montbatten was killed. The first day, I was out in the country, and there was some sort of English martial law. I went down to Newri, and I had my cameras taken from

me by these British troops who said I didn't have clearance. I had
to go back to Belfast to get clearance from the British Army people
who handled the press. They gave me a whole packet, and kept
saying, "Stay out of the Catholic area because you'll get kneecapped."
There was a little intimidation, because my name is Irish, though they
realized I was an American. That's another aspect you may have to
deal with.

Of course, I'm nagged by the question of how much showing pic-
tures of war will do to eliminate it. Do photographs and films that
show the horror of war ever change anything? Like the Vietnamese
right now; they were subjected to horror, and now they're in Cam-
bodia, doing there what was done to them.

LM: *To whom do you sell, and what are your arrangements?*

FCD: After being in Beirut twice in the spring, I talked to *Newsweek*,
and my arrangement with them is this: I work on a per diem fee,
whether or not any of my photographs are published. If *Newsweek*,
or any other publication (and it's usually the same arrangements),
sends me out of the country, they have first rights to all my film. I
primarily shoot color, and some black-and-white for magazines. I shoot
black-and-white with the idea of selling to a newspaper, and that's
on a per photograph basis. My exposed color film is shipped undevel-
oped by plane to New York. I send everything to *Newsweek*, and they
take what they want; when I'm away, my agency takes it and sells it
as stock. That's how I operate with my foreign assignments. When
you talk about transmitting on foreign assignments, the lines in Beirut
were so bad. The guy in the bureau might spend from two in the
afternoon until nine at night to maybe get two photographs out. The
lines were constantly breaking down, or he couldn't get a line out, and
he'd have all kinds of arrangements with Cyprus, because there was a
Cyprus telephone operator.

LM: *Haven't you found that most people in this business are really
good people?*

FCD: Yes, they really are. Like in Beirut, we helped one another
even though we were competitors. There was a camaraderie; you're
in a bad situation and you have to help each other out. You're up
against people—even children—carrying guns. I know when people
carry guns, their whole system changes, their attitudes change, and
they're very dangerous.

In my work there's a lot of hassle when you carry a camera.
You are a point of antagonism; you are constantly stopped. I can't
be discreet. I carry three bodies, five lenses, and I have found that

it's best to be up-front. You must realize the situation you're in and sometimes not raise the camera. That's all. We talked about it this time in Beirut. This was a tough war. You're an American, which makes you suspect immediately, and you're not going in with the American army as in Vietnam. The situation was very touchy. They know that you're a nationality that supports Israel more than it supports Palestinians.

We had to go into Fakhani, which was in the Palestinian area, to their foreign press information center, which is where we got accredited. It is a way of keeping in touch. You had to go back every two days, then every four days, give them I.D. photos. You got a sheet of paper, and people would ask for it, or they asked for a passport, which had a stamp on it. They were afraid of Israeli infiltrators.

Fakhani is an area of Beirut with multiple-story buildings, as opposed to the camps, which consisted of one-story and two-story shacks. This was a prime area for the Israeli jets to bomb. I spent many an afternoon just hoping that Arafat would come by. In the beginning, he would come by with some consistency, just to get photographed by the Western press. So the networks staked this area out, as the news media were really hot for color photographs of Arafat. Two of my photographs that *Newsweek* published were of Arafat.

But often there was heavy shelling, and then Arafat would never come, so there would be many a time when we just sat in cellars. I think the scariest thing was the jets. A shell can hit a building, and you can be in it, and you stand a chance of surviving. (Shells are fired by tanks, boats, or artillery.) But the bombs from the jets could hit a nine-story building, and it would just not be there anymore. So, if you were in a cellar, you'd be caught down there, and no one would come to rescue you, because the fighting in that area was so intense that the rescue workers would have to wait until it let up or until there was a cease-fire.

LM: *So you could have been killed in the cellars?*

FCD: Yes, and I'm sure a lot of people *were* killed, and their bodies have not been found yet. You have five seconds to get under cover. Most of the people had moved out of the camps, which offered very little protection.

There were many of us. U.P.I. had a network of stringers. W.A.F.A., the Palestinian news agency, had their own photographers around Arafat, and would give photos to the wire services. But they didn't shoot color, and the magazines were hot for color. So we had

to go there. No information was ever given about when he'd come, because if they did, a jet would be right there at the same time.

I was there waiting more often than I photographed him. Sometimes there was no shelling, and sometimes I got caught real bad. I also spent time going to high-rise buildings, just trying to get a general view of the city.

[For the first few weeks of the invasion, the Western press out of Israel went back and forth every day from Tel Aviv to Beirut, with their own escorts. It's about a three-hour trip each way. After the first couple of weeks, they stayed in Beirut, but kept their escorts.]

Sometimes, we in West Beirut were escorted. They'd sort of say, "If you want to be with us, that's okay." And if you found a group of fighters that didn't mind you, and trusted you, you went off with them to the front.

I came back from Beirut completely exhausted, and I sat on my bum for two weeks.

How Frank C. Dougherty Became a Photographer

○ Dougherty studied political science in college, and then worked for a social studies research institute. He found that very boring, and skipped around to all kinds of jobs. In 1970, his mother was going on a trip around the world, and was advised to buy a Nikon to take on the trip. When she returned, a friend of Frank's who was teaching photography at Douglass College, in New Jersey, showed him how to develop the negatives and to print.

The pivot point upon which a person's life turns can be unpredictable and often amazing. Dougherty's progress in the field of photojournalism is also amazing.

FCD: At that time, I met a couple of documentary filmmakers, and I found what they were doing to be very interesting, and began to take some courses at NYU in filmmaking. I realized that I could not afford to get into filmmaking, and began to take photography courses at NYU and at the School of Visual Arts. I also studied with my friend at Douglass College.

Although he taught photography, he was an artist; he was interested in photography as art, not in photojournalism. If students in the class were looking at pictures in magazines, he would say, "Well, anyone can do that," which isn't really true. A photojournalist has to size up a situation immediately, and must forget himself. It isn't easy, and it takes a special talent. I could never be a studio photographer.

Since I was very much interested in documentary films, I joined the Museum of Modern Art and attended the film showings often. I took

classes with Arthur Rothstein, the FSA photographer, and I like that type of photography.

[FSA stands for Farm Security Administration, an agency of the Department of Agriculture. In the 1930s it was mandated to photograph the effects of the Depression. The FSA photographers became very well known, and their work is lauded to this day: Russell Lee, Walker Evans, Arthur Rothstein, Dorothea Lange, Gordon Parks, and others were in that group. There are many books of their work, which bear studying.]

I was influenced by the quality of their work. My cousin lived on a farm in South Jersey, and there's a whole group of farm workers in that area who've been there for generations—a kind of Appalachia in South Jersey. They even have a rodeo. I did a lot of photographing of these people and all the things they did.

I made a portfolio of these photographs and took it to *The New York Times.* At this time I had done very little photojournalism. You couldn't call this work photojournalism; a better description would be documentary photography. I also took the portfolio to the A.P. The picture editor pointed out, "It's beautiful work, but it's not journalism. Oh, very strong photographs, and I can see that you're a photographer, but it's not photojournalism. This is photojournalism," whereupon he pulled out a photograph of Richard Nixon slipping, losing his balance. "People are interested in seeing this." I thought, That's not a nice picture, but I realized he had a point.

What did I do? I was a member of the volunteer fire department, and I began to take pictures of the fires and sell them to a local paper. I took a picture of a utility pole that had been knocked down by a truck. The local paper gave me a quarter of a page for that photo. I photographed an accident on the highway and sold that to the paper.

[It's interesting to note here that Dougherty's experience at the A.P. triggered him into going out and doing what they were looking for.]

LM: *How did you know to take work around to* The New York Times *and the A.P.?*
FCD: A friend of mine who worked at a magazine, the *Medical News Journal,* told me to do it. So, I went to *The New York Times* with six photographs that had been published, and it was circumstances that helped me get off the ground. In the early seventies, the Newark *News* closed; that same year, *The New York Times* decided to start a suburban section to fill the gap, and they had a page to fill every day.

The picture editor I saw at the *Times* said, "We might be needing people out there. Let me send you to see the assignment editor, and you can make arrangements with him." I went to see the assignment editor, and it was a personality thing, we just hit it off, and he gave me an assignment that week. It was to photograph some military men who were given a hearing down in Fort Monmouth. It did not make the paper, and I got real depressed, but the editor told me that it was pulled at the last minute because there was a murder somewhere in New Jersey.

Photographers do have egos, and being published is what we're after. That's one of the things that you have to cope with, especially when you're photographing overseas and in a situation like in West Beirut: You hardly ever saw anything you did that was getting published. You don't see it until you come home, and it's all piled up.

The next thing I did was at a little town down near my cousin's farm, where they were giving a hero's welcome to one of the POWs returning from Vietnam. He was on the cover of *Time* magazine. I called *The New York Times*, and they said, "We'll pay your expenses; we're not sure we'll use it, but just go." I shot like mad, and it got published.

Then over the years it built up. In the beginning, it was very slow getting assignments from the newspaper and the wire service. I answered two ads in the Help Wanted column—one to take pictures of children in a department store, which I wasn't suited to because a lot of selling was involved, and I'm not a good salesman. The other ad was to take pictures for a school yearbook company, and I got that job.

I didn't do the portraits, I just did the candids of the students' activities. I went into the high schools and had to lay low. It was great preparation for what I'm doing now—to put yourself into a situation and to be as unobtrusive as possible. It was all shooting by available light, and only black-and-white. Some of the jobs meant going into schools in rough neighborhoods, where some of the kids would give you a hard time, and you had to humor them. It was good preparation because since then, people have been putting rifles in my stomach, and you learn to talk yourself out of situations like that.

For example, this past time, I was with three other photographers near the Beirut airport. Shells were falling too close, and no good photographs could be taken because everyone was seeking shelter— there were just empty streets. We decided to try to get out of there, when we were stopped by this crazy guy who'd been up for two days fighting. He grabbed us, wanting to know what we were doing there.

We knew what he was saying, even though he spoke Arabic. There we were: him with a gun and out of control, shells landing across the road, and we had to deal with this guy before he'd let us get into a taxi. Although the high school was never that bad, the experiences there did contribute.

Basically, I'm interested in politics and people, and that's what I'm doing in photography. I find that sometimes photography in bad situations can be offensive, but I rationalize by thinking that perhaps by photographing a woman who's been burned hideously, it'll put an end to all this horror—although it usually doesn't. You have to think about these things, though they're very perplexing. There was this mother whose one-week-old twins were killed, and she had also lost a three-year-old. They took me to the morgue, and the corpses were just on the floor, and you're in there photographing, and you almost apologize for being there.

At the same time that Dougherty was working for the yearbook company, which had peak periods and slow periods, he was bringing work into *The New York Times,* and the assignments kept building up, until he dropped the yearbook job. He also started doing work for the U.P.I.; at one time, he even had a transmitter that U.P.I. had lent him, in his apartment.

FCD: I could go to the football games at Rutgers University, which was near where I lived, develop the film, print a couple of photographs, and transmit them with the captions into the U.P.I. center.

It was a small transmitter that you hook up to your phone. It was their idea. It made sense because before that I would have to go to Newark and transmit through the U.P.I. bureau there, or drive into New York City, and you could get stuck in the Lincoln Tunnel for quite a while. With the transmitter, I could go back to my apartment and transmit.

[Keep in mind that Frank Dougherty was first published in 1973, and here he's talking about 1975. That's moving up very quickly in this business.]

FCD: The way I transmitted was, I would call *The New York Times* or U.P.I. collect, and they'd call me back. It takes about twenty minutes to transmit one photograph. Sometimes there would be a break, or the

connection wouldn't be good, and there'd be a line through the print, and you'd have to start over again.

LM: *Whom do you sell to?*

FCD: I've done a lot of work for *The New York Times*. They had a page to fill every day for the Jersey edition, plus they needed material for the Sunday section. They were phoning me. I started doing work for them in 1973.

LM: *Why were they calling you?*

FCD: I did good work, and I was always reliable. On my assignments here, I get calls from *The New York Times, Newsweek*, the Philadelphia *Inquirer, Business Week*, and other publications. My specialty is New York and Northern New Jersey, where I live. I'll photograph someone who's running for a political office. I also did a story recently about a new gadget that you tie yourself up in, and if your hotel is on fire, you can throw yourself out the window and it unwinds; it's a wire. The police stopped traffic for a couple of minutes on Madison Avenue so a fellow could demonstrate it.

With most of my newspaper assignments, I let them keep the photographs in their files, and I get a small fee if they use them later or if they sell to an affiliate. I do very few self-initiated assignments.

Some clients do all the developing (*Newsweek*, for example). Some clients let me go into the darkroom and develop my film. I don't like the Kodak Versamat, which many places use for developing. It's a five-minute process, and I find that it has a tendency to scratch the film. If I have the time, I prefer to do my own developing, but the lab technicians make the prints. Those are union regulations. Then I write the captions. The contact sheets with the captions go to my agency. I even carry negative developer (D76) with me on overseas assignments and do the film myself, if I possibly can.

LM: *What got you into traveling?*

FCD: In the summer of 1975, I decided that I wanted to photograph outside of New York and New Jersey. Except for going to Canada and Mexico, I had never left the country. I seemed to be always taking my friends to airports. So, in 1975, I went to Egypt. I had been working on a free-lance basis quite a bit, and had saved some money. I had some contacts in Egypt, and decided to take off for the reopening of the Suez Canal.

I had no assignments, and paid my own way. *The New York Times* put me in touch with their bureau over there. A U.P.I. person in Cairo really helped me out. She said, "We have a photographer

coming in from Paris, but the reopening of the Canal is going to be a big thing, and we'll get you accredited as a U.P.I. photographer," which gave me access. I was quite happy; I made a front page of the *International Herald Tribune*.

In 1975, U.P.I. made use of *Al Aram*, which is the big Cairo newspaper, and not only did I sell photographs to U.P.I., but I sold quite a few to *Al Aram*. The reopening of the Suez Canal was quite interesting. It was a two-day event, and you had to make arrangements for helicoptering.

The government arranged drop-offs for your film, and it was flown back to the Cairo airport, where U.P.I. picked it up. They wanted color, which I was shooting, and they were sending the film out to Brussels for processing.

After the two days of the event were over, I wanted to go to Luxor to see the temples, which were being moved because of the Aswan Dam.

The U.P.I. editor said, "I'll give you a letter, and you can go down." So I took a ship down the Nile and joined a film crew. This is June now, and it's 130 degrees Fahrenheit. But it was interesting, and I met some very interesting people from U.P.I. I.T.N. [International Television Network], a London-based operation. That was my first foreign assignment.

From then on, Dougherty was doing assignments abroad frequently. During the first eight months of 1982 he made three trips to Lebanon, and was abroad for a total of five months. In 1981 he spent four months in Lebanon. In 1980 he did not go abroad. In 1979 he was in Ireland and Nicaragua for a total of four months. In 1978 he was out of the U.S. for eight months: in Lebanon, Iran (just before the revolution) and Jordan, where he covered the king's wedding.

As Dougherty said, very few of his assignments are self-initiated, and he usually goes abroad on assignment. However, in 1978 he went over on his own, worked on a shoestring, based himself in Beirut, and got assignments while he was there. Luckily, he met someone with a nice apartment that was too close to the green line, the area where the shooting was going on, and he moved out, offering to let Dougherty stay in it.

FCD: I was basically walking out the front door into the fighting, and fortunately the apartment house never got hit. I stayed quite a few months and then went to Syria. Then to Iran, and although the shah was still in power, the revolution was starting. But I would return to

Beirut periodically. It was my base of operations. I had gone to Leban-
on in 1975, and was there for the beginning of the civil war. Israelis
invaded in March of 1978. And I went to Beirut in 1978, to be in a
place where things were happening and to get work. There was heavy
fighting in July and August between the Syrians and the Christians in
Beirut. During the slow period, I was a sound person for a TV crew,
and I got a couple of weeks' work out of that.

Advice to Aspiring Photographers

○ I recommend that photographers who want to do this kind of work,
who want to travel, should definitely learn a second language. In
Lebanon, French is generally the second language, and the reporters
and photographers from the U.S. stationed there speak it. In Egypt,
it wasn't so bad; English is usually the second language. Spanish
is important too due to the news interest in the Spanish-speaking
countries of the Western Hemisphere.

There are so many things in my field of photojournalism—especially
what I've been doing lately—that more and more often require the
ability to get along with people, and *patience*. Patience is a big thing.
You find yourself in so many situations where people don't want what-
ever they are doing to be photographed. And you just have to gain
their confidence without being aggressive. Maybe just talk about it, and
before you know it, they're asking you to photograph them. This in-
cludes everyone from fighters to women who are in a bad situation.

When the camps got hit, they put a lot of people in a park, just living
in what used to be an open park. I felt really that we were intruding
on these people, they had no privacy at all, and I could understand
because I'm a very private person. I was with a PLO escort, and
I didn't like the way they were handling it. They were saying, "you've
got to be photographed." If somebody didn't want to, it was like they
were being ordered to. Luckily, I stayed longer, and soon they forgot
they had been told they had to be photographed. They got along
with me.

Another interesting side thing, especially with children, is to carry
a Polaroid along so that you give them something right away. I was
so weighed down that I didn't use it much on this trip. But it works
with soldiers, too. It works with just about everyone. They see their
own photograph, it's a present, and they enjoy it. And before you
know it, I could use my regular camera.

LM: *It shows that you respect them, that you're aware of their feelings.*

FCD: I think that may come through somewhere. There are so many factors, from being able to operate really fast, to having patience, to winning over those you're photographing. These people are touchy, they would say to me, "*Ameriki?*" I never denied I was an American. They saw us as the enemy at times, and certain people were more anti-American than they were anti-Israeli.

Their argument was, "America is doing this to us, not the Israelis. America is letting this happen to us. America could stop it." Many times, you couldn't even photograph because you were discussing things with people. There were many situations where I went out by myself or with a reporter, and without an escort, and we found ourselves defending ourselves, or just discussing the situation and why we were there. Hassling was prevalent, especially with the young kids; older men were more understanding. It was the younger men and the kids you had to deal with.

After a while, near the end, when the siege really got heavy, the Palestinians themselves put out a memorandum that the foreign press should be left alone, that they're here, they're risking their lives trying to do their jobs, and stop hassling them.

And that's what covering a "hot news" situation is all about—just doing a job, getting the photographs, and at the same time balancing all the added problems in very difficult circumstances.

Advertising Photography

○ The big money-making field in photography is advertising photography. It is difficult, complex, and demanding. However, if you have the myriad abilities required for this work, and become successful at it, the financial rewards are great.

Besides being an expert at all the technical elements of the photographic medium, besides having the ability to compose an effective, beautiful photograph that interprets specific directions, you must also handle people well, you must have sound administrative ability and business acumen, and you must always zero in on what the client expects and deliver a photograph that fulfills his or her needs.

The dynamics of the advertising complex lie in the fact that the manufacturer of a product or the provider of a service has to attract and inform the public about their product or service. The advertising agency organizes the project and creates the vehicle for the client, and the major component is the photograph. The advertising agency chooses the photographer to carry out the predetermined visuals, which will reach the public via the printed page, billboard, mailing piece, package, sales counter display, pamphlet, and/or brochures. Agency people like to work with photographers who absorb and understand their ideas.

Advertising photography encompasses a wide variety of photographic techniques, from large cameras to 35mm's, from still lifes to fashions, food,

products, action, sports, portraits, and even scientific photography. Some advertising photographers specialize; others do it all.

There are many ways to enter this field. One of the photographers in this chapter was first an assistant; the other two, a wife-husband team, had been models who spent many years working in advertising photography studios watching other photographers. They became totally acquainted with the business and entered the field successfully.

This chapter will give you a broad and detailed summary of the many aspects of this field. You will hear from: 1.) a top photographer with many years of experience; 2.) an outstanding rep (short for representative), the person who takes the photographer's portfolio to show at the ad agencies; 3.) the wife-husband team, formerly models; 4.) a manufacturer's executive in charge of advertising; and 5.) several models. You will then see examples of various business forms.

You will also learn how advertising photographers reach out to a whole network of services and sources to effectively implement their assignments: model agencies; good repair services; color labs; set and model builders; stylists; painters of backdrops; available locations (both interior and exterior); rental services for furniture, props, and clothing; and food stylists.

The advertising photographer must always be aware that he or she is being paid well to create a photograph whose primary purpose is to sell a product or a service.

Harold Krieger: Advertising Photographer

○ Harold Krieger is a top advertising photographer. He handles all kinds of assignments and projects, from complicated big-set studio photographs using many models, to location shots, to seemingly simple photographs. He shoots for the airlines and for automobile manufacturers; he does photographs of liquor, cigarettes, cosmetics, home furnishings, fashion, appliances, food products—anything that appears in advertisements, especially national ads.

You have seen his photographs everywhere—in magazines and newspapers, on billboards, placards, and packaging, in point-of-sale displays.

When asked to sum up the essence of advertising photography, he replied, "Clarity—with one photograph, one headline, and a minimum of copy, a message must be conveyed instantaneously."

After several years of working in other studios, he opened his own studio in the early fifties. He says, "And even then I didn't hit my stride until ten years later."

He has received well over one hundred awards from such prestigious societies as: the Advertising Club of New York (the ANDY Award), the Art

Directors Club, and the American Institute of Graphic Arts (AIGA).

He is highly talented, he is knowledgeable about all the technical aspects of photography, and also has the capability of running a big studio with hundreds of thousands of dollars invested in equipment. He employs a staff that is augmented by many free-lancers, depending on the requirements of a particular job he may be working on. His phone bill runs over a thousand dollars a month. The budgets for some of the photographs he shoots can run to over five figures. Advertising agencies use him with confidence, as he has proven himself time and time again.

His darkroom handles all the black-and-white processing and printing, but the color is sent out to a custom lab, and his monthly bills from them can run over one thousand dollars. All this should give you some idea of the size of his operation.

He has a rep, who has been with him for almost twenty years, who is out constantly showing his portfolios to ad agency art directors. These portfolios are updated regularly and are handsome presentations of his work. His rep's yearly income is in the high five figures, based on 25 percent of the photo fees of the Harold Krieger Studios.

In other words, Harold Krieger, like other top advertising photographers, runs a business based on his talent, his great knowledge of photography, and his administrative ability. Krieger points out that there is an ebb and flow of busy periods interspersed with slow periods, and the work is done in 150 to 175 days of the year.

Now let us take a look at his studio. Overall, it is 100 feet by 32 feet. The shooting area is 45 by 32 feet, with a 25-foot-high ceiling. The rest of the area is comprised of a reception room, office, storage and utility rooms, dressing rooms, kitchen, and darkroom. There is also a garage, as well as a huge basement for storage, other offices, and editing rooms.

Cars can be driven right into the studio from an opening on the street. This facilitates the moving in and out of large sets and all kinds of furniture and props needed for the assignments.

His camera room is like a small store, containing all kinds of professional cameras in all sizes: 35mm's, 2 ¼ ", 4 " x 5 ", and 8 " x 10 " large-format cameras, with a tremendous variety of lenses. "Although most jobs require normal equipment," he says, "When there is a need for something special in equipment, if I don't have it, I get it." The equipment is taken frequently to the repair shop for checking, as it must always be in top-notch condition.

In the studio are rows and rows of background paper, several strobe lights on stands, and a large bank of strobes and incandescent lights enclosed in a box that is set on a stand. After every shooting, the lights are always moved off of the set, wires are disconnected, wound up, and hung on the light stands. The lighting equipment is stacked against the wall, the studio is cleaned up, swept, and ready for the next job.

There is also an overhead light box which Harold Krieger designed, be-

cause, as he says, ''I hate having wires on the floor.'' It is an 8′ x 8′ x 3′ box, with one side a panel of frosted plastic. The light box is filled with strobe and incandescent lights, and is suspended on a horizontal set of tracks the width of the studio. These tracks are attached to a vertical set of tracks running the whole length of the ceiling, so that the box can be moved in any direction. There is also a pulley system that enables the box to be lowered, raised, tilted, and rotated. It is motor-driven, and can be moved into any position and angle all over the studio.

The staff consists of two people in the front office, a producer and a bookkeeper. In the studio, Krieger works with a first assistant and a second assistant, both of whom do the darkroom work. According to the demands of a particular job, an auxiliary staff of free-lancers will be taken on—more assistants, grips, stylists, hairdressers, beauticians, food economists, carpenters, electricians.

HK: We do use a lot of free-lance people, because it would become too unwieldy to have all the people on staff that we need at times for various jobs. The producer organizes the jobs, does casting, hires stylists and location hunters, does estimates, gets everything together to see that the job works, but also consults me and knows the people I like to work with.

To give you a concept of the great number of details that comprise a big-set shooting for an advertisement, let's go in and observe the step-by-step shooting of a cosmetics ad, which will run in national publications, brochures, and mailing pieces. Some he photographs for package design and for point-of-sale displays. This account is given to show you how an advertising photographer proceeds and interprets a client's need for an advertisement. It's quite complicated, and the photographer must be able to do everything quickly and be right on the mark.

The layout for this ad shows an expensively dressed, poised woman in an elegant room, with a garden outside the window. Various cosmetics are on a marble-topped table. Although the products are small, the copy will tell us about them.

The concept for this image has come about in the following manner, as do most advertising photographs: First, the client, the manufacturer of the product, and the advertising agency decide on the general look they want in the photograph. It could have gone in several directions—an outdoor shot, a close-up of a beautiful model, or perhaps just a still life of the products.

The art director at the ad agency works on some sketches and the copywriter works on the message; they develop several possible versions, which they discuss with the people in charge of advertising for the manufacturer.

When they all agree on a visual and the copy, it is done up as a sketch, called a layout, which is what the photographer follows.

If a location is called for, the photographer would rent a place that matched the look and atmosphere indicated in the layout. This would mean paying a rental fee and moving the lights, the camera, and a whole entourage to the location.

However, in this case the decision has been made to shoot in the studio, and a set will be built; furnishings and props will be rented. A whole corps of free-lance people will be activated—stylists to rent the clothes, jewelry, furnishings, and props. There are many rental places in New York and other centers to provide these services to photographers, theater people, and TV or film makers.

A carpenter who is an experienced set builder works on making the set, which in this case consists of two walls, wallpapered, with a window and a doorway.

On hand for the shooting are the photographer, his assistant, his rep, the carpenter, a stylist, the hairdresser, the art director from the ad agency with his assistant, two people from the client, and the model.

For an important ad like this the choice of the model is done very carefully. Models have copies made of a good portrait, called a head shot, with measurements on the back. The model agencies send these to photographers and ad agencies by the hundreds. Advertising photographers keep these filed according to types: juniors, children, older people, high fashion, etc. In this case, the file entitled "Women, high fashion" is taken out. The art director and the photographer go through the file. They are looking for a model with dark shoulder-length hair. They probably have a certain model in mind. Often top models are heavily booked and may not be available on the day planned for the shooting, and the shooting date may even be rescheduled around the model's availability.

The stylist does not make final decisions, but after the search makes notes, sketches, or takes Polaroids of the clothes and props, and the final choices are made by the photographer.

For this shooting, the photographer chooses an ornate marble-topped table, a tall Chinese vase to stand in the corner of the room, a small vase for the table, and an Oriental rug. Everything must be in the studio for the day of the shooting. Most rentals are for three days to a week, in case a retake has to be done.

The carpenter plans his work so that the two walls with the fan-topped window and door are ready and in position in the studio on time. Since everyone's work has been coordinated (no mean feat), everything is ready on the morning of the shooting. The set is up, the furniture and props have been delivered, and the rented dress and jewelry are in the studio. An advertising photographer, besides being expert in photography, must also be good at this kind of planning and coordination.

The model and the hairdresser arrive two hours ahead of the shooting to get ready. The photographer, his assistant, the ad agency art director, the carpenter, and stylists are busy getting the set ready.

The marble-topped table is placed in position. As the set takes shape, the photographer and his assistant adjust the lights and check constantly through the camera.

The tall vase is placed on the floor; the rug is rolled out and covered with wrapping paper to keep it clean until the shooting. The truck from the florist's arrives with a hanging plant, flowers, and extra greens, which are all arranged by the stylist in the two vases. Several potted trees and bushes are placed outside the window and the glass-paneled door to create the illusion of a garden.

The assistant adjusts the lights outside the door and window to achieve a sense of daylight in the garden, even though little of it will show in the photograph. In this kind of a shooting, nothing is left to chance.

The photographer keeps checking through the camera as things come together. The stylist acts as a stand-in for the model; the carpenter is up on a ladder adjusting the height of the hanging plant.

The photographer and the art director pop into the dressing room every so often to make sure that the model and the hairdresser are getting the look they want. The big overhead light box described earlier is maneuvered and adjusted again and again. The assistant has the film, the light meter, and the filters on a stand next to the tripod. Polaroids are taken, and the photographer and art director check them against the layout. A few minor adjustments are made. Everything is ready for the shooting.

There is a break; lunch is brought in. After lunch, the model is ready to take her place on the set. She comes out of the dressing room. Everything about her appearance is checked; she does look wonderful. She goes over to the table, and the art director places the products on the table.

The photographer takes several Polaroids, and a few small adjustments are made. The camera, a Hasselblad (2¼"-square format), is raised. When the shooting starts, everyone is quiet. It is like a formal dance between the model and the photographer. There is an invisible connection between them. He gives her some directions; she follows them. He tells her how great she looks. A rhythm is set up and there is a quiet excitement on the set.

It should be noted that at no time during the preparation and shooting were any voices raised, no sharp words uttered, never any display of temperament—all the forces and energies were directed to the job at hand. This is another quality that makes for a superb photographer. Harold Krieger shooting sessions are always very upbeat experiences, no matter what the problems.

Commenting on a photography session, Mr. Joe LaRosa, chairman and creative director of the advertising agency Waring & LaRosa, "I had a bad

experience with a photographer once. He was just terrible. I don't like being on a set with a photographer ranting and raving, screaming and yelling at a model. I don't admire people who create tension in a studio to a point where the assistant is trying to hide behind the lights. Some photographers get insecure, they panic, and the tension mounts. If the studio staff is uptight, or there's grumbling or harsh words between them, it affects everyone. I had never worked with that photographer before, and never did again. It was a horrible experience. I got a good picture, but . . . that's not enough."

Nothing like that goes on in Harold Krieger's studio. Everything is serious and concentrated, but pleasant. Despite the relaxed atmosphere, the photographer is controlling a great number of details. While shooting, he directs his assistant to put a filter on the lens, then take it away; he adjusts the lights. He raises the camera, the assistant unloads the films and puts fresh film in; all the while, Krieger keeps directing the model.

Although she cannot move much, the model doesn't just stand there stiffly. She knows just how to project the look, the feeling, the attitude that's needed for this shot. It's remarkable how a good model can transform herself into the person wanted for the photograph, how to keep her face and body animated.

An experienced model has seen so many pictures of herself that she knows exactly how the camera sees her, exactly what facial muscles to move, exactly the right tilt of her head. During this shooting she faces straight front, then slightly sideways. She touches the bottles; she holds one up. The hairdresser, just out of camera range, steps in every so often and fixes her hair.

From time to time the art director looks into the ground glass. He directs the stylist to move some of the products around. More shooting. Then some white flowers are added to the bouquet on the table. In less than an hour, the shooting is finished. Around twenty rolls of 120 color film have been exposed. A messenger from the color lab comes and picks up the film. Although umpteen jobs like this have been shot, nothing is left to chance. A few test rolls will be processed first to determine the correct processing times for a perfect color rendition. The set is left up in case a retake will be required.

Everyone relaxes. The hairdresser gives the photographer and one of the stylists a trim. The model is out of her dress and into her street clothes, signs releases, and then is on her way to her next booking, to play another role, create another image.

Although this was a "beauty" job, a fashion assignment would be handled in a similar manner. The same great care would be taken with the

*Quoted from Elaine Sorel, "Overnight Success" in the January 1982 issue of *Photo District News*, a monthly paper aimed at the professional photographer.

model's appearance, and the strong relationship would exist between the model and the photographer to get the right feeling. There would be the product, the garment, and the appropriate setting, which might be a location or a studio with a set or a plain background.

When the first test rolls come back three hours later, everything is found to be fine. Instructions are given on how to process the balance of the film. The carpenter, the assistant, the photographer, and the stylist begin to take the set apart; they make calls to have the rented props and furnishings picked up and returned.

Now let's look at how Harold Krieger creates a totally different kind of ad, a location shot. This one is for Nabisco, the food-products manufacturer, and this ad will be for their crackers. The layout showed that the photograph had to contain three main elements:

1. The background—a beach scene, people picnicking, sunbathing, playing in the water—in soft focus.

2. The foreground, in the lower right-hand corner, large and sharp—the product, a group of cracker boxes.

3. In the sky (and this is *the problem* element) is an airplane trailing a banner with the message "Did You Remember Nabisco Snack Crackers?"

The third element, the airplane and the words on the banner, had to be in sharp focus, since the words on the banner are the headline of the ad. What does one do? Go out and hire a plane trailing a banner, and direct it to fly in the right place with the banner stretched out so the message is clear, and coordinate all the elements? That would be almost impossible, and too costly. Shoot the plane and banner separately and strip it in? Also chancy and costly.

The job was presented to several photographers. Harold Krieger got the assignment because he came up with a viable solution, one that would stay within the budget. Because of an earlier experience, he knew that a model plane had to be used. He determined the size of the model partly by instinct and partly by experimenting with several toy planes in the studio.

He had the plane and banner built by a model maker. The plane was ten inches long, and the banner was a little over four feet long—five feet overall. The banner was held in position horizontally with chicken wire, appearing to be trailing behind a flying plane.

The plane and the banner were attached by fishing line, which doesn't show up in a photograph, to two tall poles set up on the beach out of sight of the camera. By experimenting ahead of time in the studio, he knew that the poles would have to be set up about eight feet in front of the camera.

The plane and the banner were attached by fishing line, which doesn't show up in a photograph, to two tall poles set up on the beach out of sight of the camera. By experimenting ahead of time in the studio, he knew that the poles would have to be set up about eight feet in front of the camera.

It was winter, so the job had to be shot in Florida. The studio called for head shots from a Florida model agency. Since the models were more or less background, the choices weren't too critical. A Florida stylist was hired to coordinate the clothing and the picnicking props, to get lunch and refreshments, and also—very important—to obtain permits to shoot on the beach and to pay for the county beach-cleaning trucks to pick up debris from the beach.

The shooting took place from two until five P.M., but Krieger and his assistant arrived three hours ahead of time to scout locations, to make sure the beach was cleaned, and to start setting up the tripod and camera, which were never moved. They placed the packages in the foreground; the poles with the plane and the banner were all set up. As Krieger says, "Nothing is left to chance."

When he started shooting, he faced the water. The sun was behind him, giving the scene a warm light and making the message on the banner very clear.

Krieger points out that shooting on location presents special problems. The light is constantly changing, and in the case of this job, he often had to switch the arrangement of the cracker boxes in the foreground. He used a fill-in strobe to brighten them up. He shot with three 35mm cameras, several lenses—normal, and wide angles, and a variety of filters. He bracketed exposures because of the shifting light.

There was also the problem of directing the models. He had two key models pointing to the plane, and made sure that all the models projected the right attitude—a sense of fun and relaxation, having a sun-fun time.

The weather was good. If it hadn't been, he would have had to stay over and wait for good weather. He was also prepared to shoot the plane and banner separately later and have it stripped in, but that wasn't necessary. When he got his results, everything had worked out well. "Luckily, we had the most beautiful day. It looked real; it was fantastic," he said.

A prime coup for an advertising photographer is to get the campaign to introduce a new product. This campaign is crucial, as a distinctive image for the product has to be established from the very beginning. The concept for an ad campaign originates with the client, the advertising agency, the art director, and the copy writer. A concept for a new product only emerges as a result of a lot of experimentation. It is all very carefully thought out, and the preparation can take from six months to a year before the ads appear.

Krieger was given the campaign for the introduction of a new product, Barclay cigarettes. He worked on this with the agency and the client. He did a number of different tests to help them evolve what was to be the final image. Kreiger says, "I only play the piano. I don't make the decisions; I only do what I'm told, and bring to the effort my photographic know-how and taste."

The ad is a close-up of an urbane, sophisticated man, and the indication

of a woman—just her hand or her shoulder, but attracting an intent interest from the man.

It has turned out to be a successful campaign. Most of the shots are done in the studio, and although the backgrounds are just barely perceptible, they are worked on carefully. Krieger pointed out that a three-dimensional set is always built. Some of the shots are done on location for various reasons.

HK: Sometimes the atmosphere, the authenticity cannot be duplicated in the studio, and a real location at times is more effective than a set with props. This is true when certain physical properties are too difficult to duplicate in the studio, such as a real fireplace with a fire in it, or a special kind of architectural detail—a brick wall, for example. To cement the pictorial identity of the series, the same model and similar lighting are used for all the ads.

In some of the location shots, the light may come from three different sources: strobe, which Krieger brings in; incandescent light from a lamp that is part of the location; or the light from a fireplace. A glow from these light sources coming into the photograph can enhance it.

HK: Always keep in mind that working on location requires lots of time and thought, and you are dependent on the elements. If someone asks you to photograph a man smoking a cigarette with a very specific expression, and with a very specific lighting, with a gorgeous sunset behind him, you must remember that sunsets only last ten minutes, so this is close to impossible to do with a real sunset.

Once we used a painted backdrop, but very carefully. A window was built on the set, with rain on it. The city at dusk is seen through the window, and this is another natural-light element that isn't always right and doesn't always last long. I had a backdrop painted of the city at dusk (there are studios that specialize in painting backdrops for photographers, for movies, or for TV). Because the backdrop was behind a window splattered with rain, and there was a sofa in front of the window, it all blended in, and the illusion of the real thing was created. You must consider all the details, all the possibilities, to make it look real and natural, and as simple as possible. It you don't know how to achieve this—find out.

Here we have a campaign of photographs that appear to be simple, but the process of producing them is actually quite complex.

Because of his vast experience, Krieger can explain why certain things

can or cannot be done. That's one of the many reasons clients come to him. Because he has proven himself time and time again, he has earned his credibility in this difficult field of advertising photography. In the course of his career, he has traveled all over the world: Africa, Europe, Japan, Israel, South America, the islands of the Caribbean, and all over the U.S.A. and Canada.

Now that we know about the Harold Krieger of today, let's find out how he started and how this phenomenal career developed.

He went to art school and studied drawing, thinking that he might become an illustrator. He took some photo courses, and he said, "They weren't much, but I did learn how to develop film and print pictures. Actually, all I could think about when I went to school was getting out of school."

He says that he really learned about photography in his first job, as an assistant in a portrait studio where the 8″ x 10″ camera was used, and he also learned a lot about lighting. At this time, he acquired his first camera, a Rollei, and also began taking pictures on his own—mostly portraits.

He then went to work in a graphic arts studio, where he was the only photographer. His job was to take photographs for the illustrators to work from. The shooting area was very small, with rudimentary lighting, and a 4″ x 5″ camera was used. Ordinarily, he would photograph one or two models in the poses and costumes needed by the illustrators. If a group was needed, up to five models could be photographed together, or he would photograph them separately and make a collage.

Harold then went to work as an assistant in the Paul Dome studios, a large commercial advertising photography studio, and stayed there three years. "This," he says, "was my college education. I did everything: worked in the studio, worked on the lighting, did darkroom work, and after a while, when the principals went on vacation, I did the photography."

In the early fifties, he opened his own studio. His lighting consisted of daylight (the north wall was all windows); he used tungsten; and he also designed two 6-feet long fluorescent lights mounted vertically on two light stands. "Like all young photographers," he said, "I wanted to do fashion, and these long lights gave a very nice, soft lighting, eliminating harsh lighting on the models' faces."

His camera equipment consisted of an 8″ x 10″ Deardorf, which he still has, a 4″ x 5″ back for the Deardorf, and two Rolleiflexes. At that time, 35mm cameras were not considered professional studio equipment. He first acquired 35mm cameras in the early sixties.

LM: *How did you get your first commission?*
HK: I probably begged for it.

However, the first job in his own studio was a fashion job for a publicity firm, and it was a long time before he got paid, but he kept doing work for them, and eventually this led to other work and provided him with good samples for his portfolio.

It is important to note that many of the people Krieger did jobs for in those early years have moved up the ladder in the advertising business, and he has retained a working relationship with them.

After six months in his own studio, Krieger got an agent (a rep) who was also starting out. Nothing happened, so they parted company after half a year.

[She went on to become successful with another photographer. *Please note:* The six months of nothing happening did not discourage either Harold or this rep from continuing in their careers.]

Then there were two other reps for short periods, and finally, one who stayed with him for eight years. Steve Gould, his present rep, started with him in the mid-sixties. Gould had had only a little over two years' experience, but Krieger was impressed with his drive, enthusiasm, and energy, and they are still together.

HK: It took ten years to hit my stride, getting lots of experience, constantly acquiring new and different equipment. Then I began to do editorial work too, because the advertising commissions were coming in, and so I could afford to do the editorial work.
LM: *To what do you attribute your success?*
HK: It's an aggregate of tremendous experience, and also a kind of positive quality about the things that I'm doing. I know what I'm doing. I was never positive in the beginning. I still am surprised at certain things that happen in the camera, but I did have a definite kind of taste and believability then, as I do now. I did have a point of view. I was always excited by good lighting. Lighting to me is the essence of good photography. And every time I see a beautiful photograph, I say, "I wish I had taken that," whether it's an advertising photograph, an editorial photograph, or even a snapshot. I'm crazy about photography.

Although Harold Krieger has reached the pinnacle in the field of advertising photography, and is a wealthy man, he did not accomplish this overnight. It was a matter of constant dedication and persistence. He never sat back on his successes, but always gave the same complete attention to every job.

His advice to young photographers?

HK: You must not be deluded into thinking that this work is easy. It has many facets; no detail can be overlooked; and there is much to learn.

LM: *Why do you work so hard?*

HK: I love my work. Photography makes me feel good, to have all the forces under control; there is a centering.

Steve Gould: **Photographer's Representative**

○ The portfolio of the advertising photographer is his primary selling tool, and a rep shows it at the ad agencies, finds out what assignments are up for photography, and tries to get them for the photographer.

A responsible rep must have an in-depth understanding of the problems of both the art directors who give out the work, and the photographer. The rep absorbs a lot of pressure, works on budgets, and negotiates for a price, leaving the photographer free to concentrate on the photographic aspects of the work.

Steve Gould is a highly competent rep. He has worked successfully with one of the top advertising photographers for a long time, and you will find his comments illuminating.

He generously explains his work and provides many pertinent insights. Of particular interest is his forceful and positive attitude. You will understand what an important role a good rep can play in achieving success in advertising photography.

As mentioned previously, Steve Gould is a rep for Harold Krieger. The rep's function is to go to the advertising agencies with a portfolio of the photographer's work and see the art directors, with the objective of getting assignments. Since the rep plays an important role in a successful advertising photography studio, hearing from a rep of Steve Gould's calibre and experience will give you a great deal of insight into advertising photography.

Some reps handle several photographers, but Steve reps only Harold Krieger.

LM: *How did you become a rep?*

SG: While a college student majoring in psychology, I got a summer job through a card tacked up on a bulletin board. The job was to walk behind Fritzie Miller, carrying her portfolios.

[Fritzie Miller was a famous rep, not young, who always employed a young man to carry her portfolios when she went out to the ad agencies.]

She repped a group of very talented photographers and illustrators. When I worked for her, Andy Warhol was a shoe illustrator, and

I used to run between Fritzie's office and Andy's home with jobs for shoe illustrations that he did for seventy-five dollars a pair, for department stores.

But I was Fritzie's star carrier of portfolios, and she created a job for me when school started, just to keep me around. I even arranged my program so that I left school at noon every day and went to work for her. She was a top rep—she was my mentor—and I learned the fundamentals about repping from her. I saw at that time that good reps were a rare commodity on Madison Avenue.

Even while I was just carrying portfolios for Fritzie, I was in demand. Photographers who had to rep themselves would come up to me and beg me to come to work for them; they would call me at home at night. Everybody thought that the rep was going to do it, even back then, the late fifties, when lots of work was being given out, and the competition wasn't as keen as it is now.

After finishing school and a stint in the Army, I met a young, talented photographer whose portfolio was exciting. I repped him for two years, and during that time he went from obscurity to billings in the neighborhood of one hundred thousand dollars a year in photo fees.

Then I found out about Harold Krieger. He had severed his connection with the rep who had been with him for eight years, and had been without a rep for a year. Even at his level, when an art director had a job and wanted to see Harold's portfolio, along with three or four other comparable talents, the rep had to go in and do a selling job. The work seldom speaks for itself; it has to be explained. I find that even an art director who reputedly has some taste has to be walked into an assignment.

I was twenty-five years old, I went to Harold Krieger's studio one afternoon, and I was magnetized looking at the photographs on his walls, looking at his portfolio. Here was the photographer who did every great ad that I loved, and I saw that Harold Krieger was the right kind of person for me to work with, rather than the photographer I was repping; I saw that he was a fun-loving person, that he had spirit, and that in addition to being a smart guy, being highly talented, and a great shooter, he's a fine human being. I saw that he wasn't limited, that he shot, and still does, every kind of ad, from fashion, to travel, to automobiles, everything—location jobs, big-set studio jobs, close-up portraits—and does it all superbly.

At our second meeting, over lunch, he decided to take me on. I had taken his portfolio home and spread all the photographs out on my living room floor. I spent the whole evening looking at them,

and I knew that this guy was the best. I went back to return his port-folio, and I told him that I would like a shot at showing his work.

The fact is that the chemistry was right from day one. He saw in me what he wanted to have, and I saw in him what I wanted.

LM: *How long was it before you started to bring work into the studio?*

SG: I was an eager beaver, anxious to expose Harold's work to the world, so by week two, I got Harold an assignment—a mother kissing a little girl good-bye in the doorway. I was so enthusiastic, the first year was explosive. The second week I had some cards printed, which normally last a year. I ran out of them in four months. I made it a powerful mission for me to accomplish. And, of course, I wanted Harold to be impressed with me. I did nothing but run from agency to agency, showing Harold's portfolio to everyone who would see it, from junior art directors to creative heads to receptionists, just so I could get Harold exposure. I gave out tons and tons of cards. And it certainly paid off—the phone began to ring.

I had the conviction that all the tasty people who were buying photography would give assignments to Harold Krieger sometime during their career. Harold was too good a photographer not to be used by everybody. The rejection factor didn't play at all. The competition was there, but there was a lot of photography being given out in the sixties. *Life* magazine was a weekly. Harold was doing national campaigns; he was getting the jobs to introduce new products. Harold shot *every* day for a different ad agency, at least three or four days a week, and each agency has different clients.

As I sold him, and as I continue to sell him, Harold's contribution is one of infinite taste. Whether it's selling a ladies' eye mascara, or a rubber glove worn by a woman cleaning a kitchen wall, or a famous athlete driving a new car, he gives his clients the utmost in taste, in lighting, in composition, and it is all done in a realm of photographic expertise. His enthusiasm to be an expert is always there, and whatever equipment is necessary is brought in to further this expertise.

LM: *How do you deal with rejection? You have to see so many people, many more than the number of jobs that you get.*

SG: I never do a body count of how many people I see or how many rejects I get. I really enjoy seeing art directors. A lot of them are my friends now. Some, the ones I met when I started, are now running ad agencies, and it's all worked to make this business an ongoing, exciting way of life.

LM: *Describe what happens when an assignment is obtained.*

SG: A phone call comes in from an art director who has seen Harold's portfolio. I go to the agency and look at the layout, which can be anything. Let's say it's a couple under an umbrella sipping a drink and watching the sunset in the New York harbor. I negotiate for a fee. I ask, What is the budget? How is it going to be used? What media? What exposure? Will it be a national ad? Will it be on a package? All these considerations influence the price. But let's say it's a national ad—the day rate for a shot like that may start at $3,500, plus expenses.

LM: *And you work out the prices?*

SG: Yes, and Harold trusts me to get the best price possible. Right from the beginning, I knew that Harold's fees had to be among the highest paid to a commercial photographer in our market. I knew that Harold was way beyond a beginner, or even a middle-of-the-roader, because of all his successes. He had, and is still consistently getting, gold medals, and this helps determine the fees he gets. There is no doubt in anybody's mind that he is an expensive piece of talent.

Okay—we've gotten the job. Then I go back to the studio and show Harold the layout. We talk about the best way to do it, and begin the production. At that point Harold takes over and begins to coordinate all the preshooting activities with the studio staff.

He activates the free-lance network of people we are going to need, starting with the types of models, hairdresser, stylist, wardrobe, transportation to the location (if it's a location shot), getting insurance. The whole system of making a mini-movie is done, to make a still photograph for an ad. Although there's a production person on staff, Harold and I supervise the production, and I play an important back-up role in making sure everything is done.

I am also concerned that everyone working for us, whether they be free-lancers or staff, reflects the quality of the studio. I am very conscious of making the art director, the client, feel that this network of people is organized and put together by Krieger Studios into a well-oiled piece of machinery to make his job a perfect one. It's important that the clients feel that way, and that's why I get involved on the studio level—to make absolutely sure that everything is done smoothly.

LM: *Although you keep your eye on the jobs as they are being shot in the studio, you are still going out and seeing art directors?*

SG: Yes, it's a constant going to the agencies. That's the basic scenario. I also deliberately try to make the stress disappear for the art director. When they go into an assignment there's a lot of appre- hension; there's a lot of money involved. Everybody has a sense of

nervousness about it all. There has to be the reassurance that what we're doing is professionally perfect.

The rep's job is also one of being a gatherer of information. There is no such thing as an inconsequential piece of information. We don't do accident-type photographs. In a rough sketch of a skin lotion ad, if it shows articles on a bathroom shelf as a man is washing himself at the sink, the rep and the photographer find out what articles that art director expects to find on the shelf.

Besides seeing the art directors, I also read all the advertising trade journals to keep up with what's going on in the business—what accounts are moving to another agency, people who are changing jobs, getting promotions. The trade journals I read are *The Advertising Age, Adweek, Madison Ave.,* and the *N.Y. Times* advertising column.

LM: *What is the rep's financial arrangement with the studio?*
SG: It varies, but generally reps get 25 percent of the photo fee. Example: Take a picture of a car in the desert. Photo fee: $3,500. Expenses: Models, film and processing, props, assistants, styling, accessories, location, and travel to the location. So, the expenses can run to $7,000. or more. The bill may be $10,500. The rep gets 25 percent of the $3,500 photo fee, or $875.

Then the rep has to take care of his expenses, which are the portfolios, all custom-made, and new ones frequently; enormous phone bills; lunches; entertainment; taxis; and promotional material, four-color illustrated cards, which are expensive. I also pay 25 percent for any studio parties, and these can be black-tie, catered affairs.

LM: *How do you relate to art directors?*
SG: Some I like, some I don't; and if I don't like them, I know that Harold's not going to like them either, so I don't spend a lot of time with them. I know that there are people I'm not going to get along with, and that Harold is going to be struggling with them. I know that in addition to giving them a great picture, part of Harold's thing is to share experiences with them, and if the guy is a zero, a negative, I know that it's not going to work out with Harold.

LM: *What would you say impresses art directors?*
SG: Frequently it's a multifaceted thing. The primary answer is the portfolio. The fact is that we show thirty or forty pictures, each one carefully picked to impress the particular art director I'm seeing. The thing I always want to impress them with is that Harold is the supreme, consummate photographer when it comes to shooting a commercial assignment, and the portfolio manifests that.

LM: *You must have a great talent in handling art directors, in zeroing in—*

SG: (Interrupts) Excuse me, but art directors are the same as every-body else. They're not any different, so the concept of handling them as a separate category is not applicable. The applicability of it is, you are handling human beings. Frequently the jobs we get called up for are big ones. There's a lot of money riding on them, and many of the art directors are terrified. They want to know that they're getting the right person, and I convince them that by using Harold they will be taking the stress out of what could be a crazed assignment.

LM: *Even though Harold is at the pinnacle of his field, why does the rep have to keep seeing people so actively?*

SG: Because a photographer is as good as his last ad. They don't remember what he did. A rep is essential in terms of exposing the work, because the only guy who knows what a photographer has done is the one he did the job for. Remember—advertising pho-tography is highly competitive, and there are many advertising photographers.

It's a very tough profession. New York City is like a magnet. Everyone who won a photo contest and wants to be a little bit visible, and rich, wants to be a Madison Avenue advertising photographer. So New York is filled, literally, with thousands of photographers of all ages, shapes, colors, sexes, all plying their trade to these same art directors, who are barraged with phone calls, with material coming in the mail.

You cannot be going to the ad agencies and also be a genius shooting in your studio. A photographer needs a rep in order to have the time to create an opera. The rep is important if for no other reason than to show the work. I've seen photographers in the ad agencies who are dying for reps. Their lives are screwed up, they have to go to the agencies in the mornings and do tests and shootings in their studios in the afternoon. Some of them beg me to rep them, and even offer fifty percent. They all want that magic rep to open up those doors that are otherwise closed to them.

LM: *Do the ad agencies ever call on several photographers for bidding?*

SG: They do sometimes give a job out to three or four photographers and ask for estimates. It's happening more and more because they are becoming very cost conscious. Sometimes we get them, sometimes we don't. Actually, for the work he does Harold is cheap at the highest prices.

LM: *It's interesting that some art directors you've been seeing will finally come through even after three or four years, that you don't give up no matter how long it takes.*

SG: Right, it's always an ongoing process, you never know. They can transfer, get into a new area of ads; it's always changing. That's inherent in this business, continual change, and everyone is a possibility even after ten years.

LM: *Do you have four or five different portfolios, or do you rearrange one according to the person you are going to see?*

SG: I have portfolios to cover virtually every category of commercial photography. We sell Harold as the consummate commercial advertising photographer. Anyone who needs a commercial picture done is remiss by not being exposed to Harold's contribution. He takes the fear out of shooting. That really sums Harold up, and I say that with the sense of one hundred percent conviction.

Nancy and David Brown: Photographers

○ Nancy Brown and her husband, David Brown, are advertising photographers, handling primarily fashion and beauty accounts. They had a most unusual preparation for this field of photography. Their background gave them a very special viewpoint and an opportunity to learn every single detail and facet of this specialty. They are examples of what it takes to be successful in this quite complex field of photography.

Anyone can learn the techniques of photography, of darkroom work, but their story reveals all the other intricacies of the fashion and advertising world that are so very important to know if one is to succeed in this business.

They were both models for fifteen years before opening their studio. They worked in top advertising photography studios for the top photographers. They could observe how these photographers worked. After all, the model is in a very close and responsive situation with the photographer. They knew all the different ways that good photographers worked with their models, how they acted toward their clients, how they handled their staffs, and most important, how they carried out their assignments. They also worked for some not-so-good photographers, and saw the differences between them and the good ones, as well as the differences between the top-notch photographers.

They saw how things were organized, how to work with stylists, with the hairdressers. They knew who the best photo dealers were and where to get equipment repaired reliably.

They knew of all the different kinds of equipment the photographers used, and what they did with lighting. They went on location with the photographers, they traveled all over the world with them, and often the clients went along. The Browns were also aware of the highly competitive nature of the business.

They were an integral part of this world; they understood its language, its behavior. It was all like an incredible rehearsal, so that when they were ready to enter this world as photographers, they could switch roles without too much effort.

While they worked as models, they met umpteen art directors; they knew where one got props. They knew where to get Christmas decorations in July, how locations were found, who were the excellent assistants. They knew what was needed for a well-functioning studio and how preparations were made for location shots, whether the location was an hour away from the studio or halfway around the world. They knew how to get cooperation once they got to locations, how to get permissions, how to get clearances.

They knew all about the minute business details and the etiquette, and knew how important it all was. They knew all about the forms, the model releases, how to do cost and estimate sheets when bidding on jobs, how to research and where to find prospective clients, how to analyze a layout.

They knew how to act when they went to the advertising agencies; they knew exactly the position the art directors and account executives were in, how they felt, what their thinking was, and what the advertising people expected of a photographer.

They knew about self-promotion, exhibiting their photographs in spaces that almost every advertising agency provided for photographers to show their work. They knew they would have to send out mailing pieces and see that their portfolios got around to the art directors at advertising agencies as often as possible.

Their fifteen years of working as models in this business gave them the total picture, an invaluable experience. They observed and absorbed.

They had no illusions; they knew exactly what to expect and what not to expect. They realized how difficult the field was, how demanding, how exacting, how competitive, and how many talented photographers there were working in it. They were thoroughly realistic—they didn't look for a quick and easy success; they knew how difficult it would be, first, to get the clients, then to hold them and do competent jobs. That was one side of their preparation.

In other words, there were no mysteries for them; there would be no sudden, unexpected surprises.

They knew that being a good photographer was the foundation of this whole tremendous superstructure, and that without good solid photographic ability and talent, no matter how well they understood all these other elements, their work would be to no avail.

So, long before they planned to make the switch from modeling to photography, they began photographing. They learned everything necessary about using a camera, about films, about working with their subjects, about good prints, about the similarities and the differences in approach between color and black and white. They took courses; they studied. They started

photographing ten years before they retired from modeling and began their advertising photography careers.

They worked hard at becoming good photographers and, just as important, photographers who knew how to satisfy their clients. They knew about professional organizations; they knew about sources of information such as the *Madison Ave. Handbook* and *The Black Book*, both listing advertising agencies and other sources. For self-promotion they bought display pages in *American Showcase* and the *ASMP Silver Book*. They knew about the *Photo District News*, a monthly newspaper for professionals, containing news pertinent to the business.

The Browns knew that the bottom line—besides photographic excellence—was the portfolio, beautifully put together and beautifully presented. As they were working as models and photographing, they began building their portfolios with tremendous care, being tough on themselves. They knew that every photograph in the portfolio had to be perfect in every way.

They saved their money, knowing that starting an advertising photography business was an expensive proposition. Establishing a studio goes far beyond the popular conception of the photographer as a carefree spirit with bag on shoulder: Have camera, will work.

They invested in a good space, knowing all the contingencies that could arise, knowing that a great space with the best lighting and camera equipment was not enough. They knew they needed a first-rate darkroom; that the reception room, the dressing rooms, the entrance, and the furnishings had to be attractive and well designed. They knew that the studio had to be comfortable and functional, and must project the message that the photographers in this studio knew what they were doing.

They knew that they needed the wherewithal to provide refreshments during a long shoot; that the studio could and should also function as a place to entertain clients.

They knew all this from having been in every great studio, and every not-so-great studio; from observing how the clients were made to feel during a shoot, before the shoot, and after the shoot. They knew that all this counted for a lot. They planned carefully, and the studio they started in was comparable to the best.

From having been models, the Browns understood the kind of imagery, the kind of look that the clients and the advertising agencies working on fashion and beauty accounts wanted. They understood the mix between fantasy and reality that the clients expected in their photographs; the kind of image that the clients knew, from years of experience, worked for them; the image that would deliver the message to the public and would sell their products. People outside the business have almost no awareness of this point.

The Browns understood how to embody in a photograph those elements that would come through and touch and reach the consumer about the products represented in the advertising photograph.

They understood what details needed a lot of careful attention and what they could let go. They understood how to utilize all the elements and blend them into a photograph that spoke about the products in the way the clients wanted. They knew how to utilize all the pieces and all the realities to make a photograph that would do its job effectively. This was another kind of important knowledge that they brought to their new career.

And of course they knew about the model's function and how important it was in creating this very special kind of photograph. They knew what a model should and could be expected to do. They also knew how models should behave. They knew how to recognize a model who would make a great contribution to a shooting. They knew how to get models to project, to respond, to deliver. They knew who the top models were.

They knew how to deal with model agencies. They knew all the ins and outs of booking models, how to call in for "go-sees," how to put models on hold, how to book a model for a location shot with a "weather-permit." And they knew the models; they knew the people working in the model agencies. They knew how to talk to these people; they knew how to work with them. They also knew who the good stylists were—the hairdressers who understood the photographer's problems.

They knew that it would be quite some time before the money flowing in would equal the money flowing out, but they also knew there would be even more time when the money flowing in would exceed the money flowing out. That was their goal: to be as successful as photographers as they had been as models.

So, they opened a full-fledged, perfectly equipped studio. They did not spare the bucks. They had their portfolios ready, and they started not as infants in the business, but fully grown.

Things have been difficult, but they expected that, and they're getting jobs, doing the work, and they are satisfied. Their careful planning and preparation has been worked out. And that is the message for you aspiring advertising photographers—preparation and a thorough understanding and appreciation of all the facets, and there are many, of this specialty are very, very important. It's true that if you find success, advertising photography is where the big money is made, but it's not easy to come by. You don't make it by snapping your fingers, there's a lot to know, and you've got to know what you're doing. There are a lot of talented accomplished photographers out there after the same things, hungry for the success, and able to work hard.

Getting an Account

○ There's a cosmetics firm with a nice, juicy beauty account, a firm Nancy Brown had done a lot of modeling for. She knew exactly what they liked, exactly what they expected, and when the Browns opened their studio, they set the goal of getting that account. They anticipated that it would be a dif-

ficult target. They knew the mentality of this company, and they knew the kind of photograph this firm liked. They also knew there were samples in their portfolio that were precisely what this company looked for.

In addition, Nancy Brown knew the people of this company. As a model, she had worked with them frequently; she had gone on location shootings with them. And you, the reader, must understand that going on a location shoot often means being together all day for days at a time. It's not only working together, but eating together, playing together, being in airplanes together.

With all those advantages on her side, Nancy Brown called on them thirty times with her portfolio. On the thirty-first visit, she landed an assignment, and now the Browns' studio has the account.

Nancy Brown told this story to Stanley Karp, a highly respected photographers' rep with twenty-five years' experience representing two top successful advertising photographers. He has been out there with the portfolios five days a week, making five to six calls a day at advertising agencies, and his comment to her about finally landing the account on her thirty-first visit was, "You were lucky."

Andrea Hewitt: A Client

○ The advertising photograph originates with the person who has something to sell, be it a manufacturer of a product or a supplier of a service. They want to attract the attention of the public; to do so, they advertise. The photographer must always be aware of this, of what the client wants, for it is the client who pays your bills, who buys your work.

To understand what the photographer must be concerned about, let's hear from a manufacturer. The basic premise is the same whether the company buying your talent is a car manufacturer, an insurance company, a bank, a garment manufacturer, or, in this particular case, a cosmetics company.

Andrea Hewitt is a director of a large cosmetics company, in charge of their advertising policy.

AH: We determine what we want our products to represent in the mind of the consumers. For instance, if our objective is to convey elegance and high quality, we are careful to communicate that our products are indeed elegant, by depicting them as being sophisticated and fashion-right. We must also convey the conviction that our products will produce the desired effects. These elements must be telegraphed by all our visuals, especially by the photographs in the advertisements.

There are other qualities that we could have chosen to convey:

mystery, glamour, charm, all-American fun, magic, or—change your life. However, once we in the company have decided what we want to stand for—everything, the advertising look, the product, the packaging, the store, the attitude of the salesperson—all have to adhere to the concept we have chosen, and be consistent and faithful to it. We must constantly check to be sure the message we have chosen is clear at every point where it reaches the consumer.

Working with the Advertising Agency

○ First, we must convey our objectives to the advertising agency. We give them a lot of input at the onset of any project. When they deliver a visual, be it a sketch for a layout or a preliminary photograph, we must know if it is on target. When it is missing the general feeling, or something specific, we must explain why and send it back.

I don't create the pictures, but I have an idea of how the drawing, the photograph should look—that is my job. However, it can happen that the drawing or the photograph is not what I had in mind, but a different interpretation that basically achieves our objective. Then I must be open-minded and accept it. That's how I learn.

Along the way, I go to the shoots, to the illustrators, to the commercial TV directors. In some cases, for the client or the manufacturer to talk with the photographer or the illustrator is a no-no. But I talk to them, to help insure that they understand our basic concept. I believe that to achieve our optimum objectives, I must be connected at each step of the way. Because with each step, you get another generation away, and the basic concept can get lost or diluted.

Models

○ Models work with many advertising photographers, and are in a unique position to observe the photographers. The models get to know a great deal about what advertising photography entails and how different photographers function.

Since advertising photographers are dependent on good models, let's enumerate the qualities a model must bring to a shooting: They must be able to project in front of a camera without self-consciousness. They have to appear natural, as though what they are doing just happened. He or she must be able to quickly change makeup, clothes, hairstyles—their total look. They must capture the essence of a quality or a mood, and have the ability to project it to the camera.

Farrell Connor

○ Farrell Connor, who worked successfully for over twenty years as a model, a longevity that is unusual, talks about modeling.

FC: Modeling is mime, it is reacting, it is the essence of simplicity. A model must have rapport with different photographers, know a photographer's tempo; some like to shoot fast and a lot, some go slower. My attitude, when I come into a studio, is not, "Here I am," but, "What can I do to help you?" Flexibility is important, to be able to adapt, to take directions, to understand what they're trying to sell and how they're selling it. You must help create a mood, an attitude, and deliver it at a certain split second of time.

You must never forget that you are not selling yourself. You are selling what you are wearing, or a product, or a place. You must be sensitive and be able to make some kind of movement or assume an attitude that is to the product's best advantage. Since the whole purpose is to sell something, you must portray the feeling of enjoying it.

Still photography is much more precise than TV or motion pictures, and you must be aware of the difference. You must not contrive or force anything, because the camera doesn't lie. I learned from my teachers, the photographers.

Colleen Stewart

○ Colleen Stewart is a high-fashion model.

CS: A shooting session at a big studio is quite an undertaking. There are the photographer, the assistant, the stylist, the makeup and hair people, people from the ad agency and from the client. I feel like one of the crew; and something else, most of the people there are your friends, they are people you know and like. We enjoy each other; we work hard. You must concentrate and do the best you can.

Part of learning to be a model is to understand the specifics of the distortions of the camera and its angles, to understand the bridge from life to a photograph, to know what the camera can and cannot do, what it sees, and how it sees it.

Michael De Moss

MD: We models are in the unique position of getting to know how a great many different photographers work. I am most impressed by the confidence a photographer conveys—how he looks at you; how

he feels about what he is going to do. Some photographers coordinate with you so that you know exactly what he is going to do. There are so many different ways of shooting and handling the model; some try to get you off-guard, some are very structured. The relationship between the model and the photographer is very unique; after all, he sees everything through the camera, and there is this special way of communicating. The model is an object, in a way, but not really. He has his very definite role, and is a human being with a very definite job to perform. The model must work in partnership with the photographer. Good advertising photographers are aware of this, and while shooting and concentrating on their problems, seem to be able to draw the best from the model.

Forms

○ In order to give you added insight into the complexity of advertising photography, here is the Estimate/Invoice Form that was designed by the APA (Advertising Photographers of America, Inc., 118 E. 25th St., NYC 10010, [212] 254-5500. This is a professional organization of advertising photographers.).

The photographers who put this form together have experience in every aspect of advertising photography: beauty, fashion, food, still lifes, products, industrial, illustrative, home products, interiors, travel, automobiles, airlines, and so on. This form includes every possible expense that can arise in every kind of assignment. However, no one assignment would require every single item. This outline is used to 1.) anticipate and work out all the expenses that may arise on an upcoming job, so that a proper estimate can be worked out; 2.) keep track of all the expenses incurred in order to bill for a completed job.

The Estimate/Invoice Form helps a lot when negotiating fees, conditions of working, and the terms of an assignment; if it is used well, there will be no unaccounted-for expenses. This alone is a great aid in avoiding misunderstandings between the client and the photographer.

In the section on the rep Steve Gould, he gave an explanation of how he works out the figures when bidding for jobs. He mentioned the photo fee, which is separate, and then the expenses that are added onto the photo fee.

This form, in a much more abbreviated version, could be very helpful to free-lance photographers. Many of them use a simplified version for their record keeping.

If you are seriously interested in advertising photography, and are thinking of working in that field, you should take plenty of time and study all the items in this form very carefully. It is additional evidence that advertising photography is no small potatoes. It will contribute a great deal to your

comprehension of the complexities of advertising assignments. Advertising photography is big business, and it involves a lot of money.

Two versions of the Estimate/Invoice Form are presented: the long form is the more detailed version; the short form is the simplified version.

The APA has also created a contract for advertising and editorial assignments. It is reproduced here after the two versions of the Estimate/Invoice Form. The contract contains a lot of legalese, but it is worth your while to review it.

Long Form

☐ ESTIMATE ☐ INVOICE ESTIMATE VALID UNTIL _____

A CREW

	PRE-PRODUCTION/WRAP					PRODUCTION				
	#	DAYS	RATE	O.T.	TOTAL	#	DAYS	RATE	O.T.	TOTAL
1 Studio Coordinator										
2 1st Assistant										
3 Assistants										
4 Research										
5 Home Economist										
6 Make-up/Hair										
7 Wardrobe Stylist										
8 Pinner										
9 Prop Stylist										
10 Model Maker										
11 Engineer/Tech Advisor										
12 Electrician										
13 Driver										
14 Police/Fire										
15 Medical										
16 Welfare/Teacher										
17										
18										
19										
	SUB-TOTAL A					SUB-TOTAL A				

B CASTING

20 Fees			25 Casting Equipment		
21 Film			26 Casting Personnel		
22 Use of Files			27 Transportation		
23 Casting facilities			28		
24			29		
			SUB-TOTAL B		

C LOCATION

30 Use of Files			44 Cabs		
31 Location Scout			45 Special Crew Equip./Clothing		
32 Polaroids			46 Generator Rental		
33 Location Usage Fee			47 Overweight Baggage		
34 Insurance (liability & other)			48 Air Freight		
35 Loc. Usage O.T.			49 Limos (celebrity service)		
36 Permits			50 Camper/dressing room		
37 Car/truck/van rental			51 Misc. outside labor		
38 Mileage			52 Shoot meals		
39 Parking/Tolls/Gas			53 Hotel		
40			54		
41 Per diems	()	()		
42 Air Fares	()	()		
43					
			SUB-TOTAL C		

Long Form (continued)

D SETS

55 Set Designer			65 Strike		
56 Carpenter			66 Polaroids		
57 Painters			67 Shipping		
58 Hardware/Lumber			68 Home Ec. Supplies		
59 Paint/Wallpaper			69 Product Preparation		
60 Surfaces			70 Greens		
61 Backgrounds/Backdrops			71		
62 Art Work			72		
63 Outside Construction			73		
64			74		
			SUB-TOTAL D		

E STUDIO AND EQUIPMENT RENTAL ☐ ESTIMATE ☐ INVOICE ESTIMATE VALID UNTIL _____

75 Rental for build/strike			84 Misc. studio charges		
76 Rental for shoot days			85 Meals for shoot crew		
77 Rental for O.T. hours			86 Camera rental		
78 Power charge and bulbs			87 Lighting rental		
79 Tel/Cable			88 Special Lens rental		
80 Production supplies			89 VTR rental		
81 Storage			90 Spec. Effects Rig		
82 Cyclorama			91 Equip. Checkout/Clean		
83			92		
			SUB-TOTAL E		

F WARDROBE

93 Purchase			97 Costume Designer		
94 Rental			98 Seamstress		
95 Wigs/Special Make-up			99		
96			100		
			SUB-TOTAL F		

G PROPS

101 Props/Set dressing					
102 Food					
103 Animals					
104					
			SUB-TOTAL G		

H FILM & PROCESSING

	35mm	2¼x2¼	4x5	5x7	8x10	11x14	16x20	ROUGH	FINAL		
105 4/C											
106 B&W											
107 Proofs											
108 Prints B&W											
109 Prints 4/C											
110 Dye Transfer											
111 Film Dupe/assembly											
112											
								SUB-TOTAL H			

Long Form (continued)

I MESSENGERS/TRUCKING (Local & Long Distance)

113 Messengers			122 Trucking	
114 Crew			123 Crew	
115 Casting			124 Casting	
116 Location			125 Location	
117 Set			126 Set	
118 Equipment			127 Equipment	
119 Props			128 Props	
120 Wardrobe			129 Wardrobe	
121			130	
			SUB-TOTAL I	

J MISCELLANEOUS

131 Office expenses			135 Gratuities	
132 Long Distance calls			136 Catering	
133 Cable			137	
134			138	
			SUB-TOTAL J	

K INSURANCE

139 Photo Pac			142 Other	
140 Liability			143	
141			144	
			SUB-TOTAL K	

L MODELS

145 Model Trans. (costs & travel time)			149 Fitting	
146 Model O.T.			150	
147 Model per diem	()		()	
148			SUB-TOTAL L	

This form has been approved for use by:
Advertising Photographers of America ╱ Society of Photographer & Artist Representatives ╱ American Society of Magazine Photographers.
Permission is hereby granted to reproduce this form in whole or in part.

Short Form

☐ ESTIMATE ☐ INVOICE ESTIMATE VALID UNTIL _____

DATE:	STUDIO JOB/INVOICE#:
AGENCY P.O.#:	SHOOT DATE:
AGENCY JOB#:	ART DIRECTOR:
CLIENT PRODUCT:	ART BUYER:

MEDIA USAGE (REPRODUCTION/LICENSING RIGHTS)

	National	Regional	Local
Consumer Mag. #			
Consumer Newsp. #			
Trade Mag. #			
Trade Newsp. #			

PERIOD OF USE: _____
Subject to terms & conditions on reverse side.

☐ Double Page
☐ Single Page
☐ ½ Page
☐ Poster
☐ Test _____
☐ Television
☐ Album Cover
☐ Photomatic
☐ Editorial

☐ Annual Report
☐ Billboard
☐ Book Cover
☐ Brochure
☐ Catalog
☐ Packaging
☐ Point of Purchase
☐ Transit
☐ Other _____

Short Form (continued)

DESCRIPTION:

COLOR:	B&W:	OTHER:	FORMAT:	STUDIO:	LOCATION:	SET:

CREATIVE FEES MAIN ILLUS.: SECONDARY ILLUS.:

PREP: TRAVEL: SHOOT: WEATHER:

A CREW: STUDIO COORDINATOR: OVERTIME:

 STYLIST: OVERTIME:

 ASSISTANTS: OVERTIME:

 MAKE-UP: HAIRDRESSER: OVERTIME:

 HOME ECONOMIST: FOOD: FEES: TRANS:

B CASTING: FEES: FILM: TRANS: USE OF FILES:

C LOCATION SEARCH: LABOR: FILM: TRANS: USE OF FILES:

 LOCATION FEE: CATERING:

 TRAVEL: AIR FARE: HOTELS: PER DIEM:

 TRANSPORTATION: CABS: RENTAL: OTHER:

D SET: DESIGN: LABOR: MATERIALS: STRIKE: O.T.:

E STUDIO MATERIALS: STUDIO RENTAL:

 SPECIAL EQUIPMENT: LIGHTING EQUIP.: GRIP EQUIP.:

F WARDROBE:

G PROPS:

H FILM & PROCESSING: POLAROID: PRINTS: O.T.:

I MESSENGERS: TRUCKING:

J MISC.: OFFICE EQUIP.: LD CALLS: GRATUITIES: CATERING:

K INSURANCE:

L MODELS (Studio paid):

 PRODUCTION CHARGES:

 SUBTOTAL (FEES & CHARGES):

 SALES TAX:

 CASH ADVANCE:

Balance due upon receipt BALANCE DUE: _____

Client Signature: _____ Date: _____ Studio Signature: _____
(If Estimate) (If Invoice)

MODEL fees billed direct

	ADULTS		CHILDREN		EXTRAS	
	NO.	HRS.	NO.	HRS.	NO.	HRS.

Client's usage rights transferred upon full payment of this invoice; subject to all terms and conditions on reverse side.

This form has been approved for use by:
Advertising Photographers of America / Society of Photographer & Artist Representatives / American Society of Magazine Photographers.
Permission is hereby granted to reproduce this form in whole or in part.

Contract Form

ALL ASSIGNMENTS ARE ACCEPTED SUBJECT TO THE TERMS AND CONDITIONS BELOW, AND THE RIGHTS AND LICENSE GRANTED ARE LIMITED AS FOLLOWS:

A. DEFINITIONS: "Photographer" refers to _____, author of the photographs. "Representative" refers to _____, Photographer's authorized agent. "Client refers to commissioning party, named on the face of this form, and its representatives.

B. QUOTED FEES AND EXPENSES apply to original layout and job description only. Additional compensation must be negotiated with Photographer or Representative for any subsequent changes, additions or variations requested by Client, and confirmed in writing.

C. CANCELLATIONS AND POSTPONEMENTS. (1) In the event that Client does not provide mutually agreed prior notice of cancellation or postponement, Client shall pay 50% of Photographer's fee; except if Client cancels or postpones with less than two business days prior notice, Client shall pay 100% of Photographer's fee. (2) If Client specifies weather conditions for the shoot and postponement is required due to weather, Client shall pay full fee unless postponement is made prior to departure to location, in which event client shall pay 50% of fee. (3) In the event of cancellation or postponement of the booking for any cause other than the Photographer's, Client shall pay all expenses incurred by Photographer as indicated on this form.

D. CLIENT REPRESENTATIVE. Client is responsible for presence of its authorized representative at the shooting to approve Photographer's interpretation of the assignment. If no such representative is present, Client shall accept Photographer's interpretation of the assignment.

E. OVERTIME. (1) Overtime charges shall apply to Photographer on "day rate" only and to all other personnel required to work in excess of eight (8) consecutive hours on any given day. (2) If the shoot lasts beyond the scheduled time, Client shall pay any additional expenses thereby required. (3) Photographer shall provide a schedule of overtime rates at request of Client.

F. RESHOOTS. (1) If film at time of delivery is unusable because of defect, loss or damaged, equipment malfunction, processing or other technical error, Photographer shall reshoot without additional fee, and Client shall pay all expenses for the reshoot. (2) If Photographer charges for special contingency insurance (such as PhotoPac) and is paid in full for the shoot, Client shall not be charged for any expenses covered by such insurance. A list of exclusions from such coverage will be provided on request. (3) Client requested changes in completed shoots are subject to additional fee plus all additional expenses.

G. GRANT OF RIGHTS. Grant of any reproduction rights is conditioned on receipt of payment in full. All rights not expressly granted remain the exclusive property of Photographer. Unless otherwise stated on the face of this invoice, duration of license is one year from invoice date, and license is for use in the United States of America only.

H. COPYRIGHT PROTECTION/CREDIT LINE. *If Non-Editorial:* Client will provide copyright protection by placing proper copyright notice on any use. Proper notice may be either "© Client Name,. Year-date of first publication" (which protects the whole and all of

its component parts), or "© _____ 19____" adjacent to or within the photograph(s) (which protects the photographs.)
If Editorial: Credit line in the form "© _____ 19____" in type no smaller than that of related text must appear adjacent to or within the photograph(s) or invoiced fee is tripled.

I. INDEMNITY. Client will indemnify Photographer against any and all claims and expenses, including reasonable counsel fees, arising from its use of Photographer's work.

J. PAYMENT. Invoices are payable upon receipt. 2% per month finance charge is applied on any balances unpaid after 30 days.

K. RETURN OF PHOTOGRAPHS. Client assumes all risk for all original material supplied by Photographer from time of receipt to time of return to Photographer's safekeeping. Client agrees to return all such material by first publication or such other period as is stated on the face of this invoice.

L. LOSS OR DAMAGE. In case of loss or damage, Client agrees that the reasonable value of original transparencies or negatives produced on assignment is $1500.00 each, or triple the total of the invoice, whichever is less.

M. MISCELLANEOUS. Client may not assign or transfer this license. No alterations may be made in the above-stated provisions without the express written consent of Photographer or Representative.

Medical
and Scientific
Photography

○ Most of this chapter will be concerned with medical photography—that is, photographers working in a hospital setting—but we will also bring you the work of a science photographer working in a university setting.

Introduction

Medical photographers working in hospitals are part of a highly organized structure with very specific responsibilities. The work can be public relations photography, using standard equipment and taking pictures of the place, the events, and personalities on the hospital staff, which are used for press releases, public relations, brochures, and general documentation. We then move into patient photography, specimen photography, and areas of highly specialized equipment. Medical photographers have a scientific bent and are knowledgeable about anatomy, physiology, and surgery. There is a lot of specialization in this field; we'll bring you descriptions of several specialties.

There are two important professional organizations in this field: the Biological Photographic Association, and the Ophthalmic Photographers Society. Both publish journals, and at the end of the chapter you will find a list and addresses.

Photography departments vary from hospital to hospital. If you're in a large medical center with many departments that also engages in research, there may be a large photography section with a staff of photographers covering general photography and specialized photography. If many black-and-white prints are needed, the darkroom may contain mechanical processors and printers that can produce prints in bulk in one tenth the time standard equipment takes. There would also be a large photo file indexed according to diagnosis and patient, so that material could easily be found to illustrate talks the doctors give, as well as for reproduction. There might also be equipment for supplying the medical staff with slides for special showings. In one year, a large medical center might produce as many as 10,000 negatives, 20,000 black-and-white prints, and 12,000 slides. These figures are mentioned to give you an idea of the great need that photography serves. There would also be a comparable index file system. However, smaller institutions certainly do less work, and will not be engaged in as many aspects of medical photography as the large institutions. Veterans Administration hospitals generally have large photography departments.

Three photographers in the field of hospital photography will describe their work and their careers for you. From them you will learn not only certain specifics about the field, but generalities and subtleties, as well.

Dianora Niccolini has been involved in many aspects of medical photography for twenty years, and now is a free-lance filmmaker of 16mm surgical training films, with over twenty-five films in the American College of Surgeons library.

Ida Wyman is a specialist in photomicrography at a leading medical school.

Don Wong, the administrator of the Ophthalmology Department of the Cabrini Medical Center (NYC) will explain the specialized photography techniques in eye medicine and give a short history of medical photography.

Jerald Morse does not work in a hospital. He is a science photographer working in the Department of Forestry and Resource Management at the University of California. The techniques he uses are related to the techniques in medical photography.

Although what each photographer has to say may overlap, you will find that each has his or her own point of view, and these variances should add to your understanding of medical and scientific photography.

Dianora Niccolini: Medical Photography, General

DN: Medical photography is primarily in-house photography, staff photography. Its concerns are patients, doctors, research, laboratory specimens, unusual procedures. Medical photography has many applications; it serves as documentation and an aid in preventative and

rehabilitative work. It is also a diagnostic tool. Medical photography is important for teaching purposes and in the legal area.

The photographs the medical photographer produces are used in medical journals, in audiovisual presentations, at conferences, and for reference. Hospital staff photographers also provide general photographs of the life of the hospital, the buildings, equipment, the staff at work, visitors to the hospital, entertainment—photographs the hospital can send to the press and use in pamphlets and brochures.

A medical photographer must also be well organized and follow instructions carefully. Some medical background helps, as the language is unique, but I learned it on the job. There has to be rapport between the photographer and the medical staff. The photographer must be as inconspicuous as possible, especially in the operating room, and also be careful not to contaminate. The medical photographer should move quietly and swiftly. Studios in hospitals must be scrupulously clean. Planning and briefing are also very important in medical photography.

I feel the work, the contribution of the medical photographer, is important. The communication through print, through projection at lectures, is significant. A photograph, whether black and white or color, disseminates valuable information, enhances the prestige of the doctors and the hospital, and contributes to the improvement of patient treatment. Visuals speak louder than a thousand words.

Photographs describe a clinical, a pathological, a surgical problem, and can be disseminated worldwide. Many recent findings are communicated through photography to those places not able to do their own research. Some hospitals have to produce a tremendous amount of prints, and have darkrooms equipped with mechanical processors. Working in the darkroom can be one way of getting into medical photography. But if you were to question a group of medical photographers, you would find that there are many ways of getting into this field.

Although as previously stated, most medical photography jobs are in-house, there are some free-lance medical photographers, especially for plastic surgeons for before and after photographs of their patients. In my case, while working in still photography I learned filmmaking, film editing, and video, and also—very important—all the dos and dont's of using this equipment in a hospital, in an operating room. Now I am a free-lance producer of 16mm surgical films, doing all the shooting and editing. I also do video. This is my specialty. My expertise is based on twenty years of experience.

For medical photography, you have to have a really good technical grasp of photography. You have to know your cameras, your lenses, lighting of all kinds. For instance, in the operating room, you cannot use lights that will increase the heat. You have to know your films, black and white and color. You have to know printing.

However, there are certain things about medical photography that would make it difficult for some people. For one thing, if you are squeamish, it's not an area that would be suitable for you. Secondly, it's a high-pressure situation, so if you cannot work under high pressure, it's a field that would not be suitable for you. When the doctor needs you, he needs you. Something's happening, they want you right away, you have to drop everything and go running.

There is no glamour in medical photography. It requires a strong stomach, hard work, long tedious hours, and a personality that can hold its own in emergency situations.

So why am I in this field? I believe in the hope and promise inherent in medical science, and I want to be part of that struggle. The reward for me is in being part of something that is helping mankind.

I went to photography school, and when I finished, I looked for a job for six months. I found a job in a hospital photography department at very low pay, as darkroom technician, floor washer, flunky. The boss was impossible, and I quit after six months. I was unemployed for quite a while again, but found a job with a wonderful boss, and under him I began to do medical photography.

When he left, less than a year later, I ran the department. Then, with only two and a half years of experience, I transferred to a hospital that was just setting up a photography department. I convinced them that I could do it.

I designed the darkroom for processing and printing both color and black and white. I purchased a Hasselblad camera, a Nikon, a Polaroid copying device for making slides, an Arriflex 16mm movie camera, and all the lighting that would be needed for the department. We were equipped to do clinical, surgical, photomicrography, and public relations photography.

Others may not agree with me, but basically, my feeling about photography is that if you are a good photographer and are in control of all the fundamentals, there is no reason why you cannot apply your knowledge to any field of photography. If you are a good photographer, you should be able to do fashion photography, medical photography, industrial photography. You may have preferences, just because of your

own personality, but technically speaking, there's no reason why you can't apply basic photography to all these different fields.

When you read about medical photography, you realize that it is photography in a highly structured setting. A photographer like Dianora Niccolini, who functions extremely well in the medical photography field, is also aware of the more creative aspects of the medium. It's important to read about her other activities in photography to see how she uses it outside of her specialty, as a means of expressing her feelings about life and the world, and carrying out ideas that are important to her.

Besides her career in medical photography, Dianora Niccolini actively pursues many personal photographic projects, and is involved in activities with other photographers. Her motivation here is similar to her attitude toward medical photography, expressed earlier: "The reward for me is in being part of something that is helping mankind."

These "extracurricular" activities include exhibitions in galleries that sell her work as art. She has taught. She writes on photography. She is the spark plug behind an organization called the Professional Women Photographers. She conceived and helped carry out a compilation of the work of twenty photographers, which was published in 1982 as a book entitled *Women of Vision.*

She explains why she is so involved with other photographers.

DN: I like to use photography to work with other people—I love it. I think life has no meaning if you're isolated. I think sharing is extremely important, and one must make the effort because photography can be very isolating.

In 1975, for the International Year of the Woman, there was a group exhibition of women photographers, and I had some personal work in it. The exhibition was organized by the U.N., and it had quite an impact. About fifteen photographers from that show came together. Dannielle Hayes and Nickola Sargent started a newsletter to keep in touch. This led to the formation of the Professional Women Photographers, which now numbers over four hundred members. We have a gallery and publish a newspaper. The members work in every area of photography. Meetings are held once a month to share ideas, and to announce job openings, and at least one or two members will show and explain their work. Like so many professional organizations, it serves as a wonderful support system.

Prior to the formation of Professional Women Photographers, I banded together with other like-minded photographers in the early

seventies, who formed a cooperative photography gallery in Greenwich Village, NYC, to show the experimental and expressive work we were producing. We called it the Third Eye Gallery, and it had a life span of several years. I had a number of shows there. We got attention, and through the gallery we shared our work with all kinds of people.

I had a show there on the male nude. Men would come in and get upset and indignant, and say, "What woman would dare do this?" not realizing that men had been photographing women undressed for years and never questioning it. The ludicrousness of being indignant about male nude photography is beginning to register. There have been many other photographers also doing it and showing their work in exhibitions, so another inequality is being atrophied. I have also had several shows in various other galleries and museums.

She goes on about her other personal photography projects.

DN: Before becoming a medical photographer, I was interested in art. I came to realize that photography is a great tool for creative expression that hasn't been fully explored even yet. It has great potential to externalize inner feelings and thoughts and to make statements that can alter people's prejudices and expand their thought processes.

I do experimental color photography, and one of my projects is to take a theme, such as the Mona Lisa, and work on it. I find her much-lauded smile very stupid and idiotic—it's what men think women should be like. I copy it, make distortions, add color, sandwich it with other transparencies, and keep making copies in color. Every time you copy a slide it becomes more contrasty and the color becomes more intense. It is my way of commenting and pointing up what I consider the simpering role that has been imposed on women.

Lately, I have been using these color photography processes to express my patriotic feelings about our country. I see a reversal of exploitation of us by others, and I don't like the attitude of the rest of the world toward us. I'm sick and tired of anti-Americanism. I think we're a wonderful people, and I'm working on that motif, using the emblem of the flag.

I've been working on an extension of the male nude project, in straight black and white, which I call *Men in Focus.* Again, I reversed the practice in photography of using women as objects in front of the

camera. I did this not to hurt men, but to show the unfairness to women. I have had two exhibitions of this work, and a book entitled *Men in Focus,* published by Morgan & Morgan. I believe these efforts have made an impression, even though a small one, and that is my intent—to ameliorate an attitude I feel is hurtful to women.

In the summer of 1981, Dianora Niccolini had an exhibition to pay homage to her mother, who had recently died. It was a most deeply moving body of work. It comprised thirty black and white photographs, which she created out of pictures from the family album, and photographs she had taken of her mother and the rest of the family at various times and at family events. She used several techniques—collage, montage, and superimpositions—to heighten the feelings she wished to express. The text she wrote was equally poetic. It was a most beautiful memorial, and will be made into a book which no doubt will have broad appeal. Besides the two exhibitions, these photographs were chosen to be in the photographic section of exhibits held all over NYC in the spring of 1982, sponsored by the Women's Caucus for Art and several city, state, and federal agencies.

It is important to point out all the extra activities photographers engage in outside of their career specialties. It shows that they are not locked into one aspect of photography, that they use the medium in so many ways. This is one of the big attractions of photography: One can do so much with it.

Ida Wyman: **Photomicrography**

○ Ida Wyman is a specialist in photomicrography at The College of Physicians and Surgeons, the medical school of Columbia University. She has had two distinct careers in photography, both equally successful. Her early career, described in Chapter 2, was as a free-lance photojournalist working for leading national publications, such as *Life, Look, Business Week, American Weekly, This Week, Fortune,* and many others, from 1945 to 1951.

There was then an eleven-year hiatus, which Wyman spent at home with her young children. Although she continued to photograph, it was on a less-active level, mainly photographs of her family, neighbors, friends, and surroundings.

In 1962 she returned to the work world, and didn't even think of returning to her former career. It takes time to rebuild your contacts in the free-lance world, and because of her family obligations, she needed a job with regular hours. The job she found was the beginning of a new career in medical photography.

Since our primary interest in this chapter is to learn about the specialties in medical photography, Wyman will explain photomicrography.

IW: Photomicrography is a long word used to describe photographs taken through the microscope. It is a special microscope with fine optics, and attached to it is a device similar to a camera back for transporting film. In place of the camera lens, you view through the objectives of the microscope. The term "objectives" refers to the lens system of the microscope. Objectives and lenses serve the same function: They allow the light to be transported to the film plane area. Just as a superior lens in a camera gives you a better picture, so the objectives of the microscope must be free of any aberration. For regular viewing through a microscope, it is not as important to have the same very fine calibre of objectives as are needed for photomicrography. The manufacturers of the photomicroscopes also manufacture the film transport backs. So one could say that the photomicroscope is a very special camera.

There are many kinds of microscopes designed for photomicrography, depending on what is to be photographed. You can use roll film or cut film. I have two microscopes, and on both I can use black and white or color. In actual practice, I use my 35mm scope to produce color slides, and I use the larger scope, which takes four-by-five cut film, to do black-and-white photographs for publication. The larger negative gives me an excellent contact print, and most medical journals only require a four-by-five-inch print for reproduction, or sometimes they ask for a five-by-seven-inch print.

For photomicrography, you load your film as you do a camera, and you look through the microscope. Since I work in the Pathology Department of The College of Physicians and Surgeons, I view a glass slide that contains stained tissue, usually of a surgical or autopsy specimen. The tissue could also be from an experimental lab animal that's being tested by a researcher.

When the glass slide that holds the stained tissue is put in position for viewing through the scope, a light in the microscope is passed through that specimen to illuminate all the features. The photomicrographer must know how to adjust the light, first for viewing, and secondly to correct it for the exposure. The key factors in photomicrography are focus, color balance, and exposure.

The slide is lit from underneath, a process called transillumination, and the light must be centered. The pathologist's aim is to have as many features of the tissue as possible on the 35mm color transparency.

Since the pathology department that Ida Wyman works in is in a medical school, the transparencies are used:

1. To teach the students.
2. For conferences.
3. For seminars.
4. When there is interaction with other departments, such as surgery, medicine, pediatrics, and so on.
5. For reproduction in books and medical journals.

Specimens are photographed because:

1. They show something unusual or a rare case.
2. They show a classic case.
3. They show something new that has been discovered. New learning emerges constantly, and new findings happen with regularity.

IW: Because of magnification, only a section of the specimen is covered. Sometimes a pathologist will circle the area he or she is interested in. It is the pathologist's knowledge that determines what should be photographed; it could be cellular detail, or connective tissue, or several other features.

Often the pathologist comes in with many slides, up to forty. In those cases, I photograph at the microscope with the pathologist at my side to direct me to the area in the specimen they want photographed. Besides being a challenge photographically, it is a very human situation, and I work with many interesting people. The College of Physicians and Surgeons is a leading institution, with many prominent pathologists, some with international reputations. There are also people from other parts of the country and other parts of the world, and aside from the photography, I've enjoyed the contacts very much. I've learned much about people, their lives, and their backgrounds.

When there are many slides, the pathologist keeps a list of the sequence of the pictures, and each roll is numbered to keep the correct order of shooting.

Frequently, a doctor will ask, "Can't you make a black and white from the color transparency?" "Yes," I reply, "but it's better to have the original microslide from which to work," so we set up another appointment to shoot in black and white.

There are times when it is so busy that I've worked with two pathologists, one at the color scope and one at the black-and-white scope, shuttling back and forth between the two. However, I prefer to give my attention fully to one.

I do all the black-and-white processing and printing. The color is sent out, and the Kodak lab does an excellent job.

The larger scope, which uses four-by-five cut film in holders, is much more sophisticated than the 35mm scope. In addition to the transillumination, it has the capability of epi-illumination (lighting from the top). The wonderful thing is that the image on the four-by-five ground glass makes the observation and the composition much easier for the doctors to look at, instead of the tiny rectangle of the 35mm scope. We can see exactly what we're getting.

The magnifications on the 35mm scopes vary, mine range from 40 times to 950 times. The magnifications on the four-by-five scope are 25 times to 600 times, and for viewing purposes, the magnification can be increased to as high as 1,500 times.

The first appointment usually starts at nine-thirty A.M. The procedure is, someone calls up and may say, "I have a conference." I will ask, "What is your deadline?" If the reply is, "Two days," I have to find a way to get it done. I will use a messenger service, if we've missed the daily pickup from the color lab, to get the film to Kodak. Since conferences are very important in the pathology department, and color slides are expected, sometimes I must give explanations to get their work done. Since the scheduling is more flexible for publication, I must diplomatically get someone whose photographs are for publication to shift their appointment. But people guard their appointments zealously, and no one likes to give up time.

I try to keep the photomicrography for the mornings, and the darkroom and other work for the afternoons. Often, I am hard-pressed to please everybody, but I believe that I have managed to keep people satisfied, and there are many people I have to work for. There are several divisions in the pathology department, and many people in each division.

People are constantly being invited by other institutions to give lectures for which they need visual materials, and they also need transparencies when they have to give papers. All this generates a spate of appointments and keeps my appointment book full.

Photomicrography takes up eighty percent of my time, and the rest of my time is taken up doing a number of other things.

I mix chemicals, and I print and develop the black-and-white shot the previous day. I sort the slides. There's never a lack of things to do. The day passes too swiftly, and the phone rings.

I also make diazo slides, a process I do not like. They are made from a litho negative sandwiched with a material; when they are exposed to ultraviolet light and processed in twenty-eight percent ammonia fumes, you get the unique characteristic of a solid-color back-

ground of blue, or red, or yellow (blue is the preferred one) instead of white. It is a complicated, time-consuming, four-part process: One, shoot the litho film; two, process and dry it; three, expose it to ultraviolet light for eight to ten minutes; four, then another ten minutes in ammonia fumes. I try to discourage requests for these slides because the ammonia fumes are unpleasant, they are a health hazard, and the slides do not have the permanence of regular film material.

I make color slide duplicates with a special slide duplicator. I copy color illustrations and type material from books, with a 35mm camera and a macro lens for edge-to-edge sharpness. I also do slide binding.

I like to take informal portraits of people in their offices, labs, and around the hospital, using available light. I have one strobe, which I use to photograph events in the department: dinners, speakers, and other functions. Sometimes I also use Polaroid film materials on a camera with a superb lens, from which I make a collage which the chairman presents before the end of the affair, and this always creates a stir.

Occasionally, I get a request to photograph a patient. Photographers attached to surgery usually do this work, but I never say, "You've called the wrong photographer." I enjoy doing it, I enjoy the diversity. The photographs may be needed if the patient is going for surgery. The instructions usually go, "We'd like three views, a front and two side views," or it can be, "Just do the upper torso" or "the lower torso."

I have also photographed gels showing protein distribution, and agar plates (a round dish called a petri dish) in which various cultures have been developed. This work requires filtering and special films to bring out the colors. I have also photographed instruments, old ones, and new ones that someone has perfected. These pictures may be needed for a talk or for reproduction.

When I first came to this institution, the job description required only photomicrography and making slides. But I managed to let people know that I would do anything photographic. I like the variety and the opportunity to exercise my photographic skills.

LM: *How did you come to this job?*

IW: I was recommended by my predecessor, who knew me through the professional group we both belonged to, the Biological Photographic Association.

My previous job was in Haskin's Laboratories, now associated with the Yale University Speech Department. They did basic research investigating the quality of electrical impulses given off by the muscles in

the creation of speech. All kinds of people were tested: deaf speakers, normal speakers, people who had had strokes, people with tongue-thrusting problems.

They used one-quarter-inch electrodes on all the areas involved in producing speech—the tongue, the lips, the soft palate, etcetera—and measurements were made. I worked there for six years, enjoying the work and the people. It was a wonderful place.

LM: *How did you get the job at Haskin's, and why did you not return to free-lance magazine photography?*

IW: The answer to that question lies in the fact that I had children to take care of. And I feel that since young women will be reading this book as well as young men, the problem of a woman alone with children and pursuing a career in photography should be presented.

I spent eleven years primarily at home, devoting myself to my children, because I felt that they needed me as much as I had a need to be with them. During that period I did a limited amount of photography.

However, because of financial reasons, the time came when I had to get a job. Although I would have liked to return to magazine photography, I didn't consider that a possibility for the following reasons: 1.) Once you're out of free-lancing, it takes time to reestablish contacts. 2.) Free-lancing in photography for magazines necessitates irregular hours, and often travel, and I wanted to be home *every* evening with my children.

I answered an ad in *The New York Times* that read, "Person with native intelligence and ability to use hands." Nothing at all about photography was indicated. After I got the job, I created the photography part of it.

Initially, it involved putting together test tapes taken of the people who were going to be the future subjects. I also made the quarter-inch electrodes. I made charts, and finally I understood that drawings were made of the subjects, which were only an approximation of where the electrodes were placed on the subjects' faces.

I realized that photographs would be more accurate. The director of the laboratory had been involved in photographic color research, and there was this perfectly good basic darkroom in the lab. When I saw that, I said, "Well, I could work here, and with my Rolleiflex and a flood light, I can photograph." With the director's approval, I began to photograph, showing the positions of the electrodes on the subjects' faces and neck areas. To photograph the mouth and inside it, I needed a 35mm camera, close-up attachments and a ring light, which

the lab purchased. I was in business again as a photographer, and making use of my photographic knowledge made my life a lot happier. I also did the darkroom work.

I then met someone who belonged to the Biological Photographic Association [hereafter referred to as the BPA], which I had never heard of before. I joined the group, and took several mini-courses that they offered: How to Work with Litho Film, How to Photograph Small Objects. Another course they gave was on making slides from a typed sheet or a book. At this point, I was only doing coventional photography at Haskin's. I had never made a slide in my life—that is, a black-and-white or a color slide made from typed copy or an illustration. It was a revelation.

That course made me realize that slide making was important to the work at Haskin's. So, we got a Polaroid camera set on a baseboard with its own lighting system, and used it to photograph printed material and laboratory apparatus. I took a BPA mini-course on how to photograph patients. I did all of this before I ever dreamed that I would be in a position to use this knowledge.

[As you can see by Ida Wyman's example—and it's a point made over and over again in this book—almost all the photographers have gotten into their respective fields in their own unique way.]

I've always been very curious to know something, even if it doesn't have any immediate relevance. I find that my natural curiosity has impelled me, and when there is an opportunity to learn something, I feel that it's never wasted. It's enriching in many ways, and it is sometimes very pertinent in terms of the work, and sometimes it turns out to be very practical.

This is how I got into photomicrography. It was another course offered by the BPA. I hadn't looked at a microscope since I was in high school, and when the BPA offered that course, I thought, "Well, this will be fun," and actually, it was fun. I learned a great deal, and the course was given in the very room that I am working in now, and have been working in for the past fifteen years.

The instructor was my predecessor. There were six of us in that group, and everyone else had had some experience with the microscope. Actually, it was a brushup course for the others; I was the only novice.

Two or three years later, the instructor, whom I saw often at BPA meetings, was moving to another job, and he called me.

[This is one reason why it is so important to belong to professional organizations.]

He knew about my background as a magazine photographer, and about the work I was doing at Haskin's. He asked if I would be interested in replacing him.

"Yes," I said, "but do you think I'm good enough, because I haven't had any working experience in photomicrography?" "Yes," he replied. "You know more than the job requires." He liked the idea that I had other photographic experience. I was then interviewed by the chairman of the department. I had no scientific pictures to show him, other than the photos from Haskin's and the few photos taken at all the various BPA mini-courses. I told him that I had not had any real experience with a microscope. He said, "Okay, we'll have a three-month trial period." That seemed fair enough. A few other staff people looked at my work and liked it.

They felt that I was a serious, competent person, even though I only knew the basics of photomicrography. I really wanted to be very good at this, and so I started, and I learned by doing.

LM: *Did you overlap with your predecessor?*

IW: No. When I started, he had already left, but his assistant, who was also moving to another institution, was with me for about two days. So I was left on my own there. For about three months I was a little insecure with the two microscopes. It was all different from my previous photographic experience, the magazine work and the work at Haskin's.

One must remember that there are not only the basics, but there are always many subtleties which you only learn by doing, by experience. It all worked out almost from the beginning, but I was on edge. For the first few weeks, I had a list—Step One, Step Two, Step Three, etcetera. I knew it in my head, but I was afraid that out of nervousness, I would forget something crucial. I kept the list off to a side, and unobtrusively I would sneak a peak at it. Having it there reassured me.

Once I got the practice, the steps were very logical, and I found that there was no difficulty at all, I just needed to pay very careful attention to details. Now, with experience, I understand more about the tissues, and where to focus; and those things, of course, are the crucial matters.

LM: *Has the job gotten boring?*

IW: No, there are so many diverse things to do. Also, it's very good

to be part of the important work that the doctors I work for are doing, and it's nice to see the work published. I also enjoy the close contacts with the people I do the work for.

Ida Wyman is very highly regarded in her field for several reasons: 1.) the consistent high quality of her work, 2.) the tremendous amount of work she produces, 3.) her concern about the needs of the doctors for whom she works, and 4.) her ability in a very wide variety of photographic techniques.

Don Wong: Fluorescein Angiography

○ Don Wong commenced his career in medical photography in 1953. His experience covers all aspects of general medical photography and many of its specialties. In 1956, he moved exclusively into the ophthalmic (eye) area of medical photography, and eventually became the manager of the Ophthalmology Department of the Cabrini Medical Center, NYC.

Ophthalmic Photography

DW: Three of the major photographic techniques which serve ophthalmic medicine are: 1.) fluorescein angiography, which is a diagnostic tool performed with a special apparatus; 2.) the fundus camera, which obtains rapid-sequence photographs after injection of special dyes that reveal the retinal circulation; 3.) slit-lamp photography, performed through a binocular microscope which has a slit-lamp illuminating source attached to it. This slit illuminator produces a very fine, sharp focal beam of light, which reveals various layers in the eye tissue under the surface. These eye tissues are not visible under ordinary illumination. In slit-lamp photography, the photographer must control and focus the slit beam of light to reach and reveal the specific layer in the eye needed to be photographed.

Eye tissue ordinarily appears to be transparent, but the fine beam of light shows detail and the photographer must try to get as much contrast as possible between the illuminating beam and the nonilluminated area around it in order to get a good image. While doing all this—controlling the light beam and focusing—the photographer must also be able to manage the patient. The apparatus has a brace against which the patient rests his or her head to keep it as still as possible. While making the adjustments, which can take a while, there is a tendency for the patient to jerk and to blink frequently or to get high-

strung. The photographer must be aware of this problem and must consciously try to calm the patient. These steps can be very difficult and challenging. They are slow and time-consuming, requiring patience and concentration on the part of the photographer.

History of Ophthalmic Photography

○ In 1964, Carl Zeiss marketed the very first automatic fluorescein angiographic unit. Fluorescein angiography was established as an important diagnostic tool, and the ophthalmologists wanted full-time people to do this work. A whole group of photographers who were previously engaged as general medical photographers, but who had experience in fundus photography, transferred over full-time into ophthalmic photography.

Eventually, in the late 1960s, many hospitals installed angiographic cameras, and it was not uncommon to find that an ophthalmology department in a hospital had a larger photographic staff than the general medical photography department.

Prior to 1969 I was a member of the Biological Photographers Association. In 1969 other photographers who were specializing in ophthalmic photography and I formed the Ophthalmic Photographers Society. We publish a journal twice a year, which I edit.

In order to keep abreast of new techniques, new instrumentation, and to learn more from the doctors about the anatomy, pathology, and physiology of the eye, we attend the Academy of Ophthalmology meetings. We have meetings annually coincident with the Academy of Ophthalmology, where we offer formalized courses of training, a workshop program, and a certification program. The commercial sector supports us and lends us cameras for the training sessions.

[For detailed information write to Ophthalmic Photographers Society, ATT: Mr. Don Wong, Cabrini Medical Center, 227 East 19th Street, NYC 10003.]

Mr. Wong has written a comprehensive text on the techniques of ophthalmic photography entitled *A Textbook of Ophthalmic Photography,* published by Inter-Optics Publications, Birmingham, Alabama. To order, contact Mr. Wong.

Although we have already described medical photography, Mr. Wong breaks it down by apparatus and technique:

DW: 1. When you work in a large general hospital, you photograph patients coming in for a number of services: urology, dermatology, plastic surgery, medicine, surgery, and so on. Here, the technique one

encounters is photography of the patient—mainly, full body, half body, extremities, legs, arms, hands, fingers, toes, etcetera.

This is general medical photography using conventional camera equipment and techniques. By conventional techniques I mean using a standard camera, standard lighting, and being able to focus from infinity to three feet in a studio or in a hospital setting. Your main responsibility is to follow the criteria set up by the physicians and surgeons whom you serve. Medical photography is not only an aid to the medical profession, but is also a legal document at times.

2. Photomacrography, or close-up photography. In this work you use a conventional 35mm camera and a special lens to bring the focus up to one-to-one and up to one-to-ten times magnification. This is used in the photography of gross specimens in the pathology lab, and so on.

3. Photomicrography is beyond that ten-times magnification. You do not use conventional photographic equipment. This requires the use of a microscope, special lighting, and an attachment that acts as a camera back, which performs the task of housing and transporting the film. (See page 140, for a description in depth by Ida Wyman, a photomicrographist.)

4. Photography of cavities: the ear, nose, throat, and the inside of the mouth. This is done with conventional cameras with close-up attachments, and special lighting. The ring light was developed to help deep-cavity work. (This is not to be confused with photomacrography; it deals with less magnification than that.)

5. Gastroendoscopes are used to photograph the inside of the stomach and the esophagus. It is called fiberoptics, and can be described as plastic tubing resembling a periscope. The observations are done through the 35mm single lens reflex camera attached to the apparatus.

6. Ophthalmic Photography: Slit-lamp photography, and fluorescein angiography, explained above.

History and Development
of Medical Photography

○ Medical photography started in the 1800s. It was done by the portrait photographers, so all the early medical photographs had the trappings of a portrait studio: the velvet backdrop, the stand with the flowers, ornate drapes, the love seat in the background. The New

York Eye and Ear Infirmary is over one hundred years old, and they used photography since their beginnings. The Philadelphia *Inquirer* ran medical photographs along with their medical articles. The first fundus camera was developed in the early 1900s by a German scientist. The term *fundus* refers to cavities, such as the cavity of the eye, the mouth, and so on. Any fundus photography done prior to that was done with customized pieces designed by physicians.

In the early 1900s, Dr. Arthur Bedell of the Wills Eye Hospital in Philadelphia did much fundus work, and it was excellent work. He was very active academically and he went on lecture trips. In his professional lifetime he made over three hundred thousand color photographs.

Out of his training of young ophthalmologists, he generated another group of physicians who were weaned on the use of photography. They went out into the field, and many of them purchased similar equipment for their own hospitals, and so the field grew.

In 1961, two medical students at the University of Indiana happened upon fluorescence, and they wondered whether or not fluorescence in the eye could be photographed. Their supervising professor said that it was a valid proposal and suggested that they might look into it. They went to Kodak to get information about films responsive to fluorescence, and about proper filtration. They then went to the pharmaceutical houses to see which dyes were available that would give fluorescence, and they settled on a dye called sodium fluoroscene. On the very first injections the first successful angiogram was obtained. One doctor did this to the other. They were not photographers; they knew nothing about photography, but with the information they had gotten from Kodak, they were able to get an image following injection. They photographed the circulation of the dye through the retinal vessels, and this was of course a tremendous breakthrough.

The commercial people became interested, and by 1964, Carl Zeiss marketed the very first automatic fluorescein angiographic unit. Fluorescein angiography became established as an extremely important diagnostic and research tool.

In contemporary times, the developments in general medical photography accelerated rapidly after the Second World War. During the war there was a need for crash courses of education in medicine and the sciences, and photographs were needed as teaching tools. Then, as a result of all the trauma the physicians encountered during the war, the specialty of reconstructive plastic surgery developed. Surgeons were doing so much extensive surgery on patients, that they

CHAPTER 1, FREE-LANCERS
Chinese New Year's celebration photographed by Martha Cooper
on Mott Street in Chinatown, New York City.
Photo © 1983 Martha Cooper

CHAPTER 1, FREE-LANCERS
This photograph, taken in 1950 by Ida Wyman
for *Life* magazine, is of Lucille Ball and Eddie Albert
during the filming of *The Fuller Brush Girl* in Hollywood.
Photo © 1983 Ida Wyman

CHAPTER 2, BOOKS
Amish farm children in Lancaster County, Pennsylvania,
photographed by Erika Stone during the production
of her book *Nicole Visits an Amish Farm*.
Photo © 1983 Erika Stone

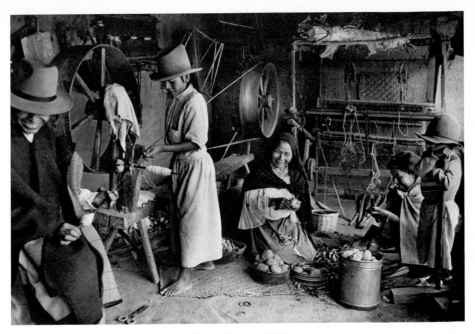

CHAPTER 2, BOOKS
Family scene from Bernard Wolf's book *The Little Weaver of Agato,*
about the life of an Indian boy living in the Andes Mountains of Ecuador.
Photo © 1983 Bernard Wolf

CHAPTER 2, BOOKS
A Sonja Bullaty photograph from *Vermont in All Weathers,*
photographs by Sonja Bullaty and Angelo Lomeo with text by Noel Perna.
Photo © Sonja Bullaty

CHAPTER 2, BOOKS
Québec (Canada) children
with ecclesiastical woodcarving
photographed by Lida Moser in 1950
while on assignment for *Look* magazine,
and published again in 1982
in her book *Québec, à l'été, 1950*
(Québec in the Summer of 1950).
Photo © 1983 Lida Moser

CHAPTER 2, BOOKS
Bernard Wolf's photograph from his book about a blind girl,
entitled *Connie's New Eyes*, showing Connie with her seeing-eye dog.
Photo © 1983 Bernard Wolf

CHAPTER 2, BOOKS
From the Kathryn Abbe and Frances McLaughlin-Gill
book *Twins on Twins*—Yarmila and Rocio Aragon,
who were college students interested in ballet
and poetry at the time the photograph was taken.
Photo © 1980 Kathryn Abbe and Frances McLaughlin-Gill

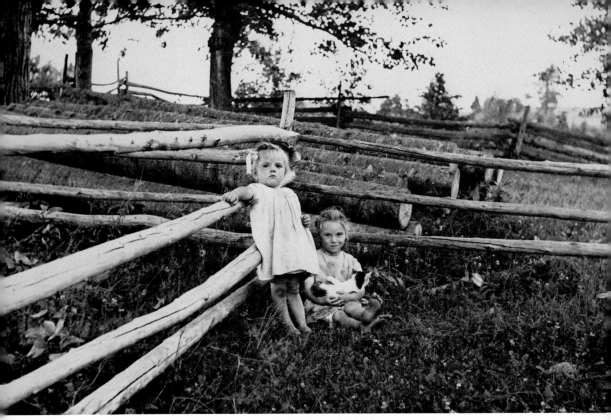

CHAPTER 2, BOOKS
Children in the Gaspé Peninsula, Province of Québec, Canada, were photographed by Lida Moser
in 1950 while on assignment for *Vogue* magazine, and published again in 1982 in her book
Québec, à l'été, 1950 (Québec in the Summer of 1950).
Photo © 1983 Lida Moser

CHAPTER 3, PRESS
Frank C. Dougherty photographed
this Palestinian fighter near
the Beirut Airport while
covering the war in Lebanon
in 1982 for *Newsweek* magazine.
Photo—Frank C. Dougherty/Camera 5

CHAPTER 3, PRESS
While on assignment covering
Western State Hospital, a psychiatric hospital,
Chris Johns photographed this patient
who found her own space
on a second-story window sill.
Photo—Chris Johns/The Seattle Times

CHAPTER 3, PRESS
While on assignment covering a volcano, El Chicon, erupting in Mexico in 1982,
Chris Johns photographed this Mexican soldier as ash rains down behind him.
Photo—Chris Johns/The Seattle Times

CHAPTER 4, ADVERTISING
A Nancy Brown photograph for Compton Advertising for Pert shampoo.
Photo © 1983 Nancy Brown

CHAPTER 5, MEDICAL AND SCIENTIFIC
Photomicrograph taken by Ida Wyman.
Photo © 1981 Ida Wyman

CHAPTER 5, MEDICAL AND SCIENTIFIC
Dianora Niccolini photographed this newborn baby
as one of the many different types of
medical photographs she did while working
as a photographer in a hospital.
Photo © 1983 Dianora Niccolini

CHAPTER 6, STAFF
Frida Schubert,
RCA staff photographer,
took this product shot to show
how the RCA VCR camera works
in conjunction with a TV set.
Photo—Frida Schubert/RCA

CHAPTER 6, STAFF
A press type photograph made by Frida Schubert of Eubie Blake, ragtime composer and performer,
when he was 99 years old. It was taken at a press conference for the introduction
of one of the first RCA video discs, March 1982.
Photo—Frida Schubert

JOHN LENNON IN NEW YORK
PHOTO BY.
BOB GRUEN 1975

CHAPTER 7, PERFORMING ARTS
John Lennon was photographed by Bob Gruen on a New York City rooftop after a session
for the cover of a record album. This photograph has been reproduced more than any other
Bob Gruen photograph and has also been made into posters and postcards.
Photo © 1983 Bob Gruen

CHAPTER 7, PERFORMING ARTS
A Kenn Duncan studio portrait
of Mikhail Barishnikov, ballet dancer,
in the costume of the ballet *Shadowplay*.
It was taken for an American Ballet Theatre
souvenir program.
Photo © 1983 Kenn Duncan

CHAPTER 7, PERFORMING ARTS
This is a Metropolitan Opera House
opening-night photograph taken by James Heffernan.
Photo—James Heffernan/Metropolitan Opera

CHAPTER 7, PERFORMING ARTS
Dancer/choreographer Twyla Tharp.
Photo © by Jack Mitchell.

CHAPTER 7, PERFORMING ARTS
Actress Meryl Streep.
Photo © by Jack Mitchell.

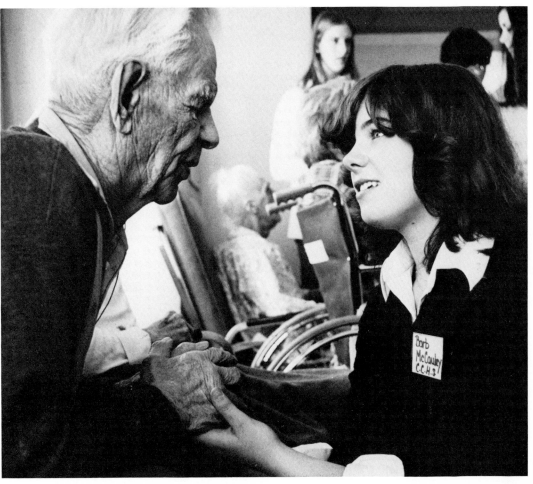

CHAPTER 8, STOCK
This photograph by Ann Hagen Griffiths of a teen-age volunteer in a nursing home
has sold well through the stock photo agency DPI.
There is a demand for this type of photo
because of the unique feeling between the young person and the elder.
Photo © 1983 Ann Hagen Griffiths/DPI

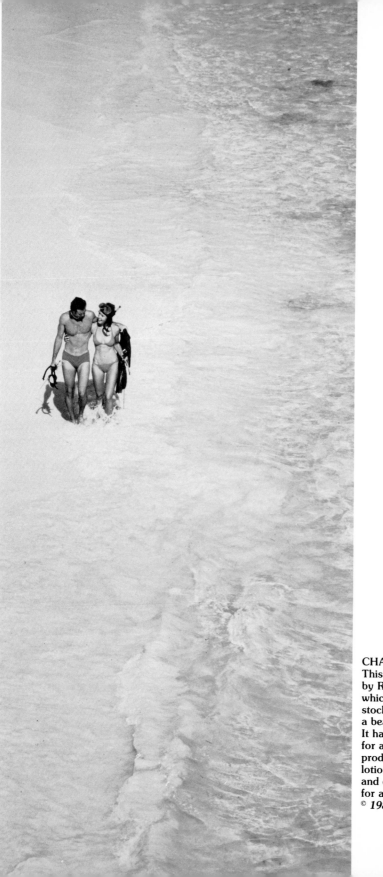

CHAPTER 8, STOCK
This photograph
by Robert T. Panuska,
which is sold by the photo
stock agency DPI, could be
a beach scene anywhere.
It has had success in sales
for advertisements for
products such as suntan
lotion, for travel brochures,
and even for a premium
for a give-away trip.
© *1983 Robert T. Panuska/DPI*

wanted to have a record showing the condition of the patients at successive stages throughout the treatment.

They started to take pictures themselves, or they would hire a photographer. In the military, Signal Corps photographers helped them. When these same doctors came back into private practice, they carried over this desire to have photographic documentation. In the late forties, there was quite a vigorous growth of medical photography in the whole country. This was helped by the VA [Veterans Administration] hospitals, which had photographic and illustration services, staffed by veterans with experience in medical photography in the armed services. I came into medical photography in 1953, and it was still growing.

Other factors contributed to the expansion of medical photography. In the early fifties, the 35mm single lens reflex camera emerged, and it is the perfect tool for scientific photography. You can look through the viewfinder and focus, and it can be attached to a scientific instrument.

Another important factor supporting medical photography is the malpractice situation in this country. Medical photographs can serve as legal documents. All plastic surgeons want to have a pre-op photograph and a post-op photograph in the patient's file, as a protection for themselves and a protection for the patients. Plastic surgery is a large client, and was one of the early strong supporters of medical photography.

The pharmaceutical houses recognized the value of photographic documentation for promotional campaigns, for research, and in the preparations of new medications.

All these factors contributed to the growth and evolution of medical photography.

Jerald Morse: Scientific Photography

○ With ingenuity, intelligence, and persistence, Jerald Morse introduced photography into the position he held as storekeeper in the Department of Forestry and Resource Management at the University of California in Berkeley. It wasn't easy, but he worked away until he was able to accomplish his goal, and eventually photography became the most important part of this job. Two other photographers who achieved the same thing are Ida Wyman, who describes her career earlier in this chapter, and Frida Schubert, Chapter 7.

Let's hear directly from Jerald Morse about how this evolvement took place.

JM: I was originally hired as a "storekeeper" in 1974, in charge of purchasing, field instrument repair, and audiovisual equipment. When I came to the forestry department, extensive renovations had created a new machine shop and photo darkroom to aid research and teaching programs.

The Department of Forestry and Resource Management is part of the College of Natural Resources on the Berkeley campus, and is considered one of the finest undergraduate and graduate professional training schools for foresters and wildlife managers in the country. They train people for government positions in policy and research as well as for private industry jobs in forest management, range management, aquatic biology, wildlife policy, forest economics, and forest genetics.

While I was officially storekeeper, I did photographic work for the forestry department, working nights and weekends without extra pay for a period of six months. Often it was discouraging, but ultimately it worked out, and I succeeded in proving my capabilities. They realized that instead of going to outside sources for their photographic needs, I could do that work effectively. In 1976 my title was reclassified to "photographer."

I perform various tasks in biological photography, as well as general photographic work. The photographs are published in research journals, university catalogs and bulletins, and are also used as classroom teaching aids.

My general photographic work includes:

1. Processing both color and black-and-white film for faculty and graduate students.

2. Printing color and black-and-white enlargements for same.

3. Retouching damaged prints.

4. Photographing special occasions and visitors.

5. Giving advice to students and troubleshooting their problems in photography.

6. Copy work on: a.) continuous-tone film; b.) high-contrast graphic arts film; and c.) color film. This copy work and slide production is for classroom use, and I do it with a Nikon 35mm camera with a 55mm Micro-Nikkor copy lens, which focuses from one inch to infinity.

Examples of Scientific Photography Work and Types of Equipment Utilized

1. I've done close-up photographs of aquatic insects grazing on streamside grasses at night. This can involve several days of repeated trekking in snowshoes across wet Sierra meadows to the study site, and then careful utilization of macro-photographic equipment, a Hasselblad 500 C/M 2¼-inch reflex camera with a wide-angle close-up lens, in combination with Honeywell strobe lights, since I was shooting at night. Also, the close-up macro lens is important here because of its capability to focus down to one inch, whereas regular lenses generally do not focus closer than ten inches.

2. I photographed and edited a 16mm film of caddis flies mating on meadow grasses. After studying the insects' behavior, I used a 16mm Bolex motion picture camera with extreme close-up lens and hours of patience to document the brief mating display. (Caddis flies are aquatic insects with life cycles similar to butterflies and moths, in that they go through egg-larva-pupa-adult stages.) They build beautiful cases of tiny stones, sand, and leaf matter found on the stream bottom where they live in their larval stage.

The film is shown at scientific meetings and seminars as documentation of the particular behavior pattern we sought to record, and will also be used as a teaching aid in animal and insect behavior classes.

3. I record the results of the differing growing treatments on root growth of Douglas fir seedlings. After removing the seedlings from soil, they are placed on a light table and photographed with a Calumet 4-by-5-inch view camera and studio lights to insure even illumination of all roots.

4. Photomicrography of Protozoa, using a Bausch and Lomb phase-contrast microscope utilizing the many illumination and enlargement features to render structure effectively.

5. Photograph fire-scarred trees in the forest to aid in determining the fire history of a region. Here I photographed this technique. The pictures are taken close-up with strobe lighting for fill to produce a series of step-by-step illustrations of a graduate student removing a precise section of tree trunk, which was then analyzed, its fire scars dated, and later photographed for publication. Fire scars represent ground fires that swept through the forest at various times, but were not intense enough to burn the trees down. Since new bark partially covers the fire scars as the tree grows older, one obtains a marvelous record of fires in a region by looking at the right slice of tree.

6. Precise color printing from aerial U-2's infrared and nine-by-nine-inch natural color transparencies depicting the earth's resources, taken by automatic cameras in the U-2. The color printing is performed with an Omega four-by-five-inch dichroic diffusion color enlarger and a Cosar Mornick color analyzer.

Equipment List

○ A good way to give you an idea of what is entailed in scientific photography is to present a detailed list of the equipment required, and a detailed description of Morse's darkroom. To do scientific photography, one has to be technically minded both because of the nature of the subject and the type of photographic equipment necessary to carry out the documentation and recording of the scientific work. Compare the following list of camera and darkroom equipment with the minimal equipment employed by a photojournalist such as Martha Cooper (see pages 14 & 15). She and several other photographers do not even get involved in darkroom work. As you can see, what's important in one aspect of photography has no significance in another aspect.

> Nikon Ft2 camera, 35mm, with a 55mm f/3.5 Micro-Nikkor copy lens and filters.
>
> Polaroid MP3 Industrial View Land camera with 4″ x 5″ and 120 film backs, and Graflex f/4.7 lens with Graphex shutter. This camera is on a stand, mounted for copy work, and produces photos or slides in thirty seconds.
>
> Hasselblad 500 C/M 2¼″ single lens reflex camera with Zeiss 60mm, 80mm, and 150mm lenses, and an assortment of extension tubes for macro photography, and quick-change film backs and assorted filters.
>
> Arkay Orbit 4″ x 5″ Professional View camera, with a Schneider 135mm lens and a large Majestic tripod to guard against wind shake.
>
> Bolex 16mm Reflex motion picture camera with Switar 25mm f/1.4 close-up lens, Switar f/1.6 10mm wide-angle lens, and an f/1.9 75mm lens.
>
> Bausch & Lomb Bal Plan microscope with provisions for 35mm and 4″ x 5″ film format photography.
>
> Gossen Luna-Pro hand-held exposure meter.
>
> Honeywell Strobonar portable strobe light.
>
> Omega D5 Color Dichroic II diffusion printing enlarger with 50mm Nikkor, 80mm and 135mm Schneider enlarging lenses.
>
> Cosar Mornick 328 Color Analyzer to aid in color printing.
>
> Omega D2V condenser enlarger for black-and-white printing and where contrast enhancement is desired.

Craig 16mm film-editing viewer and splicer.

Rogersol 20″ x 24″ light table and 16″ x 20″ medical light table with very even illumination.

This array of equipment indicates the tremendous variety in the type of work Jerald Morse does.

Just as important as the camera equipment necessary for scientific photography is a well-equipped darkroom. Following is a detailed description of Jerald Morse's darkroom setup.

JM: The darkroom is divided into two rooms: one for dry work—copy work, photo assignments, retouching, etcetera; the other room for wet work—film processing and printing. Both rooms can be made dark, but only the wet room has safelights for printing and processing film. The wet room is divided into two sides—one side is for the enlargers (the dry part of processing), and the other side, the wet side, holds a very large fiberglass sink with a Lauler mixing valve regulating the exact temperature of all water outlets, which is so important to maintain in color processing.

Also very important are an excellent fume hood, located above the sink, to draw away noxious odors, and a thick rubber mat on the floor to minimize fatigue when printing or processing film.

Morse's Background and Training in Photography

JM: My photographic training ranges from university courses as an undergraduate to informal instruction from other scientific photographers. When I began to do photography on my job, I knew little about fine color printing, and had to learn quickly, particularly in relation to infrared photography. An excellent scientific photographer was on the staff of the Space Sciences lab, and I was introduced to him by a mutual friend. He was so generous with information that I learned what I needed to know in two weeks, instead of the two months it would have taken me, stumbling around on my own with dry trade manuals or textbooks.

I have an A.B. [Bachelor of Arts] degree from the University of California in Berkeley in physiological psychology. This involved me in the study of the biological sciences and the processes of the earth's ecology. This scientific background helped me to appreciate and understand the research problems encountered by the forestry department, and to apply them to my photographic work.

My year of graduate study in filmmaking at Humboldt State Col-

lege has also proved valuable to my position, but essentially I learned much of my craft from doing it—trial and error—over a period of years.

Attending a professional photographic school is undoubtedly valuable for certain students, but is not a prerequisite for learning scientific or any other form of photography.

I believe a "hands-on" approach is much more effective. People are going to schools in great numbers and waiting for information to be imparted to them, when they might actually learn faster on their own. You can teach yourself many aspects of scientific photography, industrial, fashion, commercial, or press photography, but you must be willing to work very hard at it and to dig information out of all available sources—from books, technical manuals, and from people.

A good source of acquiring knowledge and information can be finding just the right group of people at a particular store or industrial photographic establishment. Professional photography schools tend to produce graduates of a certain mold who may not be as adaptable or inquisitive as necessary when future situations demand different solutions than those presented in class.

It is also important to love to take pictures. Photography can attract "gadget hounds" who inhale equipment, but don't really enjoy creating images. They will tire early of the profession, and may find themselves locked into jobs, unable to move. Students should examine their motives early.

[By "gadget hounds," Jerald Morse means those who do not think past the equipment. However, a thorough interest in the vast array of cameras, lenses, accessories, and so on does not necessarily stop one from being a fine, competent, imaginative, and creative photographer. This is evidenced by Jack Manning's approach to his work (Chapter 4), and Harold Krieger (Chapter 5). In fact, Jerald Morse himself has a firm grasp on all the tools necessary to accomplish his tasks. Just take a look at his equipment list and the description of his darkroom facilities. Some photographers even find the technicalities stimulating to creativity. Yet other photographers—and you will find examples of them in this book—have no interest in dealing with a broad variety of technicalities, and do not even go into the darkroom. With a minimum of equipment they do excellent work and function extremely well in their respective fields.]

Although Morse did not attend a professional photography school, he was a photography graduate student at Holy Name College, Oakland, California, from 1971 to 1973, where he spent a close two-year master-student relationship with Vilem Kriz in fine-art photography.

JM: Vilem Kriz is a surrealist photographer who came to the U.S. from Czechoslovakia in 1949. He is presently teaching at the California College of Arts and Crafts in Oakland. I first met him at a studio critique at the University of California, Berkeley, in 1970, and we soon became close friends.

I was striving to grow as an artist, and his perspective was valuable to me because it was so far removed from the American mainstream photography. When Vilem told you a print was "garbage, my dear," he was usually right. There was none of the wishy-washiness one encounters at some art institutions. He is a master printer who made the study of photographic aesthetics come alive for me, and I feel greatly rewarded for having studied with him.

I was a teaching assistant in his class and brought him my own negatives and prints for comment. The darkroom time we spent printing together was instrumental in my developing a love for photography. He made it magic.

Morse's Other Photographic Work and Personal Projects

○ Another interesting aspect of Jerald Morse's involvement with photography is that despite the heavy load of his work in the forestry department, he finds the time to do other kinds of photography. He is the official photographer for the Berkeley Stage Company, a community theater in Berkeley, California. He is still interested and involved with the concept of photography as an art form. His photographs have been exhibited in galleries, museums, and universities, and his work is included in the collections of the Humboldt State College and the Oakland Art Museum.

JM: Almost all the photographs I have exhibited, as well as fifty percent of the work I do for the Berkeley Stage Company, are taken with a 1947 Rolleiflex (2¼″ format) I bought used in 1968 for eighty dollars. It has one lens, the Schneider f/3.5, 75mm. I also use a 1962 Leica 35mm range-finder camera with an f/1.4 50mm lens, an f/2.8 90mm lens, and an f/2.8 35mm wide-angle lens for theater photos and my personal work. It's a good idea to study the used camera market carefully.

I am currently working on an exhibition at the forestry department that I am very excited about. When I first took my job I discovered, in a small basement room, approximately five thousand glass lantern slides taken from 1900 to 1932. Most were black and white, but some were hand-painted color slides. They featured all

manner of West Coast forest and national park activities. Some of the images are fascinating; one is of a giant sequoia that had fallen in the forest, and standing atop its entire length, on horseback, is a company of U.S. Cavalry. These slides are part of a larger collection of black-and-white negatives kept at the forestry library, known as the Fritz-Metcalf Collection. This collection has never been printed, but in going through proofs of some of the nine thousand negatives, I realized that some of these pictures needed to be seen. I spent two years preparing an exhibition of this work, which opened in the spring of 1983.

Advice to Aspiring Photographers

○ I believe a key to finding and securing a job in photography, or status and recognition as a free-lance photographer, is flexibility of approach. Be able to perform more than one type of photography. This is particularly important in scientific photography, where projects change with the type of research. The biological sciences are a fascinating area to work in. And having a fun and challenging work environment may be more fulfilling than financial gain. I think it is possible to create a career as a photographer if you use your imagination and love for photography to your fullest extent. Try to cultivate perseverance, and try not to despair.

Courses and Organizations

Courses in medical photography are given at:

> Western Pennsylvania Hospital
> 4800 Friendship Avenue
> Pittsburgh, PA 15224
> Brooks Institute
> 2190 Alston Road
> Santa Barbara, CA 93108
> Rochester Institute of Technology
> 1 Lomb Memorial Drive
> Rochester, NY 14623

Societies and journals for medical photography:

The Biological Photographic Association, founded in 1931, is an organization for medical photographers, which gives workshops and publishes the *Journal of the Biological Photographic Association.*

For information, write:

> Biological Photographic Association
> P.O. Box 2603, West Durham Station
> Durham, NC 27705

The Ophthalmic Photographers Society gives workshops and has a certification program. It also publishes the *Journal of Ophthalmic Photography.*

For information, write:

> Ophthalmic Photographers Society
> c/o Mr. Don Wong
> Department of Ophthalmology
> Mother Cabrini Medical Center
> 227 East 19th Street
> New York, NY 10003

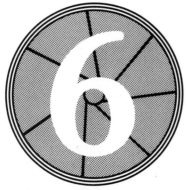

Staff
Photography

○ When thinking about a career in photography, one thinks about having one's own studio, or working in an established studio, or being a press photographer, or working as a free-lancer. But one can also be a photographer on staff in a corporation.

Being a staff photographer means that you will have regular hours (with occasional exceptions) and a steady salary. There are other benefits, such as a pension plan, health insurance, and so on. What you photograph varies according to the work of the company. Staff photographers do a lot of work that is akin to press photography and photojournalism—for company publications, outside publications, or press releases. They photograph people at work, special events, meetings, community relations, portraits, educational projects, sports activities, product shots, and anything else the company may be involved in.

There are staff photographers in government agencies. There are photographers in the Armed Services. Companies in the photographic industry have staff photographers; Kodak alone employs over one hundred photographers.

Most public relations firms engage free-lance photographers, but a few of them have photographers on staff. After all, photography is a very important element in their work. Some advertising agencies employ staff photographers, who are involved in the preliminary concepts for the visuals,

although rarely in the finished advertisements. Medical photographers in hospitals and science photographers in universities or in science laboratories are also considered staff photographers (see Chapter 6).

To give you an overall view into the work of the staff photographer, you will read specifics of the following:

1. Jerry Rosen is a staff photographer employed by The Port Authority of New York and New Jersey. This agency supervises the tunnels, bridges, and highways connecting the two states. It also administers airports, heliports, marine-port facilities, and two of the tallest skyscrapers in the world, the World Trade Center.

2. Eastman Kodak employs so many staff photographers that we have presented a general review of their work.

3. Frida Schubert is a staff photographer for RCA (Radio Corporation of America), a company involved in high-technology electronics and communications, television and radio broadcasting, vehicle renting and leasing, and financial services. Its research and development laboratories provide technological support for RCA divisions and subsidiaries.

Jerry Rosen: Staff Photographer, The Port Authority of New York and New Jersey

○ The general rule for success in photography is: Find an area in photography that interests you, stick with it, become highly proficient at it, and get to be known for it. However, this is not a hidebound rule, and several photographers in this book have gone from one specialty to another and have built very satisfactory careers. Specializing is fine, but wanting to be involved in several aspects of photography has as much validity.

The career of Jerry Rosen proves this point. From the time that he started in photography, everything about the field intrigued him—all the different kinds of expressions, all the different techniques. The early part of his career was spent absorbing a broad range of knowledge and following his instinct. As it turned out, this was the perfect preparation for his present position: staff photographer for The Port Authority of New York and New Jersey. His job requires this kind of full grasp of the many specialties in the medium of photography, and a great proficiency in all these specialties.

Before we describe his work, and how his background prepared him for it, it would be best to explain exactly what the concerns of The Port Authority are, because few of us comprehend the scope of its facilities and activities. It is an astounding organization.

The Port Authority of New York and New Jersey is a bistate, nonprofit public agency involved with interstate transportation and world trade. It is jointly administered by the states of New York and New Jersey. It was created in 1921 to work in the area designated as the Port District, approxi-

mately a twenty-five-mile radius centered on the Statue of Liberty. Its mandate is to operate airports, bridges, tunnels, container ports, and marine terminals, the rail transit PATH lines, bus terminals, and the World Trade Center (the twin-tower skyscrapers in lower Manhattan). The offices of The Port Authority are in the World Trade Center, as is a school it operates—The World Trade Institute and Language School. Recently, the two governing states have given The Port Authority the go-ahead to develop industrial parks in the area of its jurisdiction.

The Port Authority operates on a high-quality level. Just take a look at the World Trade Center, an incredibly fine structure. It follows that this high level of quality must be reflected in its photographic work and in its many publications. It publishes magazines, annual reports, brochures, newsletters, and employee newspapers. *Viaport,* a magazine published by the Port Authority on shipping, has both cover and inside photography that ranks with the finest magazine photography seen in top national publications.

However, it is best to have Jerry Rosen explain the photographic work.

JR: We in the photo section service all the publications, all the departments, and all the facilities of the Port Authority. The work we handle includes:

News and public relations photography
Illustrative photography
Magazine photography
Still-life photography
Portraits
Aerial photography
Legal photography
Architectural photography

In order to give you a review of this broad scope of photographic work, let's divide it into two general categories: 1.) location work, and 2.) studio work.

Location Work

○ We photograph at major construction sites—before, during, and upon completion. As a matter of fact, they're still working on the Port Authority Bus Terminal at 42nd Street, and I'm going up there tomorrow to do construction progress reports.

Requests come in to cover V.I.P. receptions. There are many news situations. For instance, when the hostages first returned from

Iran, I covered their arrival at LaGuardia Airport, a P.A. facility, and the dinner given for them their first night back, which took place in the famous World Trade Center restaurant, Windows on the World. The media and the press were let in for fifteen minutes, and I was the only photographer in the room all through the dinner.

I have photographed presidents and heads of state arriving at the airports. Queen Beatrix of the Netherlands was greeted at LaGuardia Airport by top-level P.A. officials, and she was escorted by them around New York City and the World Trade Center. My primary function was to feature her activities with the P.A. executives and facilities. I also photographed Prince Charles of England arriving at the Wall Street heliport.

The Port Authority also stages the huge harbor festival celebration every Fourth of July, and I photograph all types of activities involved, such as music and entertainment on the World Trade Center Plaza, harbor boating activities and visiting ships, and the gala parade up lower Broadway. A busy day!

These photographs are taken primarily for our own records and our own publications, of which there are many. Sometimes we release them to the press and media, depending on how well they have covered the event. Our public-affairs department also releases, to the news media, photo stories that they feel are of interest to the public.

We supply photographic illustrations for the many P.A. publications, the annual reports, and *Viaport,* a magazine on shipping that is distributed worldwide. There are also many brochures, pamphlets, posters, and technical and procedural manuals, all requiring photographs. All this printed matter is designed and planned in our own graphics and design studio. The situation for the photographer in this regard is the same as with regular magazine work—we work closely with the art directors. We also receive and fill requests for photographs from outside magazines, publications, and individuals.

Besides the events, the facilities have to be photographed, not only for the publications, but also for record keeping and for documentation. Illustrations and documentary photography are two quite different photographic techniques.

For the annual reports, I have to go to the facilities; even now, after a few years, and photographing every day, I still haven't been in every nook and cranny of these facilities. Before coming to the P.A., I had worked for photo studios that specialized in doing annual reports, so this type of work was familiar to me.

I get to see my work published—color covers for the magazines,

inside stories, well-produced brochures, posters, ads—all as interesting as working for any top magazine or in any commercial studio.

The legal department keeps us quite busy, as our facilities are used by millions of people, and if there is any kind of mishap, the location must be photographed exactly as is—no fill lights, no interesting angles. It all must be photographed realistically, with *every detail clear*, and from several points of view. For the legal work I never use anything smaller than a 2¼-inch format camera, the Hasselblad. Legal photographs must be as sharp as possible, and are sometimes blown up as large as thirty by forty inches if the case goes to court, so we must have perfectly clear and detailed prints.

The P.A. has two helicopters, and I often go up in them. When shooting aerials, I use both a 2¼″ camera with an 80mm lens, and a 35mm camera with a variety of lenses. Because of the vibrations of the helicopter, I never shoot at less than 1/500 second. If I'm using color, the film may have to be pushed in processing, depending on light conditions. On a sunny day this is never a problem, but many aerial scenic color shots are taken at dawn or at dusk, when the light is fading. However, these light conditions create some very beautiful scenic photographs.

We also use the helicopter to make photographic surveys for planned construction. The P.A. is working on redevelopment plans for the waterfront area in Manhattan. On a request from the engineering department, I was up this morning, shooting Tri-X [black-and-white film] at f/16 at 1/500 of a second. It was a bright, clear day.

We are doing aerial photographs for another engineering project in the planning stages—new roadways, ramps, and park areas for the approaches to the Holland Tunnel. This project requires that I go up to take general area photographs, and also to photograph at different times of the day to show traffic flow.

The P.A. is planning an industrial park in the Bronx, eight square blocks, which have been completely cleared. This has been documented photographically from the ground and from the air, and as construction proceeds, photographic documentation will continue to be made.

Another specialized type of photograph needed are architectural photographs of existing facilities—that is, bus terminals, airport terminals, PATH (rail) line stations, the World Trade Center, the bridges. I try to make them as attractive as possible by putting something interesting in the foreground, and also by getting the best angles. This can take a long time to set up and make all the dynamics of photography

work. What is very helpful in these situations is my background in advertising photography, where one learns how to make any and every subject interesting and attractive.

The audiovisual section, which prepares slide shows on many different subjects, also generates a lot of work for the photographers. One of the presentations, "I Love New York," was made to arouse interest in travel to NYC and New York State, and has been shown worldwide. Photographs were shot specifically for this, following a script and directions given to me by the audiovisual section. It has scenes and activities photographed all around the city and state, showing all the many wonders and attractions of the area.

One photograph that is particularly effective is a color shot of the World Trade Center taken with a telephoto lens, from a pier across the Hudson River, just after sunset, when there's still a glow in the sky. The towers are white against the darkness of the rest of the skyline, and the sky is a rich violet. This color slide was also enlarged for a wall mural for office decoration.

JR: Another audiovisual presentation I worked on was made to show the redevelopment of the Erie Basin waterfront area in Brooklyn into a commercial fishery complex, which enables fishing vessels to come right into the metropolitan area with fresh fish. Many aerial photographs were needed for this presentation, which is not for the general public, but is distributed to other interested companies and organizations.

The public relations department uses us frequently to help them inform the public about The Port Authority, and to convey the correct story about the agency. They requested a photograph, to be used as a poster in the new bus terminal, which would inform the passengers about the various employees who are there to assist them and to maintain the bus terminal. I did an advertising type of photograph, showing twenty-nine bus terminal employees in the main concourse of the P.A. bus terminal on 42nd St., Manhattan. Everyone was in their appropriate dress or uniform, and with the apparatus that they use, indicating their functions. Two 1,000 watt quartz lights were placed along a nearby balcony to add fill lighting. It was a complicated shot, requiring much organization.

Part of my job is to cover agency functions: medal awards, ceremonies, retirement events, promotions, and that sort of thing.

The Port Authority administers The World Trade Institute and

Language School, located in the World Trade Center. This school attracts students from all over the world. We photograph visiting dignitaries, and groups that are taking classes in world commerce, for their newsletter, and brochures, which they send to companies and governments who are contemplating sending people to study at the school.

The institute brochures, with photographs of reception areas and classrooms, are exceptionally handsome. They rank with the type of work you see in the best architectural and interior design publications.

Studio Work

JR: We have a well-equipped thirty-by-thirty-foot studio, with incandescent, quartz, and strobe lighting; a good range of colored background papers; large Fome-Cor panels for reflectors; and several low tables for the still lifes we have to shoot.

We do executive portraits and also passport photos. I use a 2¼-inch camera, the Hasselblad, for portraits.

When a new facility, or a change in a facility, is proposed, the engineering department builds architectural models, which are brought up to the studio to be photographed. Often these models measure up to five feet, and there is not just one version of the model. There are several interchangeable modules, which show the various possibilities in the overall design. We don't take just one photograph of the model, but photograph the various combinations using all the different modules.

The engineers come up to the studio and work with me, arranging and interchanging the modules. It goes without saying that the lighting of these models is very important. We shoot the models in both black and white and in color, for print and also for audiovisual presentations to the P.A. commissioners and government officials. I use indirect strobe lighting for most architectural models and always try to avoid harsh shadows.

Darkroom facilities are excellent. We process black-and-white film, and our lab technicians print both black and white and color. A lot of work can be turned out in our darkroom.

Summary

○ I like working here. Being a photographer for the Port Authority is like having many different clients with many different needs.

There is a lot to do, and it is all very diverse. A big plus here is

that you're not dealing with big egos, but you come in contact with interesting, important, and talented people.

Background

○Jerry Rosen described the time when he applied for this job.

JR: There were thirty other applicants, and I beat them all out. Over the years, I must have worked for over sixty photo studios, either on staff or as a free-lance assistant—in the studio, in the darkroom, and on location, worldwide. There isn't anything in photography that I haven't done at one time or another, and this has more than prepared me for the type of work I'm doing on staff now. There is heavy photographic activity going on here. Although I may be in a new situation as far as the Port Authority is concerned, it's not that new to me. Sometimes I'll get into a strange situation, and I just stand back for a second and think about it, and something I've done in the past will come to mind. I'm never in the position of a rookie whose mouth drops open and eyes glaze over when he doesn't know how to handle a situation.

Because of the scope of the P.A.'s activities, the photographer in this staff position must be well versed in every kind of camera technique and in every kind of photographic situation, as has already been explained. Let's recap Jerry Rosen's background, which prepared him so well for this unusual position.

JR: My school was the U.S. Navy. I got into photography by accident, and because of an accident. I was an amateur photographer, and while stationed on an aircraft carrier, I became friendly with the photo officer. One day, on my time off, I went up on the flight deck to see him. He wasn't there, and a plane came in for a landing, and there was a crash and an explosion. I got a series of color photographs. The photo officer was impressed and got me into the photographic section on the carrier. That's where I basically learned everything. Darkroom work came very easily to me.

There was no formalized training, but I watched and observed, and it all made sense to me, no big problems.

When I came out of the Navy, I worked for a short time as a salesman in a photo store. Then I went around looking for photo jobs, and I had some horrendous ones—mostly darkroom work, then a stint with a sleazy guy in the Times Square area, then into a color lab.

I finally got a job with two photographers doing publicity work for

organizations—functions, dinners, grip-and-grin photos. Eventually they let me shoot for them. Except for personal work (I had been shooting for myself all along), this was the first actual professional photography I had done in the three years since I left the Navy.

I left photography for a short time and sold cars, but found that photography was the field that I knew the most about, and I began to miss it. I went back to work for the very same studio, the two publicity photographers, doing darkroom work and shooting.

Then, through them, I met an advertising photographer and became his assistant and darkroom man. I stayed with him for several years. It was a good foundation. He was a very good photographer, very good at lighting. He did a variety of assignments—ads with people, illustrations. Gradually, he began specializing in still life. I learned a lot and began to do shooting. If he was out seeing a client or on vacation, and if clients had to be serviced, I would take care of them. By this time, I was proficient enough to be able to handle the jobs.

While working at these jobs, I worked weekends shooting weddings in order to earn extra money. The next several years, I worked as the studio manager in a top advertising photography studio. This gave me the broadest possible base. I did quite a bit of shooting for the studio. I handled the still lifes. Also, there were times when we would go out on location, and we'd be rained out for a few days, and the photographer would have to go back to the studio for something he was committed to. I would remain at the location until the weather cleared, and then do the pictures. I learned a lot on that job—about lighting, studio operation, and the care that goes into a wide variety of shooting.

I decided that I wanted to branch out into free-lance assisting and to work in other studios. I spent several months in a studio that only did beauty and high fashion. It was so specialized that after a while the most beautiful top models, who frequently came into that studio, began to look like coat hangers to me. I got very bored and I felt that it was time to move on.

One free-lance assignment I got while working in the studio was to photograph approximately one hundred detailed color illustrations for an instruction book on embroidery. For this I used an eight-by-ten view camera. The work had to be very precise, very exact.

I even worked for a photographer who had a client in the building-maintenance business, and I had to go up on scaffolds on the sides of skyscrapers. I also did travel assignments and shot from airplanes and helicopters.

Between the Navy and The Port Authority, I must have worked

for at least sixty different photo studios. That's a lot of different people and a lot of different experiences.

Incidentally, I would like to write a how-to book on assisting. There is a special talent to being an assistant. First, you have to know how to keep your mouth shut. You have to be very tactful. You must do your job, and yet not steal the show. You must blend in with the atmosphere and the rhythm of the different studios.

LM: *Could a beginner have gotten a job at the Port Authority?*

JR: No, absolutely not. My background has more than prepared me for the type of work that I'm doing on staff now at The Port Authority. It has given me such a broad base that I don't think you can name one type of assignment in one form or another that I haven't been involved in. That was one of the reasons I got the position.

Eastman Kodak

○ In an examination of staff photography within a company, we should certainly consider the work of the staff photographers of Eastman Kodak Company. As a world-leading photographic company, they have more than one hundred photographers on staff; these people work on every possible kind of photograph, for a great number of purposes.

First, they're involved in the testing laboratories and special studios that Kodak maintains. These photographers run tests on products—papers, films, chemicals, cameras, and any other equipment Kodak produces. They are particularly concerned with the new products. Before any of this material is presented to the public, you can be sure that extensive tests, which duplicate whatever situation the material is intended for, have been carried out. These photographers who do the testing also contribute to the data sheets, the technical manuals, and the instruction books Kodak publishes.

Second are the photographers who are engaged in creating photographs and slides for traveling road shows, lectures, and demonstrations in national parks, auditoriums, and theaters. These programs are primarily travel oriented and are given free of charge.

In the third category are the photographers in the Photographic Illustrations Department. They photograph for:

1. Advertising and counter displays.
2. Posters, billboards, and wall decorations.
3. Books, magazines, brochures, and pamphlets.
4. Exhibitions, public relations, and press releases.
5. Stock photographs in the library that Kodak maintains.
6. The Colorama in Grand Central Station, NYC, and the smaller Color-

amas in Chicago, Rochester, Hollywood, and Oak Brook, Illinois (description on pp. 172–173).

Besides the obvious reason that Kodak is in the business of photography, Mr. Lee Howick, the manager of the Photographic Illustrations Department, explains why Kodak finds it advantageous to produce their own photographs:

1. The proximity to the people who are implementing the visual communications.

2. Security, especially in the preparation of new products. Confidentiality is better maintained if the work is done in-house.

3. By doing the work within the company there is a great saving of money.

If you're an enterprising photographer, the foregoing would be good selling points to convince a company—any company—to set up an in-house photography section, as visuals are needed in so many businesses. (See the section that follows, about Frida Schubert, as an example of this.)

Most Kodak staff photographers are graduates of photography schools, primarily the Rochester Institute of Technology, a school very closely associated with Kodak.

The kind of qualifications expected of their staff photographers, especially those in the Photographic Illustrations Department, are described by Mr. Howick:

LH: First, they must be equally at home with all camera formats; from 35mm to eight-by-ten-inch view cameras. Our photographers use the latest and best equipment, and of course, there's no problem getting film.

Second, they must be multitalented, versatile, and capable in every aspect of photography. They must produce outstanding photographs, whether they be scenics, products, human interest, special effects, aerial, underwater, portraits, etcetera. Most do not specialize in one thing.

Third, they must be able to travel and to overcome the complexities and adversities of an overseas assignment. They must plan itineraries and do research on extensive assignments. When abroad, they must be very diplomatic. In a strange land with interpreters, they must be patient, persistent, and kindly. They must represent their company properly.

[See the comments of press photographers Chris Johns and Frank C. Dougherty in Chapter 4 on the responsibilities of a press photographer on an assignment, especially overseas. Their comments may be worded dif-

ferently, but the meaning is essentially the same. Besides being technically proficient, a well-functioning photographer must have all these other qualities.]

Mr. Howick continues, and what he says is applicable to many other areas of photography, especially free-lance photography.

LH: When on assignment, our photographers must think in terms of taking photographs for all kinds of uses. They must recognize a situation that has potential, even if not anticipated, and make decisions on the spot. For instance, if they have gone out primarily to photograph for posters, they must recognize possibilities for the Colorama, or for advertising use, or for the multitude of books we publish. They should be aware of needs that may arise in the future.

Kodak maintains a large photo library, and while on assignment, photographers may encounter possibilities that will be good for stock photographs for the library. When the photographers have ideas they may want to try, they can use their spare time for taking photographs that will go into the photo library. These opportunities can be a creative outlet for them, and an opportunity to demonstrate initiative.

Within the company, the assignments are given to individual photographers according to their availability, and by matching talents with the assignments. Although the photographers are multitalented, one photographer will veer more in one direction than in another. For instance, one might be outstanding in human-interest material, while another may be an outstanding scenic photographer. Also, some have unique specialties they're particularly attracted to. For instance, one of our photographers is an excellent underwater photographer, while another is particularly good at aerial photography.

Every kind of photograph you can think of is done by the Kodak staff. However, the Colorama in Grand Central Station (NYC) is unique to Kodak. It is undoubtedly the biggest color transparency in the world, measuring eighteen feet in height by sixty feet in length. Just the processing, printing, and finishing of a Colorama takes a seven-person crew working in a special laboratory.

LH: The Colorama requires a special ability to see and compose in the one-to-three format.

Spectacular scenic views are most often used for the Colorama. Effective photographs of scenics, especially ones that convey a sense

of grandeur, are not easy to do; they require a great deal of effort.
A particularly effective Colorama was a scene of Jackson's Hole,
Wyoming. It was taken in the early evening with the town's lights on,
and the snow-covered mountains in the background. It is always thrilling
to walk through Grand Central Station, in the middle of New York
City, and look at these gorgeous landscapes, but seeing that vast
snow-covered mountain range and the vivid blue of the early
evening sky was particularly impressive.

Neil Montanus, a Kodak staff photographer in the Photographic Illustrations
Department, took it, and he explains how he did it.

NM: I was assigned to do a winter scene. I picked the Rocky Moun-
tains, and after researching a location, contacted the Jackson Hole's
Chamber of Commerce. For six days after I arrived, it snowed con-
tinuously, so—unable to photograph—I used this time to test shoot
and to scout around until I found a vantage point that would give me
a good view of the town with mountains in the background.

When it stopped snowing, the sun came out clear and bright. The
snow was glistening and fresh, and the Grand Teton Mountain Range
was visible.

That afternoon, I went to a spot I had found on Snow-King
Mountain. I set up the tripod and the 8-by-10-inch Deardorf view
camera, equipped with a 165mm Schneider lens. Using Kodak Veri-
color II film, I started photographing at four P.M., and made exposures
every fifteen minutes until nine P.M.

Although he had hoped to get a snow-and-sunset scene, the exposure
chosen for the Colorama was made at 7 P.M., after sunset, showing the rich
blue of the early evening sky.

His lens setting was f/16 at thirty seconds. Since the temperature was
zero degrees, he covered the camera with a blanket between exposures,
and kept the film holders in an insulated container.

Great scenic photographs are seldom done by just going "pop"—and,
in the one just described, photographers almost always have to spend time
waiting for the right moment to capture the optimum light conditions for the
feeling they're trying to capture.

This is just one of the innumerable projects carried out by the Kodak
staff photographers. Now we're going to describe the work of a staff
photographer mentioned earlier who introduced an in-house photography
program in the company where she works.

Frida Schubert: Staff Photographer, RCA

○ Frida Schubert is the staff photographer in the executive offices of RCA Corporation. Her case is unusual because she started working there as a photo librarian; it wasn't until five years later that she became staff photographer as well. How she developed into staff photographer should be of interest to all of you.

Many companies maintain photo libraries, and Frida Schubert may serve as an inspiration to you, demonstrating how you can start off with a job related to photography and develop it into a photographic job. Jerald Morse (Chapter 6) is another person who, by his own efforts, developed a job he had into a photography job.

As a photo librarian, Schubert's responsibilities are to maintain high-quality picture files containing historical photographs that document RCA's pioneering work in radio and TV technology as well as current photographs that highlight the different RCA divisions and operations. The photo files are constantly updated with editorial-type photographs that have a good chance of being published.

The photo librarian services picture requests for RCA news releases, publications, speeches, slide presentations, exhibits, and for any other special in-house projects where photos are required. Schubert also services requests from outside sources such as newspapers, weeklies (*Time, Newsweek, Business Week*), general interest magazines, TV shows, trade publications, book publishers, school publications, slide presentations, educational filmstrips, and exhibits.

The RCA picture collection, which dates back to the early 1900s, has been compiled from a variety of sources such as company publications, staff photographers from other RCA divisions, free-lancers who do special assignments for RCA, and from some of the RCA pioneers who had the foresight to keep precious archive photographs on RCA in the early days. Since Frida Schubert became staff photographer a decade ago, her photography has also become part of the RCA photo library.

Being constantly occupied with reviewing top photographers' work is what led Frida into becoming a photographer.

FS: Before coming to RCA, I had the position of photo librarian and photo researcher with an international oil company. The editor/manager of publications had enough faith in my abilities to select me for the position despite the fact that I had no prior training in the field. He took the time to teach me the skills to edit, catalog, research, and crop photos for best composition and impact. He also taught me how to order repro-quality color transparencies and black-and-white exhibition prints, primarily for use in the company's prestigious magazine

and then for other photo requests. He was an excellent teacher, and I valued all the knowledge on photography that he imparted.

Here I was gaining all this terrific hands-on experience from reviewing top photographers' work in both the RCA and oil company files. I never had the added benefit of going out with photographers on a shoot, but I studied the results of each assignment very carefully. I became very conscious of what elements were needed to tell the story in one photo for news releases and what made a good series of editorial-type photographs to illustrate company articles.

It was only natural to want to extend that experience to include handling the camera as well. The idea of becoming a photographer nagged at me for some time, but I didn't pursue it sooner because I was led to believe by a good many professionals that the details one needed to know to operate a camera were too complicated. This thinking, fortunately, was quickly dispelled once I examined the controls of a professional camera. I decided that day to buy a Nikon, not a cheaper camera with the idea of graduating to a better camera system. I started practicing on my own, shooting personal pictures on vacations, at demonstrations (which were very popular in the 1960s), at family events, picnics, hiking.

On my own, I then photographed the first Earth Day demonstration [1969] which took place on Fifth Avenue, near the office. I chose four photographs to be enlarged from my contact sheets and showed them to a member of the editorial staff. It just so happened that he needed photos on demonstrations and wanted to include my pictures with two hundred other nominations he collected from free-lancers and photo stock houses for a story his department was publishing on air pollution. To prevent any prejudices because I was not considered a professional photographer, he said he wouldn't tell the designer that my photos were included. He came back with the news that six photographs were selected for the article, and that two of the six were mine. This was a tremendous thrill, as it was the first publication of my photographs.

When I first started photographing, I used available light—still my favorite light source—and tungsten light. Later I acquired a simple electronic flash. This, coupled with becoming thoroughly familiar with the basics of cameras and lighting, has made handling the equipment second nature to me now.

I then took some evening courses on photography at New York University and found that a good deal of what they were teaching I already knew from on-the-job experience. However, these courses

were still beneficial because they served to reinforce what I had been learning. One never finishes studying camera work, as it is open-ended. I'm constantly experimenting to achieve special effects with the camera.

I began to show my photographs to the people at RCA, and they liked them. It landed me a couple of good assignments, such as photographing people at work and a few product shots. More diversified assignments were then given to me by my boss in the news and information department and by the editor of our in-house publication. These photo sessions proved to them my capabilities of carrying out a specific assignment, which is quite different from photographing for oneself.

For one assignment, I got the idea of photographing our editor interviewing himself as the author of a book. I had the concept. Now I had to research how to accomplish it. The how-to book explaining how to make a double exposure against a white background left out one vital detail. Because of this omission, my first results were poor. My double exposure had ghost images, not quite what I had in mind when I was photographing someone from the real world. The trick— I finally figured out—was to mask one half the lens for the first exposure and mask the other half for the second exposure. After another try, I knew I would have no trouble getting two strong images of the editor on one negative. No experience—even a failure—is wasted. The mistake did show me how to create ghostlike images, and if I ever wanted to give the impression of someone not of the real world, I could do that too.

Becoming a staff photographer evolved slowly, but when the time came for a title change and greater responsibility, I was ready for it. My own pictures are part of the photo files; they are available for all types of requests. As a result, my photos have been published in *Time, Business Week, Ebony, The New York Times,* to mention a few publications.

Equipment

○ Frida Schubert works only with 35mm camera systems. She has several camera bodies and lenses from 24mm wide angle, medium focal lengths, to 135mm telephoto. A lens that she finds very useful is a 45mm–85mm zoom. For lighting, she uses either portable tungsten lights or a simple but very good electronic flash system consisting of several slave units and a high-voltage battery pack for quick recycling. She likes to avoid using flash for portraits, preferring available light or tungsten lighting for fill.

She advises that one should always get as detailed instructions as possible for each assignment and, if time permits, photograph different set-ups so there is a wider variety of choices in the final selection. For instance, if assigned to shoot a meeting, find out exactly what is needed—overall shots of the whole meeting, groups, the speaker, individual people attending the meeting, or any display materials. This way you will bring along the correct equipment and photograph what is required for that assignment. With her multiple-flash equipment, she has the ability to light up large areas, if necessary. Often she is asked to photograph a subject where the background or foreground is equally important for pictorial impact. So using fill lighting in either or both of these auxiliary areas may be necessary to equal or nearly equal the light level on the main subject. It's advantageous to shoot for photographs that can be cropped and published both horizontally and vertically. This is especially important for pictures that are to be used for publication, as this gives the editor an option in the layout.

Let's take a look at the types of photographs a company staff photographer may be called upon to shoot:

1. Portraits and candids of high-level executives when they are appointed to new positions. The portraits are usually sent with news releases to newspapers, and the candids are usually sent to magazines, company publications, and trade journals.

2. Editorial-type photographs of employees at work, either singly or a group of people involved in a single project. If Schubert has to do an environmental portrait of an important executive where some interesting pertinent prop or special scenery has to be included in the photography, she may do a trial run with a stand-in, provided there is time. Then she can select the strongest compositions and concentrate on those angles for the actual shoot.

3. Special events: twenty-five-year dinners, dealer meetings, press conferences, annual shareholder meetings. For most of these assignments, electronic flash is used.

4. Products and equipment. Schubert photographs these both as still lifes and as editorial-type photographs. By using a mirror, she was able to incorporate three RCA products in one photograph, and in a vertical composition. The man in the photograph (see insert) videotaped his own reflection in the mirror, and it is seen on the screen of a video cassette player. This photograph was picked up by several trade publications, and was also used as an inspiration for an artist's rendering.

5. Occasionally Schubert does assignments away from the office, such as photographing a new lightweight professional TV camera broadcasting a World Series baseball game at Yankee Stadium; the topping-off ceremony of the TV antenna on the roof of the World Trade Center; the presidential election returns in the NBC studios. For the returns of the presidential elections, she worked until 3 A.M., took overall and close-up photos of the news-

casters while they were telecasting, and of the tote board that showed the number of votes coming in, as well as behind-the-scenes photos. Above all, she had to be constantly careful not to interfere with the TV cameras, and had to use only available light, absolutely no flash. At a hospital, she photographed two microwave applicators that RCA developed for cancer treatment. For this she used bounce flash and wide-angle lenses to demonstrate how these applicators were used on patients. Just showing the RCA devices was not enough, because the photographs had to show how they were used with the hospital equipment. These story-telling photographs were used by RCA scientists in reports, slide presentations, and for teaching.

Frida Schubert's job is certainly an example of how varied and challenging a staff photography position can be.

Professional Photography Organizations

○ As has already been pointed out, membership in professional photography organizations can be very helpful. Photographers often work alone, with little contact with other photographers. These organizations give you the opportunity of meeting other photographers and people working in fields related to photography. You exchange ideas; you discuss common problems. All this contributes to improving your work, helping solve problems, triggering new ideas, and even generating new work.

Aspiring photographers should acquaint themselves with different organizations. Most meetings are open to nonmembers, and if you attend you will see how helpful they can be. You will meet people in the profession and listen to some very interesting programs. Speakers are invited to the meetings, and discussions are held on various phases of the business. Colleagues explain and exhibit their work. Technicians from testing labs talk about new products, new equipment, and new opportunities. Representatives from equipment, paper, and film manufacturers are also invited to talk at meetings.

Frida Schubert is a member of three professional photography organizations:

1. The ASPP, Inc. (American Society of Picture Professionals). The membership is made up primarily of photo researchers and photo librarians who work for publications, companies, and stock houses; some are free-lancers. Photographers also belong to the ASPP. For information, write to: ASPP, Inc., Box 5283, Grand Central Station, New York, NY 10017.

2. The PWP (Professional Women Photographers), an organization of women photographers in every specialty of photography. They hold monthly meetings and publish their own newspaper. For information, write to: PWP, c/o Photographics, 43 West 22nd Street, New York, NY 10010.

3. IPANY (Industrial Photographers Association of New York). The membership is made up of company staff photographers, free-lancers who specialize in industrial work, and photographers who have their own

studios. They hold meetings once a month. For information, write to: IPANY, Bruce Hoffman, U.S. Trust, 45 Wall Street, New York, NY 10015.

Frida Schubert has found that in addition to the interesting and relevant information she gets at the meetings, the interaction with other members has also proven very helpful. It's all part of the on-going learning process in photography.

Performing Arts Photography

○ If you care about the theater, the ballet, the opera, the rock music world, the recording industry, solo entertainers, and the people of that world, then the field of performing arts photography may be for you.

Introduction

○ Photographs are very important in the performing arts world, and the performing artists must be presented to the public through photographs in an advantageous manner.

In this chapter, you will hear from several photographers in this field. Some of them do similar work, and there are areas in which they overlap, but each brings his or her own unique flavor to the work they do. By reading about all the photographers, you will get an overall view of the special aspects, problems, and needs of their clients, as well as the problems of the photographers.

You will discover that besides technical skill, the successful photographers all have a great interest in performing arts, an affinity to it, and a strong desire to cater to the special needs of their clients. These photographers produce photographs that are useful and that fulfill very specific purposes. If you have these attributes, you will enter a most interesting world. There is always something new to photograph. You are working with people who are committed, who are dedicated, who are sensitive, who are

talented, who are in the public eye, and some who are very famous—the celebrities and stars.

The performing arts need photographs to get attention to bring the public in to attend performances. Not only are factual photographs constantly required, but also photographs that may employ special effects to emphasize certain aspects and feelings in a play, a ballet, an opera, or a rock music concert. The photographer must have the ability to capture the essence of what is being expressed.

In this field, as in all the others, there are several photographers who have built wonderful careers. They have produced useful, interesting, and beautiful work; as time goes by, their photographs increase in importance, often constituting historical documents.

In this field of photography, the client and the photographer often have an on-going relationship, and can develop close ties. You're involved with people who are in the public eye, and if you're good, you will be very much respected and admired by your clients. You are very important to them, and you become a part of their creative world.

We will outline all the different types of photographs required, how they are used, how and from whom the photographers derive their incomes. The stories of the photographers in this field will explain how they approach problems, how they accomplish their work, and what led them into this field.

Types of Photographs Needed by the Performing Arts

○ All photographs described below are in both black and white and color.

1. Performance pictures, sometimes taken during a performance or a dress rehearsal. However, most performance pictures are taken after a performance, at a session specially arranged for photography, which is called *photo calls*. Anywhere from one to four hours will be allotted for the photo call. There are also special sessions for souvenir books or magazine articles, when a day or more may be allotted for the photographing.

For the photo call, the technical crew is on hand (lighting people and stage hands). The photographer may be given a layout, and the publicity people for the production as well as the stage manager may be present. The photographer has generally seen the performance, and is familiar with the play, the ballet, the opera, or whatever. Photo calls may also be called after a production has been running, when new people join the cast. Photo calls may also be held on the road, before the production opens officially, so that photographs will be ready beforehand.

What takes place on stage may not necessarily look good in a photograph, and the photographer is allowed the liberty to make adjustments. However, the essence of the scene must be retained. Usually the stage lighting is used, and the photographer may or may not bring in additional lighting. Close-ups of the leads, soloists, and featured players are made at

these sessions. The leads and featured players may also go to the photographer's studios with their costumes. These photo calls are very costly for the producers, and the photographer cannot flub.

When photographs are taken during an actual performance or dress rehearsal, the photographer can move around in the auditorium, and sometimes work from the wings. He or she cannot exercise any control, and must catch it "on the wing." At these times, the photographer functions like a press photographer.

2. Rehearsal photographs are usually made in the early stages of a production, with no sets or costumes. The photographer will wander about and shoot from many different angles. These photographs are usually made for the producer, or can be assignments from magazines or newspapers. Besides being used later for publicity, these photographs are also helpful for the director as a reference to the actors' positions on stage and for documentation for later productions.

3. Portraits or head shots, which is what theater people and models call them. These must be simple, well-lit, straightforward close-ups. They must look like the sitter, and they must be flattering. Every performer needs them.

4. Documentation pictures of the set, the costumes, the props. Not necessarily done by a professional photographer. Can also be done by the directorial staff or the stage manager, and often a Polaroid is used.

5. Magazine or human-interest photographs of the people involved in a specific production. Besides the performers, these photographs may include the playwright, director, composer, set designer, and/or choreographer. Can be taken at the theater, backstage, in the dressing rooms, or while the people are involved in various activities outside the theater: at home, shopping, in restaurants, and so on.

Use of Photographs

○ Performing arts photographs are used in many ways, but their function is primarily to generate interest in a production; to attract attention. Here are some of their specific uses.

1. Advertisements—in newspapers, magazines, flyers, mailing pieces, posters, and on TV.

2. Publicity—photographs are released to the press, and used in all kinds of publications.

3. Souvenir programs (especially dance companies, musicals, and opera). These programs are very handsome, and are usually sold in the lobbies of theaters during performances. They are mostly in color, with texts and explanations, pictures of the leading performers, the directors, and others involved in the company.

4. Theater programs, the playbill given to the audience by the ushers. These are mostly black-and-white photographs.

5. Photographs are used in displays in front of theaters and concert halls, and in the lobbies.

6. Portraits, head shots, are the calling cards of performers. They send these out frequently with their resumés to casting directors and agents. They leave them when they go to auditions. You also see them autographed and displayed in stores and restaurants. The head shots are also used for publicity releases to newspapers, magazines, and other publications. These photographs are very important for performers. When performers get a suitable portrait, they take it to a darkroom firm that specializes in making prints, inexpensively, by the hundreds.

7. Record albums use photographs of performers on the front and back covers, as well as on the inside.

8. Books, either published contemporaneously with the performances, or general books on theater, usually history. Published plays contain photographs.

9. Magazine covers and inside stories.

10. Documentation and archives. Photographs become important historical documents. They are used for many different publications and for reference and guidance for subsequent productions.

11. Fund raisers, producers, and executives of opera and dance companies use photographs when trying to interest prospective donors.

Income of Performing Arts Photographers Comes from Various Sources

1. Fees from producers and performers.

2. Assignments from newspapers and magazines.

3. Salary—assistants on the staff of a busy performing arts photographer. A few opera, dance, and theater companies have staff photographers.

4. Royalties from books.

5. Second rights—sale of photographs for use as posters, greeting cards, calendars, and so on.

6. Resale, stock photos—the bigger the stock and the more time that goes by, the more income from resale.

7. Photographs as art. Several of the leading theater and performing arts photographers who produce very beautiful work have begun to derive an additional income from the sale of their work as art. This is in keeping with the new regard of the photograph as a collectible art form. However, it must be pointed out that these photographers did not set out to create "art." They were doing their jobs, and as time went on what they did in the course of their everyday work became recognized as art.

The photographers in this field share much in common, but as in other specialties in photography, each has his or her own personal style. Some

spend more time on portraits, others on production photographs. Some spend more time with one art form over another.

The photographers also gain attention and build reputations as their credited work is seen published. Very often, the approval of a well-known performer enhances the reputation of a photographer.

Their work is a combination of photographs done in the studio and on location. Good darkroom facilities are also of paramount importance.

The following photographers will share with you what they do and how they go about it, and a theater manager will explain the importance of photography to a theater.

Sue Daly:
General Manager, Community Theater

○ Not only do the big commercial theatrical productions need photography, but every community theater, every small nonprofit group needs photographs. These are essential primarily to get people to want to come see the performances, and also to explain to the board of directors and to the donors what the theater group is doing. Photographs are also used in approaching prospective donors, with applications for grants to foundations and other funding sources, and for the historical record. Also, the people involved in the theater—the performers, designers, playwrights, and directors—need records of their work.

If you are a beginning photographer, doing work for a local theater is an excellent way to get experience and to get your work known. It can lead to all kinds of photography, press, publicity, and even advertising photography.

Sue Daly is the general manager of The Stage Company, a ninety-nine-seat theater in Berkeley, California, established in 1974. Here is her explanation of their policy on photography.

SD: In the beginning, a professional photographer who was interested in our theater donated his services and photographed for us as a favor. But this was a sometimes thing, and we could not expect it to continue on a regular basis. It became clear that the theater had to develop an alternative.

At first, photography was not high on the priority list. But we soon realized that we needed photography to create an image for the theater, to convey the message about our theater, and to market it. These considerations led to the decision to treat photography on a professional level. These were services that we had to go out and purchase. We had to find someone we wanted to stick with, since you only grow as an organization if you avoid turnover, if you get a group of people to

work with over a period of time, and so eliminate all kinds of wasted energy. We realized that we had to get a photographer who knows what is required, and who was really interested in theater.

Sue joined the theater in 1975 as a lighting designer, and wanted a record of her work. She commissioned Jerald Morse (see Chapter 6), a photographer involved in scientific photography on the staff of the University of California, Berkeley. He had shown an interest in the theater and liked doing this work, as it provided a different dimension from the scientific photography of his regular job.

His work for Sue was so good that other people in the theater started hiring him to get photos for their personal records—the costume and set designers, the directors, and the actors.

SD: We hired Jerald as it became clear how important good photography was to the development of the theater. Now photography gets a definite percentage of our budget. For backup, we have a relationship with another free-lance photographer, in case Jerald gets tied up on his regular job.

Since our funds are limited, the photographs have to be done within a strict time limit. We pay by the hour, plus expenses. The photo call is carefully organized so as not to waste the photographer's time. Jerald Morse is truly dedicated; besides a shooting script, which we give him ahead of time, he tries to see the show in rehearsal before the photo call, and he always reads a synopsis of the play or discusses it with one of us.

For the photo call, a shooting script is prepared by the stage manager and the director. The costumes, the set, the props—all have to be ready for the shooting. The time set aside for the photo call is for photography only. The guidelines given to the director for the photo call are:

1. One to three times during the run of a play the director has to give his or her total attention to photography.
2. The director cannot give notes to the actors.
3. The director cannot have a costume parade.

As listed previously, the photographs will have to serve several purposes—publicity and press photographs, more artistic photographs for the lobby display, and archival photographs.

So, each photo call must produce a wide range of results in as short a time as possible. Our archives are very important, and must contain only good work—no slipshod snapshots. I want to produce

consistently top-level photography. We do a lot of premiere productions, which gives our theater status and recognition nationwide, and even worldwide, especially when these plays are produced subsequently by other theaters. Our photographs are sent to these theaters, and represent what we stand for, so they have to be excellent. This expectation has been validated by several awards given for photographs taken for us by Jerald Morse.

Since we are a nonprofit organization, we need photographs to explain what we are doing to the donors. For this purpose, photographs are much more effective than slides, videotape, or movies. No rooms have to be darkened; no special equipment has to be set up for projecting. We have put together an attractive presentation of photographs which has proven worthwhile for the purpose of approaching prospective donors—generally very busy people who are inundated with printed matter—and has proven very effective in conveying the message about our theater. The Stage Company's photographs taken by Jerald Morse have also been published in theater journals, in magazines, and on the cover of the textbook *Fundamentals of Play Directing*. His work also received a first prize (one hundred dollars) in the Performing Arts Competition, Theater Division, 1980.

Sue Daly spells out excellent guidelines for all aspects of performing arts photography.

Kenn Duncan: **Theater and Dance Photography**

○ Kenn Duncan is considered one of the leading photographers of the performing arts, specializing in theater and dance photography. Duncan was a performer himself, a roller-skating champion who studied ballet, and then became a dancer. An early injury cut short a promising dancing career, and he had to find a job. He did not seek a photography job per se, but just happened to get a job in a photography studio that specialized in fashion, photographs for hair stylists, and portraits for theater people and models.

Duncan had no formal training in photography. Everything he learned about photography, he learned on this job. However, while in school, he had studied commercial art and fashion illustration; that, combined with his performing experience, talent, and lots of very hard work, are what contributed to his emergence as a leading photographer in this field.

KD: Having been involved with movement and fascinated by it, once I got an understanding of photography, how to use the camera and do darkroom work, I became committed to try to capture and express movement in a still photograph.

After his first year in the studio, Duncan began to shoot. He started with the children who came to the studio for modeling composites. Gradually, he began to share assignments with the other photographer. This photographer moved abroad in 1973, and then Duncan took over the studio, the very place where he first got his job. He is still there in the same studio—from beginner to recognized, important photographer.

He does all aspects of theater photography, and lots of photography for ballet companies and dancers, which he photographs both in the theater and in his studio. He is very well known for his portraits of many theater people. He says, "I love the intimacy of portrait work with these artists."

The first important step in bringing attention to his work was a magazine assignment. A dancer who liked his work introduced him to the editor of a magazine called *Ballroom.*

KD: They were planning to update it, and change the format, and assigned me to photograph the musical *Hair,* one of the first shows to have nudity on stage. They changed the name of the magazine to *After-Dark.* Their first cover was one of my *Hair* photographs, and they did a six-page inside spread.

Since that beginning, he's done the production photos for a very great number of Broadway and Off-Broadway plays, and for over forty dance companies. His photographs are in dozens of souvenir programs. The list of actors and dancers for whom he's done beautiful portraits goes into the hundreds, and includes such well-known stars as Carol Channing, Johnny Mathis, Bette Midler, Dick Cavett, Mikhail Baryshnikov, and Lena Horne.

LM: *How did you build your business, and how do you maintain it at such a high level?*
KD: By always being here, being anxious to do the work, and it builds itself. By making people feel relaxed and confident that I know what I'm doing, and that my first concern is to satisfy them.

Duncan still works for *After-Dark* magazine, and his work appears in many other publications. In the studio he does portraits, full-lengths, groups, and dancers dancing. He does more work in the studio than on location. Besides the theater work, he has retained the fashion, hair styling, hat, and wig accounts that the previous photographer took care of. He also does a perfume account.

Despite his busy schedule, he also gives himself many self-assigned projects, both for exhibitions and to try out new ideas, which are often incor-

porated in the work he later does for his clients. His famous sitters work with him on these projects.

KD: It's fun for them. They enjoy the photographic creativity, and it's a good attention-getting device for myself and for them.

One of these projects he called the "Red Shoes Project." It consisted of beautiful color prints of well-known theater people in costume, all wearing red shoes. Judith Jamison, the great modern dancer, is in white, holding a white lily, and wearing red shoes; Bette Midler in red shoes; Maxwell Caulfield, stage and movie actor, as Tarzan in red sandals; John Curry, the ice skater, as Hans Brinker with red ice skates; and so forth. In all, there were thirty actors and dancers included in this series. An exhibition of the work opened in the Lincoln Center gallery, November 1981, and then toured other galleries throughout the country.

 Duncan's work has been exhibited in more than twelve galleries in the United States and Europe, and many of his photographs are bought by collectors. Several books of his work have been published.

Equipment and Facilities

○ Kenn Duncan has two studios—one is thirty feet by fifteen feet, the other is twenty feet by twelve feet. This enables him to have a setup in one studio and still be able to shoot in the other studio. He uses Nikons, with primarily 50mm and 105mm lenses, and Hasselblads with 80mm and 150mm lenses.

 Lighting in the studio consists of custom-built strobe units with bounce umbrellas, a black light to highlight the hair, two 800 watt-second ratings, and two units of 200 watt-second ratings.

 Just as important as the equipment in the studio is the ambience he has created to give a feeling of comfort; it includes soft sofas and a marvelous stereo system. There are two large, attractively furnished dressing rooms with excellent lighting and large mirrors. He wants his clients to see themselves well, because good makeup is very important for the portraits they need.

 Duncan does a lot of work in color, and he has a room set aside for editing and filing color shots. It contains a light table and a projector for viewing and editing.

KD: A good filing system for slides and black-and-white negatives is very important. Often prints are requested after a lapse of time.

The darkroom area consists of two large rooms. One is a negative developing and printing room with two sets of stainless steel sinks—one for nega-

tives, the other to wash prints in. There is an Omega enlarger which can accommodate all types of negatives—4 ″ x 5 ″, 2 ¼ ″ square, and 35mm—in this room. The second room, the outer darkroom or finishing room, has a large drum dryer for fast print drying, to accommodate the large number of prints the studio turns out each week. Then there are large tables for laying out and sorting the prints and for numbering the negatives, and a small table for spotting and retouching.

In this room there is also a 4 ″ x 5 ″ camera, which is set up specifically for making copy negatives of retouched prints. Duncan and his staff also use this camera to make copy negatives in order to change the look of a photograph. For instance, they can make a copy negative on Kodalith film so that the middle tones are eliminated, thus getting extreme blacks and whites. Or they will purposely make a heavy negative in order to get denser grain. They also use this camera to make black-and-white conversions from color. In this finishing room, there is also a setup of a slide-duplicating camera for copying color slides.

Ira Wechsler, the studio manager, instituted the practice of numbering every negative, ignoring the printed numbers on the negative stock. Initially this is time consuming, but since there are so many repeat orders, it ultimately becomes a time-saving device, and helps tremendously to avoid mistakes and minimize waste.

Ira Wechsler describes the darkroom work.

IW: Deadlines must be met. Our principle is to produce work of the highest quality. The key is to always be aware of the clients' needs. There is the balancing act of keeping many projects going simultaneously. Other photographers involved in theater work can do "turnaround" service. That is, they have prints ready the next day. We do that occasionally when absolutely necessary, but not as a general practice.

Since Kenn Duncan does portraits that have to be used for many purposes, including newspapers, it is interesting to learn how he handles it. First of all, his work has a recognizable look. It is well lit, no deep shadows, and the personality of the sitter is always there.

KD: It is very important for my sitters to feel relaxed. My working surroundings are geared to make people feel good, to feel attractive. I try always to make them comfortable. The portraits must resemble the person and must be flattering. You must get their personality. And for the people in the performing arts, the photographs are generally retouched.

Some of Kenn Duncan's photographs of famous personalities in costume and in dance poses are so striking that silkscreens have been made and used for posters. These posters have become collectors' items.

When Kenn Duncan goes on location, he goes alone. He has done production shots for many Broadway and Off-Broadway plays and musicals, and also goes on location to shoot for ballet companies. For this work, which is in both black and white and color, he uses a 35mm camera, and takes with him two 800-watt second strobe units, which he uses in addition to the stage lighting.

Kenn Duncan is an example of a photographer whose work, although within a specialty, is tremendously varied. When he chose this particular specialty in photography, all he thought about was doing the best he could. He did not expect to see his work in art galleries or in books. That came about only because he set high standards, adhered to them, and produced work that was excellent.

James Heffernan:
Metropolitan Opera House Staff Photographer

○ Most performing arts photographers are free-lance and self-employed. However, there are theater, dance, and opera companies with staff photographers. One of them is the Metropolitan Opera House, which has an in-house photographer, and a studio and darkroom right in the building. A review of what the photographer, James Heffernan, and his assistant, Winnie Klotz, do will give you a thorough understanding of performing arts photography, since the Metropolitan Opera House is such a massive organization, and has a great need for many different kinds of photographs.

One big difference between the staff photographer and the free-lance photographer is that the Metropolitan Opera House furnishes the studio and darkroom, and pays for all the supplies. All the photographs and the negatives taken belong to the Metropolitan Opera House.

If you're interested in performing arts photography, you might consider attaching yourself to a local or community performing arts group (theater, dance, or opera). If you do this, you would be functioning similarly to the Met Opera photographers, although on a much smaller scale.

There is a great volume of work needed by the opera house. The staff photographers do almost all the photographs seen in the lobby displays on tour, in the mailing pieces, in the annual report of the Metropolitan Opera Association, as well as those in the programs, the souvenir books, and more. In 1981 a Metropolitan Opera calendar, containing four-color reproductions of the opera stars in costume, photographed by James Heffernan. in the backstage studio, was published for the first time. It is sold in the gift shops of Lincoln Center.

James Heffernan also takes news-type photographs such as contest winners being congratulated by the stars and the executives of the opera; and dignitaries who attend performances—Presidents Reagan and Carter, Kurt Waldheim, Prince Charles, Pierre Trudeau, and many others.

He makes copies on 35mm transparencies of the 8″ x 10″ glass slides which are used for projections, to create scenic effects for many operas. The large glass slides can break easily, and duplicates can be made quickly from the 35mm copy transparencies.

When magazines or publications send photographers to cover the opera, they go through the press department. They inform Heffernan so that he can help the photographers, if necessary.

Since the darkroom is located backstage and is equipped with mechanical processors, photographs taken from the wings when the opera starts can be ready in less than two hours and given to the critics by the second-act intermission. This is usually done when there is a new singer in a role. One photograph of the clown in *Pagliacci* was shot in the studio just before the singer went on stage, and photographs were ready halfway through the performance. Besides press releases, this picture has been used in advertising, for a record album cover, and in the 1981 calendar.

[Many years ago the author of this book was the photographer for a summer theater. With ordinary darkroom facilities she could have a photograph that was taken at the evening's performance, or of a V.I.P. attending a performance, ready no sooner than the morning for the local press.]

For the national tours, Mr. Heffernan does multiple printing, hundreds of prints at a time, for the press kits, and the lobby displays in all the different cities on the tour.

The photographs he does are also very important for fund raising. When planning a trip to see prospective donors, executives of the opera company will request a set of photographs of the sketches and scale models for the set of a planned new production, as well as other kinds of photographs for these trips.

Facilities

○ In the small but adequate studio backstage, James Heffernan has two strobe units—one 400 watt-seconds, the other 200 watt-seconds—and changeable background papers in many colors. The singers come to the studio to be photographed in their costumes for various roles, and also for portraits. Since it is so convenient, the singers can come to the studio before going on stage.

Besides his salary, through a special arrangement James Heffernan sells prints of these photographs, or of any taken during performance, to the

singers for their personal use. Visiting singers, he says, are delighted by this.

He shoots both black and white and color in the studio, and also for most of the other photographs taken in the theater. He uses color negative film, which gives him the latitude of correcting the color in his own darkroom. The darkroom is equipped with mechanical developing and processing equipment, enabling a photographer to produce work quickly, an absolute must for the opera company. Mechanical processors use resin-coated paper rather than fiber-based papers and resin-coated paper has the advantage of drying in two to ten minutes.

Filing

○ The filing of negatives and contact sheets is of utmost importance, and is done as soon as they are finished. They are filed by date and cross-referenced by date, by opera, and by artist. If a request comes in with just one of those pieces of information, there is no problem finding a specific photograph. A tremendous amount of work is produced; and everything must be filed carefully and be easy to get at. There is no question of ever disposing of anything, and without a tight filing system, chaos would reign. The historical and archival use of these photographs is almost as important as the current use.

Performance and Dress Rehearsal Photographs

○ Rather than having a special photo call, as in the case of the free-lance photographers, performance pictures at the Met are taken during dress rehearsals, and only the stage lighting can be used, no auxiliary lighting. A platform is set up in the orchestra over the seats, about fifteen rows back from the stage. The platform is big enough for a second photographer to stand on if necessary. The photographer, usually Winnie Klotz, has two cameras and two tripods. To avoid missing an important shot, they use two 35mm cameras, with a telephoto lens on one, for close-ups, and a wide-angle lens on the other to cover the whole stage.

During the dress rehearsals, while Winnie Klotz is photographing from the platform, James Heffernan goes all around the auditorium. He will shoot from the first row of boxes, the wings, anywhere in the house, and he also uses the platform. He uses several Leicas and mostly telephoto lenses to get close-ups and medium shots. Since the photographers cannot stop the dress rehearsal or make any kind of rearrangements, they overshoot to insure that everything is covered. Sometimes they have only three or four seconds to capture a scene, as in the cover photo of the annual report of 1976–77. It is the opening scene from the *Dialogues of the Carmelites,* with the nuns lying on the floor face down. After one bar of music (about four seconds), the singers get up and take other positions on the stage.

After shooting a full dress rehearsal, two sets of contact sheets are made. One is for James Heffernan's file; the second set is given to the director's assistant. He cuts up the frames and pastes them in their correct position on a music score. This score becomes part of the production book (explained below).

A long-standing tradition is that at the beginning of each season, an opening-night picture is taken of the conductor, the orchestra, and the full house with the lights on. It has to be done just before the curtain goes up. James Heffernan shoots this with a wide-angle lens from the stage just above the prompter's box. It has to be done very quickly, and he always has a prearranged signal with the conductor to avoid attracting any attention from the audience.

Production Book

○ Another important type of photograph James Heffernan does is the documentary photograph.

Every set for every opera has to be photographed. Fourteen prints of each shot are made and sent to the fourteen departments of the opera house: scenery, carpenter shop, lighting, stagehands, press, music, chorus, ccnductor, director, executive, and so on. Operas have many scenes: *Carmen* has four, *La Boheme* has five, *Mahagonny* has twenty, *Macbeth* has sixteen, *Boris Godunov* has ten. That adds up to a lot of prints.

There's another important use of the documentary photograph, and that is the production book. It contains the musical score, mentioned earlier, with the frames cut out from the contact sheets of the photos taken during dress rehearsal and pasted in position on the score. Then, in the studio, the sketches of the sets, the models of the sets, the actual sets, the sketches of the costumes, the finished costumes, and every single prop are all photographed. All these detailed photographs go into the production book—And there is a production book for every single opera, as well as for every different production of each opera. It is a master reference. Production books may be lent to other opera companies, and sometimes a duplicate production book is put together.

History

○ Photography is a second career for both James Heffernan and Winnie Klotz. Besides proficiency in photography, their effectiveness as Metropolitan Opera photographers also comes from the fact that both their previous careers were in the opera world. They understand all the subtleties, all the sensitivities of the singers, and all the split-second pressures of opera performance and production.

James Heffernan had been a New York City Fire Department captain, and was the safety inspector for the old Metropolitan Opera House. This job

satisfied his deep interest in the opera. When the new opera house was built in Lincoln Center, he retired from the fire department and was brought in by the Met management as a house manager. His responsibilities were for security, ushers, safety, electric bills, heating, air conditioning, the structure, and the medical staff (nurse and doctor). There were 260 people on his staff. He was also hired because the management wanted to insure even more safety than the city ordinances required. This position enabled him to get even closer to the opera, which he cared for so much.

Besides an interest in opera, Heffernan had always had a great interest in photography. In his fire department days, he had a darkroom set up in the basement of the firehouse, and he took courses in photography. "From them," he says, "I didn't learn so much what to do, as what not to do." While he was the house manager, the resident opera house photographer died. James Heffernan applied for the job and got it.

Winnie Klotz, his assistant, was an acrobatic dancer and a supernumerary in Metropolitan Opera productions. Photography fascinated her; whenever she could, she would stop by to visit at the studio. As things got busier in the studio, she offered to help with the filing of the negatives and the contact prints.

JH: That's her province, and she's almost too good at it. You take a negative out of the file, lay it on the desk, turn around, and she's filed it.

Gradually, she learned more and more, including how to operate the mechanical processing equipment; and she took classes in photography. In 1977 she left the performing end and became a full-time assistant. Besides filing the negatives and contact prints, and doing darkroom work, she takes the performance pictures from the platform while James Heffernan wanders around the auditorium with his Leicas. Their thorough knowledge of opera, their long association with all the people of that world, and their close and constant contact with the performers, combine to create a favorable atmosphere for getting very good and effective photographs.

Jack Mitchell:
Photographer of Performers
and Personalities in the Arts

○ Jack Mitchell occupies a unique position in this field of photography. His photographs bear his stamp, his look; they are strong and unforgettable; they are technically brilliant. He zeroes in on essences. For the past fifteen years his work has been frequently seen in the cultural section of *The New York Times.* His work is also published in many periodicals, but the *Times*

has been his most attention-getting exposure. He caters to his clients, but on his own terms.

Mitchell is not on the staff of the *Times*. He is assigned by them on a free-lance basis to photograph people in the arts. This is a great acknowledgment of the outstanding quality of his work, especially when one realizes that the *Times* receives an untold number of publicity photos, that they have their own staff photographers, but still choose to spend the extra money and get photographs on their pages by Jack Mitchell.

It is good to know the reasons why Mitchell is worth the extra expense, especially for you who are contemplating taking up this specialty in photography. The staff press photographers, who are fine and competent people, may be doing three or four assignments a day. They may not have the time to do the extra bit of coddling that performing artists may require.

Jack Mitchell is primarily a studio photographer. His specialty is photographing personalities, but he does not confine himself to performing artists,

JM: I love to photograph the best people in all the arts, the creators as well as the performers, the writers, the composers, the sculptors, the painters. I love to relate to people in all the arts.

It is this deep feeling of respect for people in the arts that accounts for the rapport he has with his sitters, and which results in the excellence of his portraits. Does he do retouching?

JM: Yes. Performing artists should look in a photograph as they do from the eighth row of the orchestra.

Several of his assignments, especially for record covers and magazine covers, originated because important personalities who have the clout requested him for important photo sittings. For instance, he does many Angel record album covers, and for them he photographed soprano Leontyne Price. Soon afterward, he got a call from RCA, her regular recording company, to do a cover portrait for them of Leontyne Price. Since then he has done most of her record album covers, not only for RCA, but for other labels, at her request.

He did an ad of Angela Lansbury as Auntie Mame for *Fortune* magazine, and when an ad was needed for a production of the musical *The King and I*, she requested that Jack Mitchell be the photographer. When *People* magazing decided to use Lauren Bacall for a cover, she also chose Jack Mitchell.

He also photographs groups in his studio. He photographed the whole cast of eighteen performers in the Alvin Ailey American Dance Theatre pro-

duction of the ballet *Revelations.* And his studio is not that big. He has had five dancers in dance movement in his studio. He has done groups of thirty musicians. "I turn my studio into a stage," he explains. His arrangements are not accidents. He very carefully composes his group pictures. One, a photograph of the seven resident playwrights of the Playwrights' Horizons Theatre Company, looks like a mountain range, with a head on top of each peak. Jack Mitchell created this effect by having each playwright wear a black turtleneck shirt, so that everything below each playwright's chin was one black mass.

He is the photographer for a large percentage of the *Dance* magazine covers. His Twyla Tharp Company photographs, which he took for *Dance* magazine, were requested and used later by the magazine *Dialogue,* which is published by the U.S. Information Agency and distributed abroad.

He doesn't do production shots as such, but is commissioned to take special photographs of performers on stage, which are used for special purposes: souvenir books, record covers, and special lobby displays, for example.

JM: When I do this work, I will not use the stage lighting. I bring in my own lights. I select moments, and work closely with the choreographer, or ballet master, or director, or playwright. I make changes for the photographs, yet I am careful to be certain that the photograph is faithful to the performed work.

He often employs special effects, such as montages or double exposures, for these photographs. He calls these effects "Movie-poster techniques."

Mitchell was commissioned by the Royal Winnipeg Ballet to go to Canada to take "dynamite" photographs (their word), which they felt were needed for the New York engagement. He was told to do whatever he wanted. He took four lights—strobe—between 800 and 1,200 watt-seconds total, and worked with one, two, three, or four lights. He took one of his favorite photos from the top of a ladder, with one light held high at the end of a fifteen-foot pole.

He had to shoot scenes from nine ballets in the repertoire, and had not seen any of them, but he was helped by the ballet master's suggestions. It was all very well organized.

JM: I worked one day from nine to five, with a leisurely lunch, and photographed scenes from nine ballets.

The Houston Ballet commissions him for their souvenir books.

JM: They do not spare the money for the four-color reproduction and the best printing quality—and this comes very high. It is glorious to see the work so beautifully reproduced. In two and a half days, I did dance pictures of the company, photographs of the soloists in dance poses, and portraits.

He went to Belgium to photograph the Basle Ballet Company for *Dance* magazine. He sat in the front row with a long lens, and had people from the ballet on either side, "so no one would disturb me."

When using strobe on stage, a photographer cannot see what effect the strobe will have. The modeling lights are not strong enough. How does he cope with this?

JM: I see it in my head, and I have done so much dance photography that when I shoot, I am in synch with the dancer, and I almost automatically press the button at the peak of the movement.

Mitchell has been using strobe lighting since it first came out, around 1950. They didn't have bounce umbrellas then, and he felt instinctively that the naked strobe was too harsh, so he had a special umbrella custom made to attach to the strobe unit. He realized that this was a way of softening the light. Now, bounce umbrellas are standard. For studio and large location shootings, he uses 1,200 watt-second units.

History

○ When Jack Mitchell was eleven years old, his father taught him darkroom work; soon after, he began using a camera. By the time he was fifteen, he was taking photographs for local people, and getting paid. He even had a small photo-finishing business. At that time, in Florida, where he lived, a photographer had to have a license (this law no longer exists). The local photographer complained to the authorities about him. One day, coming home from school, an inspector from the state board was waiting for him with a summons. They arranged for him to take a test; he passed, paid his ten dollars, got a license, and took up his business again. So he can honestly say that he's been a professional photographer since he was fifteen years old.

He was a photographer in the U.S. Army during World War II for the public relations sector. He photographed USO shows and many celebrities, such as the Andrews Sisters and many others.

After the war, he met the great innovative dancer, Ted Shawn, who invited him to spend a summer at Jacob's Pillow (Massachusetts), a sum-

mer theater that was started before World War II by Shawn, and dedicated to modern dance, ethnic dance, and ballet. It is still in existence.

JM: The best dancers came to Jacob's Pillow. From the beginning I've been exposed to the finest artists, and from them I've learned a lot.

Mitchell has had two books of his dance photographs published: *Dance Scene USA,* text by Clive Barnes (World Publishing, 1967); and *American Dance Portfolio,* with a foreword by Walter Terry (Dodd Mead, 1964).

His work has been exhibited in art galleries, and his prints sell well. His work is in the collections of several museums—The Baltimore Museum of Art has a forty-print collection. The Albright-Knox Gallery (Buffalo) and the ICP (International Center of Photography) also have many of his prints in their permanent collections.

JM: I do commercial photography, but I approach it as an art, and I hope that it comes out that way.

Martha Swope: General Performing Arts Photographer

○ No review of performing arts photographers would be complete without including Martha Swope.

She works with a staff of six; her studio and darkroom occupy two thousand square feet. She started in this business in 1959, and by 1965 was the most active performing arts photographer. She does production photographs for 75 percent of the Broadway shows, as well as for many dance companies.

The best way to comprehend what she's about is to see her schedule for one week in October 1981. Her schedule for a month before and a month after is much the same. This is the busy theater season, but she said that the rest of the year is not too different.

Monday—Cancelled a flight to Boston because of bad weather, could not chance being late, and went with two assistants by bus to photograph the musical *Dream Girls.* The show is in previews, and we sat through the performance and took pictures from the seat, using my quietest camera, which I wrap in foam rubber when I shoot during a performance. After the curtain, we had a photo call that ran until 5 A.M. When we finished, the weather was still bad, so we caught the 5:45 A.M. train, arriving in New York at 10 A.M. on Tuesday.

[When photographing in the theater, she does not use strobe for auxiliary lighting. She uses two 1,000-watt quartz lights, which she balances against the stage lighting. She also gives her clients "turn-around" service, developing the negatives immediately, delivering contact prints the next day and finished prints the day after. Sometimes she gives them prints with the contacts. She is so respected in this business that the clients accept her choices.]

Tuesday—Arrived at the studio (straight from the train) at 10 A.M. Gave the film to the darkroom man for processing and by 1 P.M., contacts were delivered to the press agent. From 1–5 P.M., with one assistant, shot the Broadway musical *42nd Street* candidly during a dress rehearsal. The show had been running almost a year, but new photographs were needed because of cast changes and new actors going in. Dinner, then from 7–9 P.M., photographed a new play, *Mass Appeal,* before the Broadway opening, with one assistant.

Wednesday—From 11 A.M. to 1 P.M. did production shots for *Entertaining Mr. Sloane;* returned to the studio for a job there, head shots of a young actress. While attending to this, two assistants were shooting during performance, *Merrily We Roll Along,* because of a cast change. Came in for the second act, and after the curtain, ran a short, one-hour photo call.

Thursday—Everyone is in the studio all day, all getting the work out. Besides finishing prints, this also includes retouching. In the evening, I and an asssistant attend a performance of *Crimes of the Heart,* shoot after curtain until 12 midnight. While we are doing this, two other assistants were watching previews of *The First,* which I saw during the matinee, and I join them for production shots after the curtain, until 2 A.M.

Friday—All in the studio, getting the work out. In the evening see *Ned and Jack,* then do a photo call, worked until 2 A.M. The weekend is spent catching up (during performances) at the NYC Ballet—photographing from the wings or lighting booth.

There you have it. There is no one else like her.

From 1964 until December of 1980, Martha Swope worked in the front half of one floor of a brownstone, a space that was fifteen feet by forty feet. The living room was a studio and the darkroom was built in the bathroom, yet she developed her business in that space and produced a phenomenal amount of work with one darkroom technician and two assistants. In December of 1980, she moved to a new place, two thousand square feet in the theater district, at Manhattan Plaza. She now has a staff of six—darkroom technician, secretary, delivery person, and three assistants who shoot with her. One of her assistants is training to do retouching, which Martha Swope has been doing. Between shootings, they all help out with the darkroom and the print finishing work.

MS: I tripled my space and doubled my staff. We have a tremendous darkroom load. For many plays, we may have to make six prints each of fifty negatives, to take care of all the anticipated publicity, publication, and advertising needs of the clients.

We now have two darkrooms—one for prints, and one for negative developing, a finishing room, two dressing rooms, and a large studio. Between the four of us who shoot, we have every professional 35mm camera, and every focal-length lens for each camera, plus 2¼-inch format cameras, and 4-by-5-inch cameras. I use strobe lighting in the studio, and we've installed regular theatrical lights with gels and dimmers, and an eighteen-foot cyclorama like the ones they have in TV studios.

When doing production shots, some press agents or directors will give her a shooting script, but in general she blocks the show and runs the photo call. Besides making prints for the producers and press agents, actors (by the droves) come to the studio to order prints from the photo calls.

MS: Doing this sort of work means that in addition to being a photographer, you have to be a director, a diplomat, a psychologist, and a friend.

Not only does Swope get assignments from producers, press agents, and performers, but also from magazines, newspapers, and record companies. A commission may originate from a producer, and the press agent on the show will then become acquainted with her and begin to call on her. Or it may be the other way around—the press agent for a play, who knows her work, will initiate the commission.

Seventy percent of her work is shooting shows and ballet in the theater; thirty percent is in the studio, where she does setups on a show, special publicity pictures, and head shots.

MS: I'm out more than I am in.

From the very beginning, I have been aware of the archival nature of my work, and by now, after more than twenty years of working, it is quite an active historical file. People are in all the time, going through my file for research, for books, for articles, for university theses. I want it to be that way, and I have even made provisions in my will that my negative and print file will go into a good collection, one that will take care of it and make it accessible to the public.

Film Work

○ Film producers commission Martha Swope for special photography assignments, to take photographs for posters and advertisements. She has done this for many films—to name a few, *Saturday Night Fever, Hair,* and *The Brink's Job*—and did special photography for the new Paramount film, *Staying Alive,* featuring John Travolta, and written and directed by Sylvester Stallone.

For *Saturday Night Fever,* she watched a scene being shot, and then spent a morning photographing John Travolta. For the film *The Brink's Job,* she was on the set all day; at 5:50, they gave her ten minutes to photograph. She solved the problem by having the actors throw the money—one million dollars in cash—in the air, and it turned out fine. For the movie poster for *Idolmaker,* she rented a theater, spread Mylar on the floor, hung lights, and with a smoke machine adding atmosphere, she photographed the two singers.

Books and Calendars

○ Her photographs have been the basis for annual dance and theater calendars. She has had twenty books published, almost all of them on dance and theater: one on Martha Graham, the eminent modern dancer; one on Mikhail Baryshnikov, the great ballet dancer; a book about the New York City Ballet; and many others. The one book of her photographs which is not on theater or dance is about a cat, Mourka, who jumped for his master, George Balanchine. The text was by Tanaquil LeClerq.

History

MS: In the late fifties, a friend of mine gave me an amateur camera, an old 35mm Argus C40. It was even patched with adhesive tape. I was a student at the School of the American Ballet, and I started photographing my classmates and my teachers. I learned photography more or less by myself. Whenever I met an obstacle, I would ask questions. Salesmen in camera stores were very helpful, and so it went.

The people I photographed began to buy prints from me. The choreographer, Jerome Robbins, was taking classes at the School of the American Ballet, where I studied, and I had photographed him. Shortly afterward, *Life* magazine was doing a story on him, and he told me to go over there. They bought some pictures, and that was my first published work. I bought a new camera and went to Europe, where I photographed the Bolshoi Ballet, the French National Theater, and other groups. When the Russian ballet and the French National Theater came to the U.S.A. later on a tour, *The New York Times*

picked up my photographs, and then the jobs just seemed to start coming in.

Martha Swope has lots of drive; she is very focused and very disciplined.

LM: *To what do you attribute your outstanding success in this field?*
MS: Hard work, dependability, love and knowledge of the theater and dance, and taking care of the millions of details and things that need attention. It is a labor of love.

Bob Gruen: Photographer, Rock Musicians

○ Bob Gruen developed a career that is a specialty within the specialty of performing arts photography. He photographs the musicians of the rock music world. He photographs them at recording sessions, at rehearsals, backstage, during performances, in the dressing rooms, and in the wings. He photographs them in their homes, when they're out on the town; and he travels with them on the road.

He gets assignments primarily from the performers themselves; from their agents, managers, and publicity people; from record companies, magazines, and newspapers.

He also has a tremendous stock, which he sells to all kinds of publications and for postcards and posters. He has two reps abroad who sell his work, primarily in Japan and Germany.

The national magazine *Esquire* described him as "The hottest East Coast rock photographer, and the most professional." Many of the photographs fixed in the public's mind of John Lennon, Mick Jagger, Elton John, and others are his work. An exhibition of his photographs was held at Zoma Gallery in NYC in the spring of 1982, with an opening party at Studio 54.

He is a prime example of someone with a good strong foundation in the techniques of camera work who developed a career based on a consuming personal interest.

Like all the other photographers in this book, he works very, very hard.

BG: You also have to have luck, or perhaps you have to have the ability to attract the luck to yourself; there's a lot of magic involved.

One thing to be kept in mind is that the music business—including records, concerts, and TV—is a big money-making industry, and like all the other areas of performing arts, photographs play an important role in the professional lives of these performers.

BG: I became acquainted with photography when I was three years old. My mother, who was a serious amateur, took me into the darkroom with her so she could keep an eye on me. I was given a camera when I was eight years old, a Brownie Hawkeye, which I still have, and I started taking pictures and doing darkroom work at that age. At eleven, I took pictures of the kids who were in the musical plays at summer camp. I never liked sitting in an audience, and preferred wandering about and taking pictures of the performances. I sent the film home to my mother. She developed it and printed the pictures, which she sent back to me, and I sold them to the kids. It's the same business I'm in today, taking pictures of performers, except that now I do my own darkroom work.

My first published photograph appeared when I was thirteen years old, in a school magazine. I had gotten a 35mm camera then, a Minolta, which I used for many years. I had joined an offset printing club in school because they had a darkroom, and I sent pictures I took of the club into the magazine; they liked them and ran them. I did not get paid, but at thirteen I didn't care, and I was very happy. The first paid pictures I had published were on the front page of my hometown newspaper, the *Great Neck Record*. They were pictures of a fire, and I got twenty-five dollars and a credit line, which was very exciting.

Since then, and still to this day, people sometimes want to publish pictures and say that they'd like to pay me, but can't; instead, they say, they'll give me a credit line. I learned early, and I say, "That's nice, but my landlord doesn't take credit. I'd rather have the money."

I was very good at portraits from the beginning, and I was also doing sports photography for my school and another school in the town. I also did the portraits for the local politicians—candid-type pictures which they used for posters and as giveaways. When I came in to photograph them with my 35mm Minolta, which I used very well, they would indicate that they thought I was only a kid with his father's camera. So when I was fourteen, I bought a 4-by-5-inch Crown Graphic. It was an old-fashioned camera, but it looked like a press camera, and it looked professional, and no one would carry one unless they were on a job. Sometimes I would carry both cameras. When they saw me with the Crown Graphic, they would say, "Wow, isn't he young to be professional?" With that camera, I wasn't a kid, I was a photographer in their eyes.

I did my own processing in the darkroom in our basement. I continued to photograph a lot of sports. That sports experience followed through later into the rock-and-roll work—the action, and

capturing it. I began to do all kinds of photography jobs. I worked for
the college newspaper photographing classrooms, sports, portraits, and
what are called weather pictures—snow scenes, the first signs of
spring, mood pictures, rainy day shots. I did a whole calendar of
the sorority queens, glamour head shots or location shots of them,
whatever was convenient.

I really didn't know what I wanted to major in in college, and
kept going from one major to another. So I came home and started to
look for a job. But I didn't know what to look for. I didn't know what
I was or what I could become. A friend of mine said, "Well, you've
been carrying a camera every day of your life for the last eight years,
maybe you're a photographer." Suddenly, it dawned on me—maybe
I am.

So I started looking for jobs in photography. I spent three to four
years at various photo jobs not related to the work I specialize in now.
However, I think it's important to point out that each and every job in
photography, no matter how menial, no matter how far from what I
do now, contributed and taught me something important that I could
utilize.

At that time, I was very lucky. My cousin, a writer, had done a
story on the Professional Photographer's School, headed by Victor
Keppler [a well-known *Life* photographer at that time]. Through my
cousin, I went to see Keppler and showed him my photographs. He
was impressed, and gave me five letters of introduction to people in
photography. One was to Richard Avedon, who was leaving for
Europe, and told me to come back in two months. I never did, because
I felt that if I didn't get a job with him, I'd be devastated. Victor Keppler
was also nice enough to send my cousin a letter saying that I had
a lot of talent, and that I was great. This meant a lot to me and gave
me a lot of courage to pursue photography. It also helped me with my
family, because they were quite worried about me, thinking that
I had no direction.

I did get a job making filmstrips, not taking pictures. It was a lab
job, working on a large machine that could process film in bulk. After
five months, I graduated to an Oxberry camera, a still camera on a
stand, and a very precise copy camera. You could put a frame, plus
copy, plus numbers, plus a caption, and copy all that material onto
another single frame of film. It all had to be very exact. I did that for
about a year. From that, I learned a lot about film—the actual texture
of the emulsion, what shows up and how much you can push it by
burning in numbers, how to expose film for a flat piece of art, how

to balance it, how filters work. So it was a very valuable experience, although at the time I didn't know it.

While I was working there, I took a photography course at the Fashion Institute of Technology [NYC]. That was also very good for me. I polished up my craft; I learned professionalism—how to take a picture to order and then get it finished on time. Through that course I got a job as an assistant at a big commercial fashion studio. There we did eight to ten catalog setups a day. I loaded the film, changed the background paper, and helped with the lighting. And there, again, I learned a lot. I learned about how to work with models, that they were not just pretty people, but people who knew how to be models, who knew how to work.

Then I got a job in a studio that did two types of work. One, they made slide shows where six color slides would be projected at the same time, and had to be in perfect registration, so that when they were projected on a twenty-four-foot screen, they all had to fit together, and that was very difficult to do. That same company also made color slides of the paintings at the Metropolitan Museum of Art, the Whitney Museum, and the Museum of Modern Art. These color slides were sold to the public and used for catalogs and magazines. The color rendition had to be perfect, and after they showed me once how to do it, I was left on my own. I worked in the museums at night, and doing this precision work was another very valuable experience. It was hard physical labor. Sometimes it took hours to just set up the lighting to photograph one painting, as the lighting had to be perfectly even with no hot spots. Depending on the size of the paintings, we'd use from two lights up to six lights for the larger paintings. We used very slow exposures, sometimes up to two or three minutes. This was a great learning experience about how film relates to color. I became very conscious of all the shades of color, since no color film has the range of color that a painting might have. I really owe a great debt to that work, although it was very boring.

Now, every time I shoot a roll of color film, I know the whole history of it. So I can't say what kind of jobs to recommend. There are a lot of technical jobs that don't seem as though they're part of your field, but they can teach you an awful lot.

Early on, I had a summer job selling film at the World's Fair in New York City. Even that was valuable, because every tourist who bought a roll of film and didn't know how to load the camera would ask me to do it, so I got to experience every kind of camera there was in the world, and what they were like, and how they worked.

All along, most of my friends had been musicians, even when I was growing up, and in my free time I was living pretty much with rock bands. My friends went from folk music to rock music. When the Beatles became popular, my friends started playing guitars, and since I wasn't good at playing a guitar, but I was good at taking pictures, I took pictures of them. It was through the band that I lived with that I got started on my free-lance career. They finally got a record contract. I met the producer of the record company, and through him I met his publicist, who hired me to do the photographs. The producer liked my work and decided to have me do the album cover for the next artist he recorded. And the next time the publicist needed a photographic job, he called me. I ended up doing many jobs for him, and every time I did a job for him, the people I photographed would use me and then recommend me to someone else. It's still happening today.

LM: *Many people do free-lance jobs and they don't get called back. Will you please explain why you kept getting called back?*

BG: They liked my pictures, and I worked very hard, and when I promised them prints, I saw to it that they got them on time, even if it meant working around the clock. They appreciated the successful jobs. I photographed with the least amount of pain to them. I didn't intrude on anybody. I didn't go for the free food. I didn't go for the scene. I just went to do my job. I did my own black-and-white processing, and I still do it. I send out the color. I now have an assistant who prints the black and white for me.

When I started to do the music work, I continued to work at the museum job for about a year, gradually phasing out of that when the music work built up. At that time I got married, but I wasn't making that much money, since I didn't have the magazine outlets yet, so I worked in a record store at night for four months, which broadened my knowledge of the music business. I also did baby pictures for about six months on the weekends.

LM: *Were you working fourteen hours a day?*

BG: I was working twenty-four hours a day.

LM: *When you finally got in with the big rock-and-roll people, did the photo fees increase?*

BG: Actually, what happened is that the people I got in with got big. I photographed Elton John the first time he came to America, when he was an opening act, and no one had heard of him. He liked my work a lot, and every time he came back, I worked for him. He kept getting bigger and bigger, and more successful. Through those things I would meet other people, and send pictures to the magazines, who

eventually picked up my pictures and used my work frequently. It just snowballed.

[One point to be clarified here is that rock groups have many followers who photograph them and send the pictures to magazines. However, with the fans, it's a sometimes thing. What the magazines became aware of was a constant, serious, high-level source of photographs from Bob Gruen, and so began to pick up and use his work.]

One of my most famous pictures is John Lennon in the NYC T-shirt. It's been reproduced hundreds of times. That came out of an interesting job. John was recording an album in the studio. It was one of the few times that the art director came up with an idea for the cover. John usually created them himself. In this case, the art director wanted many photographs of John with different expressions, and then he planned to divide the photographs in three horizontal strips, and rearrange the features. The art director wanted Richard Avedon to shoot the pictures. John couldn't be bothered doing that, because he was working in the recording studio, and when they're in the studio making a record there's so much on their minds, so many notes, so many tracks, they don't want to be distracted.

John didn't want to go and start a relationship with Richard Avedon and do a photo session with him, when we already had a relationship—he was used to me—and so he told the art director that he wanted me to do it. Actually, it wasn't a pleasant experience, because the art director was bugged that his choice was vetoed. But John was big enough to get his way.

The pictures came out perfect. I used a Hasselblad with a 150mm lens for a portrait lens. At that time, John was living in an apartment on 52nd Street in New York City, with a roof next to his window. I taped up background paper on the brick wall, to avoid bringing up lights, and we shot the portraits in color right there by daylight.

There were problems, because the sun was going in and out of the clouds, and it was hard to get all the portraits to match. I shot twenty different poses, with a great variety of facial expressions, to get six basic different expressions. We didn't need one "good" portrait, as such. For one pose, he put on all six pairs of glasses at once, and that was the basic picture. There was another one with his tongue sticking out. After we finished, John said, "Do you want to do any other pictures before we quit, so that we don't have to do this again for six months?"

We had been in the habit of doing a session, a complete session, and then for the next six or eight months, or a year, if anyone wanted a picture, he'd say, "Call Bob Gruen and get it from him." I realized that we had a great view of New York City from the roof, so I said, "Do you still have that New York City T-shirt I gave you?" John went and put the T-shirt on, and I photographed him against the skyline. That picture has been around and has been published extensively. It's been published more than any other photograph of mine, and it's been made into a poster.

Fees

○ When I sell out of stock, they're just stock-shot fees, no matter how famous the person, from thirty-five to one hundred dollars. Sometimes I put an exclusive on a photograph, or if one magazine doesn't want me to sell to another, they'll pay double. That's selling out of stock, and the money builds up because of volume. Assignments pay better. A lot of the stock photos are the extra pictures taken during assignments. On the above-described album cover, although the art director would have paid Avedon five thousand dollars, for spite, he gave me much, much less. But I didn't have the name of Avedon, and I couldn't complain, and I was very glad to be doing it. But now I have a little more weight. I have more friends.

Equipment

○ I like to work with a minimum amount of equipment that works very well. I never liked a lot of equipment. Even with my Brownie Hawkeye, my first camera, I did a lot of good pictures with that. I've done an album cover with an Instamatic—a picture of my kid. But I got a Hasselblad in the late sixties, and I've used that for sharpness, but I find it awkward, especially in concert situations.

My basic setup is three 35mm bodies with three lenses. I switch lenses; I've become very good at that. I have one body loaded with black-and-white Tri-X, one with daylight color, and the third is loaded with tungsten color. The three lenses are a 28mm, a 50mm, and a 150mm. I switch lenses for the different films. The whole system has to be compatible. In the beginning I had a Yashica, a Minolta, and an Olympus, and with that kind of an array, you can't work different films simultaneously and switch lenses. I carry a strobe, but I do not like to use it.

When I went professional, I started using Nikons, the strongest of

the 35mm cameras. I did use motors, but I don't do that often now. Motors can cause overshooting. If you know what to take, they're not necessary. However, a lot of times in rock and roll, in the stage work, it's going down so fast that the motor helps. You might just miss something. You don't have to use your hands so much, especially if you're in a weird position.

LM: *What is a weird position?*

BG: Many of the stages are set up on scaffolding, and I could be hanging off the edge of the stage, holding onto a pipe with one hand, with a foot on another pipe. Since the show is directed at the audience, I like to get in as close as possible and shoot from the audience's viewpoint, but I do not like to shoot from the stage or the wings.

You're following the action, you're trying to stay with someone on stage, and with the motor, you don't have to worry about winding, you just concentrate on moving with them and keep shooting. I actually use the winders more than motors. It's not the speed of the motors I need, or the repetition they give you. I just need the convenience of not having to wind manually, especially when one hand is holding onto a pipe.

The Nikons are big and solid. You can practically hammer a nail in with one and still use it. But if you're carrying them all day, it's a lot of weight—cameras, lenses, motors, film, etcetera. When I was in Japan in 1981, I met the people of the Olympus Company, and I did an endorsement for them. They gave me three bodies and a whole set of lenses. They are much smaller and lighter than Nikons, and give the same kind of sharpness. Olympuses are what I use now. Basically, as mentioned above, I have a 28mm, a 50mm, and 135mm lenses. I do not use zoom lenses. I find their focus isn't right, and besides, I never found a zoom lens I really wanted. If I could get a zoom that went from 28mm to 150mm, that is small and that was f/1.4, I would take it. But a zoom with an f/4.5 aperture, and that only goes from 70mm to 135mm, or one that goes from 35mm to 70mm, doesn't do anything for me. They're either too high or too low. I never found a zoom that fit my needs. And anyway, I'm pretty fast at changing lenses.

LM: *Do you forget to change your apertures when switching lenses?*

BG: I used to occasionally, but the new cameras are marvels of modern science. They tell you right in the lens. They light up and say, "Okay, take a picture!"

LM: *Describe a tour assignment you went on.*

BG: Well, I was on tour with Kiss in Japan. They commissioned me.

[Kiss is a rock group that consists of four people who wear extreme makeup.]

I was in Japan for about a month; the tour itself was for about twelve days. I got there a little bit in advance, and stayed later to put together the stuff I'd shot, process the film, print, and get it to the publications. The assignment was paid for by the group, and so when I finished all the pictures belonged to the group. Kiss also brought about a dozen journalists with them. They gave the photographs I took to the magazines and newspapers. The Japanese couldn't believe they were getting the pictures for free, and kept saying, "Can't we give you something?" I said, "No, Kiss gave you this." They replied, "Can't we give you a present?" So they gave me a little tape recorder. And, when the photographs were reproduced in the magazines, the credit line read, "These photographs are a present from Kiss."

With Kiss, it's very difficult doing a coverage like this. With most rock groups, you can take pictures of them in the morning, in the afternoon, or near a pool. I'll do candids wherever they look good. So in a way, this job was really exciting, because the thing with Kiss is that you can't take pictures of them during the day. They don't exist except when they have their makeup on, and they only start putting their makeup on about an hour before the show. So it's only for about ten minutes before they go on that they're actually Kiss, so you have only ten minutes to get photographs of four guys that normally you would be doing all day. It's pretty limited. Most of what I was shooting was in the dressing room and in the wings of the theater, and a theater looks the same anywhere in the world.

Since we were in Japan, I suggested that we do some kind of special session to show we were in Japan. One afternoon I picked Kyoto, the ancient capital of Japan, which has hundreds of shrines and temples and pagodas. The day before the special session, I went around to the various shrines in a taxi and took Polaroids. Then I went over them with the group, and together we picked five locations which we thought would make good backgrounds.

The following day, they put their makeup on at two in the afternoon. The same cab driver returned, by appointment—and we had a bus for Kiss, and their guards, and the press—and we all loaded up in front of the hotel. I showed the taxi driver the Polaroids, indicating where we were to return. We all took off, the bus following me, and when we got to the first one, I just put the band up in front of the Buddha and started shooting. The temple guards started freaking out

because it was a shrine to the dead, and no pictures were supposed to be taken. By the time the Japanese and the English were translated the pictures were done, and we were on our way to the second location.

However, when we got there, a crowd was following us. After the third one, we had almost three hundred taxis and cars, and the crowd kept building. It was as though we were leading a parade, a whole Kiss army through the city of Kyoto. Everyone was flipped out to see Kiss outside in the daylight. Kiss is very popular, and they look like superhuman characters out of a comic book, and to see them live was really exciting.

LM: *Are rock musicians popular in Japan?*

BG: Yes.

LM: *Describe photographing at a recording session, perhaps one that went on for a long time.*

BG: They all go on for a long time. Most recording sessions are difficult to photograph because it's a very serious time for a musician. He has to concentrate on making his music perfect, and can't be distracted. So many times, taking pictures is a distracting thing, because the musician becomes self-conscious and wants to look good. The photographer has to act in such a way that you have his confidence, so he's not worried about what you're doing. At best, he should not even be aware of you, so that he can keep his concentration on his music.

Now, for a photographer to be able to do that takes a lot of time, and a lot of subtlety, and a lot of patience. We can't move around a lot. We have to be very still, to just sort of blend in. We have to be aware of when they're recording, when you can't take a picture, because they might be doing a perfect tape, and if there's a click from a camera in the middle, it's not very good. You have to be able to work in very low light situations. They don't want to turn up the lights because, again, you don't want to distract them. You may have to hand-hold your camera still for two or three seconds, and hope that the guy doesn't move, things like that.

[Gruen does not take a tripod into a recording session.]

LM: *How many hours have you spent at a recording session?*

BG: Too many; they all seem to go on forever. Sometimes you get there at two in the afternoon, and you may not walk out until two the next afternoon or ten the next morning. I would say, you never know when you're going to get out. Although with John and Yoko, after a

while I would just kind of go late at night, because a lot of the early stuff is mixing drum tracks, which takes hours and hours, and I knew they were going to be there until nine in the morning anyway. So, I would show up at three A.M., and I'd still be there for six hours, even though they may have already been there for twelve hours.

[Note how different is the function of the free-lance photographer, hired by the performers, from the function of the newspaper photographer (Chapter 2) who has to get in, get the photographs, and get out.]

LM: *Was John Lennon really such a great guy?*
BG: Yes, yes, he was; he was wonderful, compassionate, warm, brilliant.

 I spent a year in Japan. I had gone there with Yoko Ono, and with Kiss, and a couple of other groups. Every time I went there, I made more friends and more contacts. So in 1979 to 1980, I went there and spent a year. I got an apartment in Tokyo and supported myself taking pictures of the groups in Japan. I also did a story on the Japanese music scene, and sold it worldwide. It was a great experience.
LM: *What advice would you like to give to aspiring photographers?*
BG: Work hard and have as much fun as you can, but with respect for other people.

Still Photography for Motion Pictures

○ Still photographers work on film productions for feature motion pictures, documentaries, and productions for TV. The work they do is very similar to the work of the performing arts photographers you've just read about.

 Their responsibilities are to take photographs that can be used for publicity releases, advertisements, and posters. To do this well, they must be aware of and tuned in to what is going on, and try to capture key scenes and important peak moments. The still photographer is also called upon to do close-up portraits of the performers. His or her other function is to make record shots of the positions of the performers on the set and of the placement of the props, so that when shooting is continued at a later date, these photographs will be used as guides to insure that everything matches when the scenes are edited. These record photographs are important and can be done with a Polaroid.

 There are two major differences between working on a movie set and at a live performance. There is no special photo call for the still photographer on a film production.

1. You're working on a set with a large crew of other specialists: camera people, assistant directors, lighting technicians, stage hands, performers, and many others—at times there may be as many as seventy-five people. You must be part of a team effort and never, never get in anybody's way. This is challenging and can present a difficulty in getting your work done effectively.

2. This work is unionized. One union that has jurisdiction is IATSE (International Alliance of Theater and Stage Employees). The address of Photographers Local is Room 1723, 250 West 57th Street, New York, NY 10019, (212) 247-3860 and (212) 937-7250.

The other union is NABET (National Association of Broadcast Employees and Technicians), Suite 1900, 1776 Broadway, New York City, NY 10019, (212) 265–3500.

Both these unions give examinations. An explanation sheet from NABET entitled To All Applicants Applying to the Still Photography Department, states the following:

> An applicant must take a test, given at the NABET office. . . . To be accepted into our category, a person must be already able to handle a photo assignment on a film set. . . . An applicant must demonstrate that he or she is a skilled and experienced photographer and able to deal on a professional level with their assignment, their clients, producers and fellow union members. After taking the test, the applicant must make an appointment to meet and show his or her portfolio at the next meeting of the still photographers.

If you want to work on motion picture productions, these are the obstacles you must hurdle. However, determined and clever people always find ways of getting past obstacles. There are numerous examples in this book of photographers who have figured out ways of achieving their aims. If working on a film or TV crew is what you really really want to do, you might start out photographing live performances, proving that you can do it well, and get to know people in the field. Then perhaps you can find a small film production company that does not require membership in these unions. After you are experienced and comfortable doing this work, and have a portfolio, you could then apply to the unions for membership, and would probably pass their tests without any difficulty.

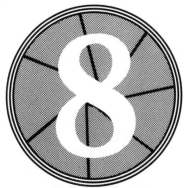

Stock Photographs

○ The term *stock photograph* has been mentioned throughout this book, and it's time to go into more detail about it, to clarify the term, and to explain exactly what stock photographs are.

Stock photographs are those that are kept on file with the idea that there will be an opportunity later to sell them.

There are firms called picture libraries—or photo libraries, or stock houses—that literally have millions of photographs on file. In Chapter 2, the picture library of the Black Star Agency is mentioned, although the selling of stock photographs is not the primary function of Black Star. There are firms that do nothing but sell stock photographs.

Some photographers who are well known for what they do administer their own stock files. Requests come directly to them. Such photographers are Martha Swope (Chapter 8), who specializes in dance and theater photography, and Bob Gruen (Chapter 8), who sells stock photographs of rock musicians. Suzanne Szasz (Chapter 3) uses her photo files to create her books. She regularly sells out of these files to magazines, books, and advertising agencies. The requests from these sources come directly to her. Jeff Blackman, the sports photographer (Chapter 2) also derives a nice income from his stock photographs.

Martha Cooper (Chapter 2) mentions the personal projects she works on, which are not being published currently, but she's sure that the time will come when there will be a demand for the subject matter she is compiling—she calls it her personal IRA. That too can be called stock.

Chris Johns, press photographer (Chapter 4), sends the extra photo-

graphs from his free-lance assignments to Black Star for stock sales. His newspaper photographs belong to the paper. Frank C. Dougherty (Chapter 4) uses Camera 3, another stock house.

Ida Wyman (Chapters 2 and 6) mentioned that when *Life* magazine returned her old negatives to her, she edited them and made prints, as they had attained a historical value, and museums and archives had expressed an interest in them. This is another form of stock.

This adds up to additional income for photographers who do not have an immediate use for certain photographs; there are not too many, but some photographers derive quite a nice income from their stock photographs.

Some photographers will shoot specifically to build up a stock file. Of course, they have a good idea of the kinds of photos that sell well.

Only a few photographers administer their stock. Most photographers deposit their stock photographs with firms in the business of selling stock.

As mentioned previously, Black Star specializes in photojournalism, but other stock houses keep all kinds of photographs on file, and get requests from every imaginable source: book publishers, magazines, TV stations, public relations firms, graphic design studios, advertising agencies, and so on.

Al Forsyth:
DPI – Design Photographers International

○ Al Forsyth is the president of DPI (Design Photographers International), a photo library at 521 Madison Avenue, NYC. He has thirty-two years of experience in this business. DPI does not limit itself to photojournalism. Every imaginable kind of photograph is in their files: illustration, documentary, photojournalism, city scenes, landscapes, gardens, still lifes, travel, machines, beautiful faces, dancers, children, holiday scenes, weddings, animals, school situations, people at work, people playing, sports, architecture, science. You name it, they have it.

Photographers leave their photographs with DPI, or another stock house, and when a sale is made, the stock house pays the photographer and gets a percentage. Of course, you should take care to put your work in a reputable agency. (This is a reason to join a professional photography organization, as you will learn from other photographers the reputations of the various picture agencies or stock houses.)

People looking for photographs either call in to an agency or send in a request sheet with descriptions of the photographs they need. These requests come from publishers of books and magazines, graphic design studios, advertising agencies, public relations firms, company publications, government agencies, or any legitimate person needing photographs for reproduction. They generally send these request sheets to several stock

houses, which may net them up to one hundred submissions, when they may need only two or three photographs. The chances of having a photograph sold are not great, but they do sell. Here are some sample requests:

This is from a book publisher requesting photographs for a high school textbook. Can be black and white or color.

1. People with wrapped presents getting on a bus or train, a Hispanic family preferred.
2. Family at an airport, getting on a plane.
3. An aerial view of lush land environment, such as a Louisiana bayou.
4. South Pole, showing barren harsh environment with no people or animals.
5. Desert, animals in a hot dry area, no camels.
6. Waterfall in a rain forest environment, with trees and plants around the waterfall.
7. Moon in sky on a clear night, city buildings or trees showing.
8. Close-up of a house cat with clear details of fur, tail, and feet.
9. An adult jungle cat such as lion, cheetah, tiger (no zoo), close-up, same as above.
10. Toucan, bird with a huge beak in a tropical environment.
11. A high school student (m or f) doing research in a library.
12. A storefront sign of a gypsy fortune teller or palm reader showing astrological chart.
(This is just part of the list, it goes up to fifty items)

This is from a national magazine. Color only.

1. Cities, surrounding areas, and suburbs of the following cities in California: San Francisco, Los Angeles, Hollywood, Beverly Hills (Rodeo Drive), Sausalito, Berkeley, San Diego.
2. California—fun and festivals. Disneyland, Sea World, Universal Film Studios, food festivals, country fairs, Safari Park, Napa wine festival.
3. California—desert, coast, industries, mountains, and agriculture.

This is a request sheet from an advertising agency. Color only.

1. Holiday scenes abroad. Holland, selling wooden shoes; a Korean Thanksgiving; a Filipino manger scene; Ecuador and Japan, New Year's Eve celebrations.

That should give you some idea of the picture requests that are received by the stock houses. When the requests come in, Al Forsyth and his staff do a file search and present photographs to the prospective clients. The photographs, as such, are not sold. Technically, what a stock house does is to license a one-time reproduction right to the client. The original photograph is always returned.

Actually, a reliable, well-established stock house such as DPI performs an excellent service for a photographer. The personnel are acquainted and have experience with many more sources than a photographer could have. They get requests from all over the country and all over the world. They also know which requests come from bona fide buyers.

The other tremendous service a stock house performs is that the staff knows all the pricing for all different kinds of reproduction usages. That in itself is an important and complicated area of professional photography, which will be discussed further in the next section on organizations.

Occasionally photographers will have a photograph that is sold numerous times. But that is very unusual. There are a few photographs that have commanded tremendous fees, upwards of four thousand dollars, because an advertising agency has purchased an exclusive on it for repeated reproduction over an extended period of time.

You can quite readily understand that being in this business, Forsyth has dealt with hundreds of photographers and has had close relationships with a great number of them. In addition, he has had daily experience with the people who buy. Therefore, he has a keen overview of the market. He knows a tremendous amount about the photograph as a salable item.

And this is what he has to say.

AF: Number one: Pinpoint the area you're interested in, or an area that is readily available to you, be it science, theater, press, adolescents, school situations, sports, children. See what is being used. Analyze the pictures you see in books, in encyclopedias, in magazines, in brochures, in pamphlets, in advertisements, on packages. Get an understanding of what goes into these pictures. Look carefully at all the photographs you see everywhere. See how a textbook photo-graph differs from an advertising photograph; for instance, advertising photographs usually have a happy quality. If you want a photograph to be salable for a long time, be careful of what the people are wearing, so the photograph doesn't become dated too quickly. Beach pictures, skiing photographs, out-of-doors pictures of people at play are almost always taken when it is sunny.

You must thoroughly acquaint yourself with the kind of photo-graph the market area you're addressing yourself to expects. Think of it as a market research project. You have to have an awareness of the potential market salability of a photograph. You must learn about the kinds of photographs that people buy.

People in advertising photographs have a certain look. If you want your stock photographs to sell, use the types of people that appeal to the buyers of advertising photography.

Some buyers are looking for photographs that are not necessarily great or unique. They want straightforward and real feelings, and photographs that are illustrative of something. Review the request list.

Pictures of people in leisure-time activities sell well: picnicking, playing ball, having a good time, and conveying a happy feeling. Try to make it look like a location anywhere, be it beach or country. If you're careful to keep the photograph from being obviously dated, it has more salability.

[Suzanne Szasz, Chapter 3, mentions using photographs that were fifteen years old out of her files for her books.]

Other guidelines are: Try to keep your photographs graphically simple, timeless, clean, sharp, and with good contrast.

Releases

○ Number two, releases. If you start right now taking photographs, be serious about it and always get permission from the people you photograph—that is, get a release. You never know when that photograph will be something you can sell, and without a release, you cut down at least fifty percent on its value. A photograph without a release and with an identifiable person or private property in it can only be used editorially. And that, too, may become a problem, as the result of a recent court case. Even the sale of a photograph for editorial use may require a release.

With a release, a photograph can be used to fill any request. The advertising agencies will not consider any photographs without releases. It has been my experience that those photographers who are conscientious about getting model releases have photographs that sell better. Being conscientious about getting a release indicates a seriousness toward the work which carries over into the quality of the photograph.

You must develop the technique of getting releases. It's as important as taking good photographs. If you're reluctant to present a release form to a stranger, you might ask for their name and address, and perhaps offer to give them a photograph. When you send or give them a copy of the photograph, you can then ask for a release. But nothing is better than getting the release form signed when you take the photograph.

It's curious, but some photographers have the ability to shoot

photographs that sell well for stock. They've obviously done their research. However, to make some sort of return on your stock file, you must think in terms of having at least a thousand suitable photographs on file.

There is the odd outside stroke of good luck for a photographer with ten photographs on file in a stock house to sell two to advertisers for over three thousand dollars each. It's almost not fair to mention it, it is so rare, but it has happened.

There are a few photographers who are so adept at shooting very salable stock photographs that they concentrate primarily on stock. One in particular, who is with DPI, used to do corporate, travel, and advertising photography, and has built up a very valuable stock file that nets him a high income per annum. His stock photographs are sold through DPI and also through stock houses in other countries. He shoots only color (black-and-white conversions can be made if necessary). He covers what he chooses, when, and travels where he wants. However, he always gets releases and arranges an agreeable compensation with the people he photographs.

There is another photographer, living in a suburban area, who specializes in beautiful children, happy families, in gorgeous settings, either exterior or interior. She seldom travels, but there is enough material in her own neighborhood that she has derived a very good income-producing stock file. Also, she has the advantage of dealing with people and situations and events where she is known, and therefore has minimal problems in getting releases.

Appendix

Release Forms

○ Following are two kinds of release forms.

A release form can be carried in a card case, and is very handy. It is good for most purposes, and it is also a way of getting the person's name and address. If you need a firmer release because of a sale, you will pay the subject a model's fee, and they will probably be happy to give you a firmer release.

Next is a more comprehensive release form.

<div align="center">MODEL RELEASE</div>

For valuable consideration, I hereby irrevocably consent to and authorize the use and reproduction by you, or anyone authorized by you, of any and all photographs which you have this day taken of me, negative or positive, proofs of which are hereto attached, for any purpose whatsoever, without further compensation to me. All negatives and positives, together with the prints shall constitute your property, solely and completely.

Model_____
 (Signature of Model)

Address_____Phone_____

City_____State_____Zip_____

Signature of Parent or Guardian if Minor_____

Witnessed by_____
 (Signature of Witness)

MODEL RELEASE

In consideration of $ (amount can be $1.00 or more, or explain you will pay when the pictures are sold) and other good and valuable consideration paid to me by _____, (the "Photographer"), I hereby give the Photographer, his licensees, designees, nominees and assigns the permission and right to use, publish and reproduce the photograph of me, a copy of which is attached hereto, in all forms and media and in all manners, including advertising, trade, editorial, art and exhibition.

I hereby release and discharge the Photographer and his licensees, designees, nominees, and assigns from liability for claims which I might have based on defamation, invasion of privacy or any personal or proprietary right I might have arising from any use, publication or reproduction of the photograph of me.

I am more than twenty-one years of age and agree that this release is irrevocable and inures to the benefit of the Photographer's successors, heirs, licensees, designees, nominees and assigns.

Dated:
This _____ day of _____,

Witness:

_____ _____
 (Model's Signature)

PARENT'S OR GUARDIAN'S CONSENT

I hereby certify that I am the parent and/or guardian of _____, an infant under the age of twenty-one years, and in consideration of value received, the receipt of which is hereby acknowledged, I hereby consent that the photograph referred to in the release above may be used by the Photographer for the purposes set forth in the release above signed by the infant model, with the same force and effect as if executed by me.

Dated:
This_____ day of _____,

Witness: _____
 (Parent or Guardian)

*Amount can be one dollar or more, or explain you will pay when picture is sold.

Professional Organizations

○ Membership in a professional photography organization can be extremely helpful to your career. Throughout this book the photographers have mentioned the organizations they belong to. Usually the organizations are related to their specialties. Members exchange views and experiences, and can learn a lot.

There is an organization that is all-embracing, and photographers from all kinds of specialties are members of it. It is the ASMP—American Society of Magazine Photographers. The name is somewhat misleading. It started out as an organization for magazine photographers, but it evolved into an organization to which all kinds of photographers belong. Among the many purposes they stand for, one they mention is ". . . to cultivate friendship and understanding among professional photographers." This alone is a very necessary pursuit, as photography can be an isolated enterprise, and interchange with your colleagues is very important. The national office is: ASMP, 205 Lexington Ave., New York City, NY 10016, (212) 889-9144. Monthly meetings are open to nonmembers. Many things about the medium are discussed; information is exchanged; and frequently, prominent members doing interesting work give talks and show their work.

The ASMP publishes a monthly bulletin containing information and notices of all sorts—jobs, opportunities, new developments in equipment, studios for rent, and so on. Free to their members they publish a membership directory, and *ASMP Survey of Trade Practices,* which is a guide to information in all media. It includes contract forms for books, agents, models, and property releases.

They also publish the *ASMP Professional Business Practices in Photography,* which can be purchased by anyone. For more information write to the national office of ASMP. Another important publication they do is *The ASMP Book,* an annual that is a promotional publication for professional photographers.

ASMP recommends insurance and legal services, and keeps abreast of pricing for reproduction fees in all media, and information of all sorts for the industry.

Categories for Membership

○ Categories for membership in the ASMP will give you an idea of the breadth of the organization:

1. Students
2. Assistants
3. Associates—photographers with less than three years' working experience.

4. General—professional photographers with more than three years' working experience.

5. Sustaining members—people in a field related to photography.

This is an organization that offers the beginning, and even the pre-beginning, photographer the opportunity to meet established photographers and to benefit from the experiences of people with many years of solid work behind them.

There are twenty ASMP branches: Arizona Chapter, Phoenix; Colorado Chapter, Denver; Dallas Chapter, Dallas; Florida Chapter, Miami; Gulf Coast Chapter, New Orleans; Houston Chapter, Houston; Long Island Chapter, Farmingdale; Mid-Atlantic Chapter, Washington, D.C.; Midwest Chapter, Chicago; Minneapolis-St. Paul Chapter, Minneapolis; Mountain West Chapter, Salt Lake City; New England Chapter, Boston; New York City Chapter, New York City; Northern California Chapter, San Francisco; North Carolina Chapter, Winston-Salem; Pacific Northwest Chapter, Seattle; Philadelphia Chapter, Philadelphia; San Diego Chapter, San Diego; Southeast Chapter, Atlanta; Southern California Chapter, Los Angeles.

To get information about any of the chapters, you can write to the national office at the address given above.

Anyone seriously interested in making progress as a professional photographer would do well to look into the ASMP. Other professional organizations connected to different specialties are mentioned throughout the book.

Newspaper—*Photo District News*

○ This is a newspaper that was started fairly recently, which is aimed at the professional photographer, and has turned out to be excellent. It is chock full of information, articles about many different photographers, all kinds of interesting work, developments and services in the field, and even social events involving photographers.

The address is Photo District News, 201 E. 16th Street, New York, NY 10003. It would be worthwhile to send away for a copy. You will be pleasantly surprised by all the articles on the many different facets of the field, and you will find it all very helpful.

Summary

○ The purpose of this book was to bring you, the reader, as close as possible to photographers at work, to let you know how the photographers feel and think while they are working, and how they feel and think about photography. This book also tells you how each photographer began his or her career, in order to give you insight and inspiration. The best way to learn how to start is to discover how others have done it.

As you have learned, there are definite guideposts and rules; the film, the paper, the cameras are all very important. There are many ways of working—some photographers work simply and accomplish a lot; others work in a more complicated manner, are involved with many technical aspects of the medium and elaborate studio setups, and also accomplish a lot.

Photography is both a science and an art form. It is mathematical, it is magic, and above all, the scope is tremendous. It is hard work and it is fun. You can use it to make a modest living or to make a lot of money. It can be very precise, and yet there's room for far-flung imagination and ingenuity.

Now that you have read about the workings of the world of photography, by having the photographers talk directly to you, it is hoped that you realize another important aspect of this work: how the photographers relate to all the people their work involves them with—their clients, be they art directors, editors, doctors, celebrities, or dedicated performers, models, assistants, engineers, architects, or artists. The list is endless.

You should now have an understanding of the characteristics of many

photographic specialties. You should have an idea of what you most want to do, what you are most suited for. If there is a specialty that hasn't been mentioned in the book, be assured that something close to it has been mentioned and spoken about in detail.

The "star" and "glamour" aspects of photography are often over-emphasized. What you've read in this book should make you aware that there are many photographers who have fine careers, who do wonderful work, and who don't think of themselves as stars. Their names aren't touted everywhere; drooling articles aren't written about them. They just work hard and well, with intelligence and energy and enthusiasm. They find out what's needed, how to master it, and how to market it. What they do have is dedication to their work.

Many people are attracted to photography because they think it's a fun thing. It does have that element, but the photographers who succeed are serious; they are all very hard workers, are focused, have a lot of drive, and know what their goals are.

Some choose a specialty and never change; others absorb and work in the many specialties of photography. But photography is that kind of work—you can mold it to fit your concepts and desires. As Dianora Niccolini says,

> If you are in control of all the fundamentals, there is no reason why you cannot apply your knowledge to any field of photography. If you are a good photographer, you should be able to do fashion photography, medical photography, industrial photography. You may have preferences just because of your own personality, but technically speaking, there is no reason why you cannot apply basic photography to all those different fields.

Photography can be a gregarious occupation, or you can spend a lot of time alone. It has its struggles, its disappointments, its triumphs, its frustrations—but it is a very satisfying, much-loved medium. It can be creative and satisfying on many levels.

This book goes beyond an instruction book. It should appeal to aspiring professional photographers, amateurs, and also to working professional photographers who want to know more about other specialties. It should appeal to everyone who is interested in photography, which is almost everybody.

Index

M

N

P